The Prince
and the Plunder

About the Author

Andrew Heavens has worked for newspapers and press agencies for almost thirty years, including six years as a reporter and photographer in Ethiopia and Sudan. He grew up in Nigeria, Kenya and Egypt, and lives in London. *The Prince and the Plunder* is his first book.

The Prince and the Plunder

How Britain took one small boy and hundreds of treasures from Ethiopia

Andrew Heavens

To Amber, Rawdon and Esther

Front cover illustration: Alamayu at Rugby. (Courtesy of Special Collections and Galleries, Leeds University Library)

First published 2023
This paperback edition first published 2025

The History Press
97 St George's Place, Cheltenham,
Gloucestershire, GL50 3QB
www.thehistorypress.co.uk

© Andrew Heavens, 2023, 2025

The right of Andrew Heavens to be identified as the Author of this work has been asserted in accordance with the Copyright, Designs and Patents Act 1988.

All rights reserved. No part of this book may be reprinted or reproduced or utilised in any form or by any electronic, mechanical or other means, now known or hereafter invented, including photocopying and recording, or in any information storage or retrieval system, without the permission in writing from the Publishers.

British Library Cataloguing in Publication Data.
A catalogue record for this book is available from the British Library.

ISBN 978 1 80399 650 9

Typesetting and origination by The History Press
Printed and bound in Great Britain by TJ Books Limited, Padstow, Cornwall

 Trees for Life

Contents

List of Illustrations		VII
Preface		IX
Map of the Horn of Africa		XV
PART ONE: THE PRINCE		I
1	Home	3
2	Breakdown	25
3	War	45
4	Plunder	69
5	Exile	95
6	Arrival	113
7	Interludes	127
8	Retreat	145
9	Lessons	157
10	The Funeral Psalm	181
11	Return	191
PART TWO: THE PLUNDER		195
	Alamayu	201
	Tirunesh	204
	Tewodros	208
	'The Abuna's Crown and Chalice'	217
	The Dig	220
	6,450 Animals and a Human Skull	223
	The Kwer'ata Re'esu Icon	227

The Book Liberator	231
The Tabots	236
Alamayu's Remains	242
The Directory	245
The Maqdala Plunder, Still Missing	249
The Maqdala Plunder, Returned	251
Notes	253
Select Bibliography	263
Acknowledgements	266
Index	267

List of Illustrations

p. IX Alamayu's signature, dated 1869 (Ian Shapiro collection)

p. XI Mural of Tewodros in Addis Ababa (author's photo, courtesy of Reuters)

p. XII Portrait of Alamayu by the London Stereoscopic and Photographic Company, *c.* 1868 (author's collection)

p. XV Map of the Horn of Africa featuring key sites from the story (d-maps – www.d-maps.com/carte.php?num_car=5502)

p. 18 View from a point near the King's House, Maqdala (*Illustrated London News*, 1868)

p. 21 Boys playing *genna* on top of Maqdala, January 2004 (photo courtesy of James Ball)

p. 30 Stern's confrontation with Tewodros (from *I Prigionieri di Teodoro*, 1870)

p. 39 The European prisoners on Maqdala (from *I Prigionieri di Teodoro*, 1870)

p. 42 Britannia confronts Tewodros (*Punch*, 1867)

p. 59 Action of Aroge, from *Record of the Expedition to Abyssinia*, vol. II (New York Public Library)

p. 65 Attack on Maqdala, from *Record of the Expedition to Abyssinia*, vol. II (New York Public Library)

p. 71 'King Theadore after death', photographs of the Abyssinian campaign (1867–1868) (Yale Center for British Art, Paul Mellon Fund)

p. 79 'Son and heir of King Theodore', photographs of the Abyssinian campaign (1867–1868), albumen prints (Yale Center for British Art, Paul Mellon Fund)

p. 81 Maqdala in flames (from *I Prigionieri di Teodoro*, 1870)

p. 84 Alamayu (*Illustrated London News*, 1868)

p. 90 'Captain Speedy', photographs of the Abyssinian campaign (1867–1868) (Yale Center for British Art, Paul Mellon Fund)

p. 103 Alamayu in Malta by Leandro Preziosi (Giovanni Bonello collection)

The Prince and the Plunder

p. 110 'Prince of Abyssinia sketched at St Davids station' by Tucker (Devon Record Office; found by Dr Ghee Bowman)

p. 117 Speedy and Alamayu photographed by Cornelius Jabez Hughes on the Isle of Wight (Ian Shapiro collection)

p. 123 Alamayu on the Isle of Wight by Julia Margaret Cameron (Museum of Fine Arts, Houston)

p. 129 Tewodros's charger Hammel (Ian Shapiro collection)

p. 131 Maqdala robes on display in the South Kensington Museum, 1868 (*The Gentleman's Magazine*)

p. 132 'Abyssinian trophies' on display (*The Gentleman's Magazine*)

p. 167 Class photo, Rugby School, 1876 (Sandy & Caroline Holt-Wilson collection)

p. 168 Detail of class photo, 1876 (Sandy & Caroline Holt-Wilson collection)

p. 168 Detail of class photo, 1877 (Sandy & Caroline Holt-Wilson collection)

p. 170 Alamayu at Rugby (courtesy of Special Collections and Galleries, Leeds University Library)

p. 186 Alamayu photographed after death, 1879 (courtesy of Special Collections and Galleries, Leeds University Library)

p. 201 Alamayu's necklace (© The Trustees of the British Museum)

p. 204 Tirunesh's dress (The Victoria & Albert Museum)

p. 208 Images showing Tewodros just before and after his death (from *I Prigionieri di Teodoro*, 1870, and *Illustrated London News*)

p. 212 Richard Pankhurst with Tewodros's amulet in Addis Ababa, 2002 (author's photo)

p. 215 'A portrait of the emperor' in selections of the Gospels of Matthew and Mark (British Library OR 733)

p. 217 'The Abuna's Crown' (*Illustrated London News*)

p. 217 'The Abuna's Chalice' (*Illustrated London News*)

p. 220 The dig at Adulis (*Illustrated London News*)

p. 221 Artefact from Adulis (*Illustrated London News*)

p. 227 The Kwer'ata Re'esu icon in 1905 (*The Burlington Magazine for Connoisseurs*)

p. 231 Seymour McLean, 2002 (author's photo)

p. 236 Ethiopian delegation at Waverley Station, 2002 (author's photo)

p. 245 Richard Pankhurst and Dr Hassen Said from the Institute of Ethiopian Studies, Addis Ababa, 2005 (author's photo)

Preface

Our hero is an Ethiopian prince called አለማየሁ. It seems pretty well established that the closest English version of that name is Alemayehu. This book is going for something simpler – Alamayu – because that is how *he* wrote it, as far as we can tell from the few scraps of paper left with his handwriting. There is a handful of letters out there. The scholar–collector Ian Shapiro also found his signature written out on a slip of paper in a Victorian album of autographs.

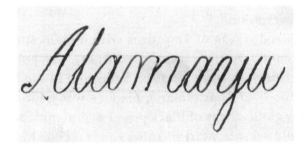

It is a young boy's faltering handwriting; you can still see the pencil guidelines and the false stops and starts on the 'l' and the 'a'. If he was reading this book – and he would have just passed his 161st birthday around now – there is a good chance that this is the version of his name he would recognise on the page.

Whenever his name comes out of other people's mouths and other people's pens, the book will keep their spellings inside quotation marks, if only to show that even those closest to him never quite got it right. Alam-Ayahoo, Alam-ayahu, Alamaeo, Alamaeio, Alamagub, Alamaieo, Alámàio, Alamaya, Alamayahu, Alamaye, Alamayo, Alamayon, Alamayoo, Alamayou, Alamazoo, Alamees, Alemayahu, Alemayehu, Alemayu, Alumaya – they are all Alamayu.

◙ ◙ ◙

I first heard his name when I was a reporter in Ethiopia in the early 2000s. There were images of his father – Ethiopia's great nineteenth-century King of Kings Tewodros II – all over the place: scrawled on school buildings, printed on T-shirts, reproduced endlessly on cards stuck on car windows in the modern capital Addis Ababa, in the old city of Gondar and in his base in Debre Tabor, east of Lake Tana. Those pictures showed a stern, muscular man with long braided hair, staring into the distance with lions lying at his feet and flags or cannons in the background.

A super-sized statue of Tewodros with a giant spear loomed over tourists and travellers at Gondar Airport, also known as Atse Tewodros Airport. In some parts of Addis and in the Rastafarian neighbourhoods of Shashamane, his face was daubed on walls next to other global icons of Black power and dignity, among them Emperor Haile Selassie, Martin Luther King and Bob Marley.

Preface

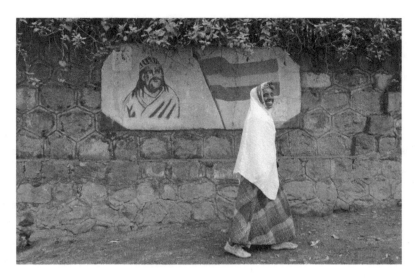

Mural of Tewodros in Addis Ababa.

This was Tewodros as African giant, the man who forcibly united his country after decades of chaos, then took on the growing imperial force of Great Britain. His coronation in 1855, as the historian Bahru Zewde wrote, 'inaugurated the modern history of Ethiopia'.

Next to all that, his son remained a bit of a footnote, a tragic 'and finally' to Tewodros's story. Alamayu was Ethiopia's own lost boy, the prince who, according to the repeated tellings of his short tale, was snatched away from his mountain home by invading British soldiers and taken to the cold, cold shores of Great Britain. Search for him now online and you'll see him on his journey. There he is again and again, row upon row of images of a little boy, a sad-eyed schoolboy of the English Midlands, a young man. The backgrounds change – a plain in Ethiopia, a photographer's studio in Malta, a drawing room in Victorian England. But one thing rarely shifts: his expression. In most of the pictures he stares straight ahead or sometimes a little to the side, wherever he is directed. He has the same good looks, the same straight-backed dignity, a sense of poise. And then there are his eyes and his mouth that naturally falls into the mildest of frowns, his separation from everything and everyone around him, his almost constant sadness. He became a myth, an icon of sadness.

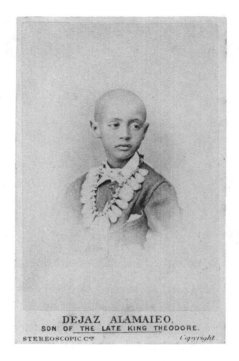

Portrait of Alamayu by the London Stereoscopic and Photographic Company, c. 1868.

That icon still evokes strong emotions. 'Whenever I see a photograph of Alemayehu I can stare at it for hours. There is always something so tragic in his pose,' Elleni Centime Zeleke, a professor of African studies at Columbia University, wrote in a poetic essay in the journal *Callaloo*. 'When Alemayehu sits for a photo he already looks like a dead memory. It is as if he already understood his fate, as did his photographers.' In 2007, the government in Addis Ababa formally called for Britain to return Alamayu's remains to Ethiopia. One otherwise hard-bitten rebel-fighter-turned-government-minister dug deep as she tried to explain what was driving the campaign. It wasn't about politics or calculated reparation. At the heart of it was something much simpler, something that any parent could understand. Alamayu, the lost boy, the lost prince, just had to come home. 'I am saying this as a mother,' she told the journalists gathered around her.

Preface

The images and iconography of Alamayu are powerful, but the details of his life have largely only been sketched in outline. This book is an attempt to fill in some of the gaps, go beyond the folktale and follow Alamayu's journey from the Ethiopian highland fortress of Maqdala out across the sea. He did not leave many words. Many books would apologise for their lack of first-hand material from their main subject. Here though, that is one of the main points. At the start of his journey he was a child, so other people spoke for him. Other, mostly European, people made decisions for him. Much of the time you are left weighing up other people's competing accounts of what happened. Very occasionally you can see the real boy through the cracks in an unguarded smile in a photograph or an overheard snatch of conversation, a flash of defiant humour, a sign of a strong and determined will. This book looks through those cracks and uses objects to fill in some of the story – Alamayu's possessions, as well as other things that should have been his possessions but were kept from him, and the hundreds of objects of loot and plunder that the British soldiers brought back from their invasion.

He spent more than half his life in Britain, so this is as much a book of forgotten British history as Ethiopian history. It is a story that starts before Alamayu was born, with an encounter between Britons and Ethiopians in the middle of the nineteenth century, in the decades between the end of Britain's dealings in African slavery and the start of its wholesale scramble for African territory, when the direction that future relations would take was still not set in stone. Somewhere in the middle of it all there is our lost prince, a young queen and a pile of missing treasure. There is also the story of a relationship between Britain and Ethiopia that burned bright, then faltered, then collapsed in disaster. It all happened a long time ago now. But in many ways we are still getting over it.

◙ ◙ ◙

XIII

A few words on words:

This book refers to 'Ethiopia' wherever it can and the archaic 'Abyssinia' only occasionally, mostly when it crops up in quotes and other people's references. For simplicity's sake, both names are used to refer to the same territory in the Horn of Africa – north of modern-day Kenya, south of modern-day Sudan and Eritrea – though I know that drives a dump truck through a whole host of important geographical and historical demarcations. Most of the action here takes place in the northern part of modern-day Ethiopia.

The monarch is Tewodros, not the anglicised version Theodore or Theodorus; his mountain fortress is Maqdala, not the anglicised Magdala. I have tried to follow the historian Bahru Zewde in the transliteration of other names, apart from Alamayu, who remains Alamayu.

Map of the Horn of Africa

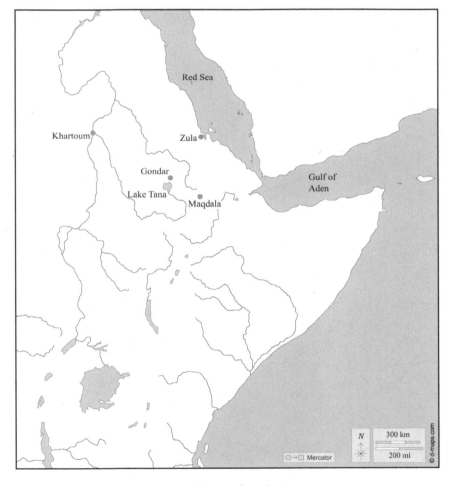

Featuring key sites from the story.

Part One

The Prince

Chapter One

Home

'Here [in the happy valley] the sons and daughters of Abissinia lived only to know the soft vicissitudes of pleasure and repose, attended by all that were skilful to delight, and gratified with whatever the senses can enjoy ... The sages who instructed them, told them of nothing but the miseries of publick life, and described all beyond the mountains as regions of calamity, where discord was always raging, and where man preyed upon man.'

The History of Rasselas, Prince of Abissinia

On the first day of March 1841, John Bell set off from Gondar on the lookout for adventure. Leaving the old city's castles and incense-filled churches behind him, he rode south, down past villages and hills and woodlands, following the winding course of the Angereb River.

Turning a bend in the track, he got a good view of vast expanse of Ethiopia's Lake Tana spread out in front of him, dotted with island churches and monasteries. The fresh, clear highland air brought everything closer. Out in the glinting water he could make out the grey mass of his first hippopotamus basking on a shoal.

The towering son of a family of roaming British seafarers had already seen more than his fair share of wonders and new horizons. He had been born on Malta, learned French, Maltese and Arabic at the missionary school in Sliema and earned his first living travelling with merchants and explorers, acting as their universal factotum and translator. While still in his twenties, he had decided it was time for some exploits of his

own, so he had sailed down the Red Sea, stopped off on the coast of East Africa and climbed up into the near-mythical mountain empire of what was then called Abyssinia. His plan: to find the source of the Nile, to fill in some of those great blank spaces on his maps of the interior, to win a little recognition back home and, above all, to forge his own future.

So that was what he was doing as he wandered south down the edge of Lake Tana. Adventuring had never been easier. Day after day he rode over gently sloping hills in the shade of acacia trees, crossing streams, shooting guinea fowl for dinner and sipping the coffee brewed by his retinue of servants. Barely a week into their journey, the small party wound its way through a hilly, heavily wooded territory, over a stream, past a church and up along a lonely woody path, bounded on both sides by high bushes. Which is where the bandits struck.

◎ ◑ ◎

Eight men armed with shields and lances jumped out of the bushes and knocked Bell to the ground. They slashed at his arm as he tried to protect his head. One servant, Gabriote, ran to his side with a sword. Bell got up, pulled out two pistols and held the attackers at bay for a second. Another rush. Bell took aim, but his first pistol misfired. So did his second. He had loaded them two months earlier and they had hung unused by his side during his wandering idyll. He took one of the pistols by the muzzle and used it as a club, lashing out. The men closed in and surrounded them, jabbing with their spears. One raised a lance and stabbed Bell in the face, sinking the point between his eyes. Blood gushed out, nearly blinding him as he floundered on, weaker and fainter. Gabriote, still at his side with five gaping wounds, still trying to keep the men away, began to totter and slumped down. One of the bandits grabbed his sword as he fell. The gang scooped up a few other bits of baggage scattered around and ran off, leaving Bell and Gabriote lying on the blood-soaked ground.

A pause, then the other servants emerged from their hiding places. The two wounded men managed to get to their feet, gather some

belongings and slowly, slowly head back to the track, staggering along, falling three or four times along the way. After about half an hour of agonising stumbling they reached the town of Qorata and collapsed at the door of a church.

By sheer luck, a merchant that Bell had met on his way into the country had a house nearby and took them in. One of the attendants gave Bell a cup of the local beer, but when he drank it some of the liquid came seeping out of his eyes. On closer inspection, he later wrote in his journal, the spear thrust into his face 'was found to have entered the superior part of the nasal bones, to have pierced the superior palate bones and to have run along the superior maxillary bone finally making its exit just below the right ear, most wonderfully avoiding the large vessels placed in that neighbourhood'. Gabriote was in no better state.

◎ ◎ ◎

After a few days, wounds still healing, Bell had recovered just enough to start making inquiries. It turned out that the eight *shifta* – a loose term covering a wide range of armed men from bandits to rebels to militia fighters – were under the command of a senior officer serving Ras Ali, that region's ruler. From his sickbed, Bell demanded investigations, compensation, punishment for the men who had dared to attack the British explorer and his party. What he got in return was a measure of sympathy from his immediate hosts but, beyond that, bemusement. The wheels of Ethiopian politics, it turned out, were not prepared to stop in their tracks to investigate and prosecute a bandit attack on a notoriously bandit-infested road. No one had died. *Shifta* happens. That was that.

Bell's merchant friend sent men to the scene of the attack and retrieved one of the pistols dropped in the melee. 'When I recovered a little I went to see the Ras, and asked him to punish the robbers,' Bell wrote. 'He refused, saying they were badly wounded as well as myself. He then dropped the subject declaring he would not hear more about it; consequently I got up and walked out of the place.'

What to do when the rest of the world refuses to play along with the grand narrative running in your head? You can pack up and go home. Or you can keep on keeping on, keep the story running in your own journal and get back on track as the explorer, pushing forward the boundaries of adventure.

A few weeks passed and an Ethiopian noble rode into town, on his way to patch up a rift with Ras Ali. At dinner one night, the noble offered to take Bell along with him on the next stage of his journey and show him some more of the country. Bell said yes and on 4 April, almost a month to the day after his woodland ambush, he jumped on his horse and was back on his way, leaving Gabriote, still badly wounded, behind him.

◙ ◙ ◙

Time to speed up. Bell was off again, fording streams, riding past old Portuguese fortresses, feasting on raw beef and honey wine, having a blast. He inspected a bog close to Lake Tana, long acknowledged as the source of the Blue Nile tributary of the great river that flowed on hundreds of miles north through Sudan and Egypt out into the Mediterranean. (Europe's geographers would have to wait another seventeen years for another wandering Brit to head around 900 miles further south and 'discover' the source of the White Nile.) Bell suffered from fevers and severe head pains. At one point he sent for someone to bleed him 'and after much difficulty a monk was found who undertook to perform the operation'. A servant held Bell in a headlock until the veins stuck out. The monk pulled out a razor, held it against Bell's forehead and tapped it sharply with a stick. 'The incision being made, the pressure was removed from my throat, and the blood flowed freely which relieved me much, and I soon recovered my usual health.' Somewhere along the way, the former wanderer called John Bell, scarred and battered, with a spear wound in between his eyes, a hole in the roof of his mouth and a gash across his forehead, decided this was where he wanted to spend the rest of his life.

Home

◎ ◎ ◎

On one trip out of the country he met another restless Briton in the port of Suez and persuaded him to come to Ethiopia and share in the fun.

Walter Plowden was another towering young man, buried up to his neck in the British establishment. Branches of his family had records dating back to before the twelfth century, with their own ancestral seat and their own ancestral chapel in Plowden Hall in the heartlands of England, in the Shropshire hamlet of, you guessed it, Plowden.

By the age of 19, he had followed his older brothers, father and grandfather by setting up shop in British India and started making his fortune the respectable and brain-deadening way, working for the banking and trading firm of Carr, Tagore and Company in Calcutta (now Kolkata). But it hadn't worked out. On the way back to England he met Bell in Suez in 1843, a meeting that, in the words of the Plowden family chronicle, 'altered his mind'. On the spur of the moment, without funds or planning, he decided to jack it all in, rip up generations of family tradition and seek out his own life in Africa.

So this is where he headed with Bell – to Ethiopia, the perfect place for anyone looking to escape the drudgery of balancing figures and counting stock. For Europeans, this was Abyssinia, one of the purported homelands of Prester John, the mythical medieval Christian priest–king whose vast crusading armies had set out with thirteen golden crosses at their head to challenge the surrounding 'infidels'. Most people realised his riches, fantastic beasts and other glories were fairy tales stitched together by the chroniclers. But the myth still held. Britons were short of facts about Africa in those days and long on legends.

Abyssinia was also supposed to be the last resting place of the original Ark of the Covenant, the chest designed by God himself for the ancient Israelites to hold the Ten Commandments. Plowden had studied the ancient Ethiopian text the *Kebra Nagast*, or *The Glory of Kings*, which set out the story of Ethiopia's first emperor, Menelik – the son of none other than King Solomon and Makeda, the Queen of Sheba – who, it was said, had brought the Ark to Ethiopia from the Temple in Jerusalem. Who

knew what other potent biblical treasures were hiding away in some church in the Abyssinian highlands?

The country was also the home of Rasselas, the fictional Abyssinian prince created by the English writer Samuel Johnson. According to Johnson's bestselling book *The History of Rasselas, Prince of Abissinia*, published in 1759, the boy lived a gilded life in a 'happy valley' where 'all the diversities of the world were brought together, the blessings of nature were collected, and its evils extracted and excluded'. The youth and his royal siblings were kept there, apart from the rest of the world, and distracted by an endless succession of entertainments and frivolities until it was their turn to take the throne. At the centre of it all stood a palace where a succession of emperors had buried their gold and jewels in hidden cavities. In the British imagination, the courtly glories of the Ethiopian highlands were part Xanadu, part potential asset.

Bell and Plowden embarked on five years of freewheeling wandering. They found no jewels but made do with several lifetimes' worth of adventures.

◎ ◎ ◎

Over time their paths diverged. Plowden dreamed of forging a grand alliance between his new home and his old. Throughout his time in Ethiopia, he sent reports back to London singing the country's praises, touting its fertility, untapped resources and opportunities for trade. He described how its soil could produce all types of grain, tea, coffee, indigo, spices, cotton, peaches, plums and grapes. After rains, 'beautiful rivulets meander in all directions, resembling the trout streams of England'. There was iron, gold and copper. Plowden's letters and journal entries created their own fantasy land to rival Prester John's. In his hands, Ethiopia transformed into a Merrie Olde jumble of courtly romance. Its *tej* honey wine flowed like mead. Its songs and singers rivalled those 'of the old Jongleur or Provençal', 'the Highland harper or Irish bard'. Its military hierarchies recalled 'the feudal times, when the great barons were followed to war by all born on their lands'.

Early on, Plowden travelled back to Britain, surviving a Red Sea shipwreck on the way, and made his case to the Foreign Office in person. His efforts paid off and in January 1848, still in his twenties, Plowden was appointed 'Consular Agent for the protection of British trade with Abyssinia, and with the countries adjoining thereto'. His official base was back on the Red Sea coast in the sweltering port of Massawa, then an outpost of the sprawling Ottoman Empire. But London, initially at least, encouraged him to keep heading up into the highlands from time to time to keep the lines of communication open and watch over the trade and diplomatic treaty he had finally secured with Ras Ali.

John Bell took things even further. He all but forgot his old land and threw himself into his home. He wore Ethiopian clothes and, in the years that followed, married an Ethiopian noblewoman, Woizero Warknesh Asfa Yilma, and started a family. John became Yohannes as he moved on from his early unsatisfactory encounter with Ras Ali and effectively signed up as one of his generals, waging Ras Ali's wars, charging around the land and leaving nineteenth-century Britain, with all its relentless clanking, steam-powered churn, far behind him.

◎ ◎ ◎

There was a tricky interlude when it turned out that Bell had backed the wrong man. This was a particularly tumultuous era in Ethiopian politics known as the Zemene Mesafint – a name that has been translated as both the Age of Princes and the Age of Judges, after the era described in the Old Testament Book of Judges when 'there was no king in Israel [and] every man did that which was right in his own eyes'. Ethiopia's ancient line of Solomonic leaders had disintegrated into a succession of puppet emperors, and the real powers in the land were the princes, the Rases, who battled endlessly over influence and territory.

Ras Ali, with Bell fighting at his side, was defeated at the Battle of Ayshal on 29 June 1853 by an emerging power – Ras Ali's own rebellious son-in-law, a minor noble turned *shifta* turned militia leader known at

the time as Kasa, the man who would go on to become King of Kings Tewodros II, the future father of our prince.

Ras Ali fled and, after a few minor skirmishes, faded from history. Bell, as the story goes, took refuge in a church after the defeat and awaited his fate. Kasa heard he was there and called him out to talk. The battle, which could have been the end of this story, turned out to be just a bump in the road for Bell and Britain's other young representative. Bell smoothly switched his allegiance to Kasa and kept diving in deeper and deeper. Plowden had already been keeping track of Kasa's rise and had been impressed with what he had seen.

◎ ◑ ◎

You can still hear the voice of Alamayu's father crackling with energy through the short letters, messages and orders sent out to allies and enemies. 'I am Kasa. No one can face me,' read one early challenge to a rival in the borderlands with Sudan. Kasa had spent his early years in Kwara, west of Lake Tana, right in those border regions, and was always haunted by the threat from the Muslim north – from the Egyptians, the Ottomans or, as he called all of them, 'the Turks'. He had suffered one major defeat in his early campaigns, when he had pushed north, only to be routed by a well-drilled Ottoman force armed with artillery. Ever since, he had also been obsessed with mastering tactics and acquiring heavy weaponry.

By early 1855, in his late thirties, Kasa had defeated most of his main rivals through a mixture of political manoeuvring, spectacular raids and military daring. So he decided to end the Zemene Mesafint and get himself crowned *negusa nagast*, King of Kings, over the whole territory. He chose the name of a long-prophesied saviour who would unify the country, defeat its enemies and rebuild its fortunes – Tewodros. The British, skimming over the details and balking at the foreign-sounding name, called him King or Emperor Theodore or Theodorus.

Tewodros promised to end Ethiopia's relative diplomatic isolation and build foreign alliances. 'Now you are the child of Christ and I am

the child of Christ. For the love of Christ I want friendship,' he wrote to Britain's Queen Victoria, one monarch to another.

But he was also cautious about foreign interference. 'Don't send us priests and clergy,' ordered another message stamped with his seal and sent to the French consul at Massawa. The Ethiopians had been Christian for centuries and had their own Orthodox Church and priests, the message said. They didn't need to learn the religion from anybody, particularly imported Catholic missionaries. But if Europe wanted to send in merchants and craftsmen, he wrote, that was a different matter. Ethiopia would welcome them with open arms, whatever their creed.

◎ ◎ ◎

'A remarkable man has now appeared, who under the title of Negoos or King Theodorus, has united the whole of Northern Abyssinia under his authority, and has established tolerable tranquillity,' Plowden told the authorities in London in June 1855, using his own spelling for *negus*, or king.

'The King Theodorus is young in years, vigorous in all manly exercises, of a striking countenance, peculiarly polite and engaging when pleased, and mostly displaying great tact and delicacy,' Plowden wrote. 'He is persuaded that he is destined to restore the glories of [the] Ethiopian Empire, and to achieve great conquests; of untiring energy, both mental and bodily, his personal and moral daring are boundless.'

Tewodros had his faults, Plowden went on in his official report: 'The worst points in his character are his violent anger at times and his unyielding pride as regards his kingly and divine right.' Plowden watched as a Catholic monk was brought in front of Tewodros and sentenced to death for refusing to recognise the king's authority. The consul successfully pleaded for the monk's life but 'could in no way persuade the King to banish him or release him from his chains'.

Overall, Plowden excused Tewodros's excesses. His harsh punishments were 'very necessary to restrain disorder, and to restore order in such a wilderness as Abyssinia'. And generally, Tewodros kept those

excesses under control, Plowden said. 'He has hitherto exercised the utmost clemency towards the vanquished, treating them rather as his friends than his enemies. His faith is signal; "Without Christ," he says, "I am nothing; if he has destined me to purify and reform this distracted kingdom, with His aid, who shall stay me?"'

There was even more in the gushing report. Tewodros had taken steps to ban the practice of enslaving prisoners of war and other groups in Ethiopia, cut trade red tape and overhauled the military. 'He wishes, in a short time, to send embassies to the Great European Powers to treat with them on equal terms,' Plowden told London.

◎ ◎ ◎

The feelings of admiration were mutual, up to a point. Tewodros knew true believers and useful allies when he saw them and knew how to make them feel special. 'You and Bell only love me,' he said in one aside to the consul, recorded in Plowden's notebooks later published by his brother.

'If anything happens to me, befriend my son,' Tewodros told Plowden, taking his hand before heading out on a military excursion. 'Write to your country; say you had a friend who loved you all, and who intended to send an embassy to you for your friendship and beg them to support my son.' Plowden promised he would. Alamayu had not been born yet. But Tewodros already had one son from his days in Kwara.

Many European commentators have presented Plowden and Bell as Tewodros's bedrock, his steadying, guiding – in their words, civilising – hand. There is little to back that up, beyond European condescension. Tewodros may have been interested in the foreigners' technology, in the head start that the Industrial Revolution had given them in matters military and mechanical. But he had done pretty well by himself before the British turned up. 'For Teodoros, the foreigners and the Westerners in particular were the barbarians who by some inexplicable dispensation of Providence possessed the knowledge of technological procedures and gadgets,' wrote Czeslaw Jeśman in his 1966 essay 'The Tragedy of Magdala'. Tewodros would 'confide in them and shower all manner

of rewards. As long as they served his purpose they were welcome; otherwise they were beneath his contempt.' Other Europeans who later felt the full force of that contempt said they regularly overheard him referring to white monkeys.

◎ ◎ ◎

So far, the foreigners were serving Tewodros's purpose. Europe had sent him explorers and adventurers and he had effectively recruited them. Europe had also sent him missionaries, and he had them exactly where he wanted them. He had stamped out direct efforts to convert Ethiopian Orthodox Christians to foreign brands of Christianity, and only let a few groups of preachers in, on strict conditions. One was a band of Protestants who had promised to focus on teaching craft and technical skills, based in the settlement of Gafat. He had already started persuading them to work with other craftsmen and turn their skills to mending the occasional musket, even casting mortars and cannons. Another band of missionaries that he was less sure about had said they were only interested in converting members of Ethiopia's Beta Israel group – then widely known by the now-derogatory term Falashas – who lived across the area covered by our story and had followed a strand of Judaism as long as anyone could remember. Fine, Tewodros had said, as long as the missionaries only tried to turn them into Orthodox Christians. Beyond that, his imperial plans were flourishing.

The Brits were also more than happy with the arrangement. Plowden had found his African King Arthur, a wellspring of future adventures and a foundation for his grand plans of British–African engagement. He pressed Tewodros to make the relationship official by ratifying the treaty Britain had already signed with Ras Ali. Tewodros held off from signing any British contract and refused to allow the establishment of a foreign consulate on his territory. Many after him might have wished they had done the same. He said he was inexperienced in such matters and wanted to hear more. Plowden suggested Britain might be able to give the landlocked mountain kingdom its own route to the sea and full

control over Massawa. If Tewodros would only accept him as consul, Plowden suggested, he would follow the monarch's campaigns and share his dangers. That, to put it mildly, is further than today's British ambassador to Ethiopia would go. Tewodros said he still had to think.

Bell was more than happy with his whole new life. He had got a title – Liqa Mekuas, literally 'gatekeeper', a kind of chamberlain. He had his official position close to Tewodros's tent, shared his food, read him passages from Shakespeare and fought in his campaigns, sometimes dressed up like Tewodros himself so he could act as a kind of body double to deceive their shared enemies, despite the obvious differences in the two men's appearance. He was 'Theodore's Englishman', *The Times* later said. 'There are in all history few instances of a devotion so loyal, so touching in its simplicity and honest bravery as that with which this single-hearted, outspoken Englishman worshipped Theodore.'

The nineteenth century's imperial powers famously focused on spreading the three Cs – Commerce, Christianity and Civilisation, all on their own terms, of course. The Europeans edging into Ethiopia and other parts of Africa at the time were interested in all three. But they were also there for the romance and the roleplay that their new surroundings allowed them. Junior officers and younger sons from relatively drab backgrounds hitched a ride on Britain's expansions and reinvented themselves in the wide-open spaces as explorers, masters and adventurers. They revelled in the exotic. Those young men could dress up and work up a whole range of new stories, casting themselves as the central characters. But stories can be dangerous things. They can go badly wrong when you try to force roles on the other people around you. Particularly when the fantasy you have spun crashes into reality.

◙ ◙ ◙

Five short years later, Bell and Plowden's fantasy crashed into reality.

A one-line report in *The Times*, dated 5 May 1860, announced: 'Her Britannic Majesty's Consul at Massowah (Abyssinia), Mr. W.C.M. Plowden, is dead.' Soon, so was John Bell.

Plowden had set off for the coast, his health deteriorating and his leg weak after a bad break, exhausted after years of diplomatic needling that had still failed to produce a treaty or any influx of British investment. 'Still very weak, but must go,' read the last entry in his journal.

On his way, a band of rebel fighters surrounded Plowden's party and took him away. There are various reports of what happened next, none of them reliable as many of the immediate witnesses were soon themselves dead. At some point one of his captors stabbed him in the chest, either during the initial confrontation or a little while later when they thought he was reaching for a weapon. Friends paid a ransom and took him back to Gondar, where Britain's first consul to Ethiopia died of his wounds, aged just 39. He was buried at a grand funeral, with thirty priests and much of the population of the city attending. You can still visit his crumbling grave.

Tewodros vowed revenge and set off in search of the rebels, with Bell in the advance party. They found them, attacked and 'a desperate melee ensued', according to one of the dispatches that made its way back to London. Somewhere in the fighting, Bell killed the leader, the leader's brother killed Bell, then Tewodros killed the brother. More elaborate versions emerged later, with Bell suffering his fatal wound as he jumped in front of Tewodros to shield him. Whatever the details, Bell died but Tewodros prevailed, killed scores of the rebels on the spot and headed north to chase down their ultimate commander.

Back in London, the civil servants started casting around for a replacement for Plowden, and for some appropriate response to Tewodros's actions. It was a delicate balance to strike. How to show Britain's appreciation for Tewodros's support for Plowden and Bell without directly endorsing the mass killings that followed? Officials on the ground suggested it might be safest to use the language of gifts and found the following on sale in an Indian warehouse:

- One large and one small gold embroidered carpet of Indian manufacture. Price demanded for both, 1,800 rupees.
- Two embossed silver cups (Surat make), 150 rupees.
- A Bohemian glass sherbet service, richly gilt, 500 rupees.

As the months passed, the list of gifts got longer and included a rifle and a pair of revolver pistols. As Chekhov might have said, remember the pistols.

◎ ◎ ◎

By the end of 1860, Britain's involvement in Ethiopia was in tatters, but Tewodros was still thriving, politically at least. His beloved wife Tawabach, Ras Ali's daughter, had died. So he decided to marry again.

The new queen – Alamayu's future mother – did not leave an account of her life, and other people's reports barely sketch her in outline. Accounts from the time refer to her by two names, both of them emblematic – Tirunesh, meaning something like 'you are good, fine, pure, clear, perfect', and Tiruwarq, meaning something like 'pure, good, beautiful gold'. Beyond that, a few other details made up her portrait. One, she was very young. Two, she was beautiful. Three, she was pious. One story was repeated again and again in mostly European reports. It describes private encounters, so it is not clear where the details came from. But repeat a story often enough and it becomes a saint's hagiography. Here's the version told by the British–French doctor Henry Blanc, who will have his own role to play in the tale:

> One day in the beginning of 1860 Theodore perceived in a church a handsome young girl silently praying to her patron, the Virgin Mary. Struck with her beauty and modesty, he made inquiries about her, and was informed that she was the only daughter of Dejatch Oubie,* the Prince of Tigre, his former rival, whom he had dethroned, and who was then his prisoner. He asked for her hand and met with a polite refusal. The young girl desired to retire into a convent and devote herself to the service of God. Theodore was not a man to be

* *Dejazmach* (a rank meaning Keeper of the Door, often translated as governor-general) Wube Haile Maryam, another one of Tewodros's vanquished rivals, one of the last great warring princes who had dominated the Simien mountains and large parts of the northern region of Tigray. Alamayu's grandfather.

easily thwarted in his desires. He proposed to Oubie that he would set him at liberty, only retaining him in his camp as his 'guest,' should the Prince prevail on his daughter to accept his hand. At last Waizero Tirunesh sacrificed herself for her old father's welfare.

Perhaps unsurprisingly, given how it started, the marriage did not go well. Tirunesh and her aristocratic family, according to Blanc's account, still saw Tewodros, the former *shifta*, as an upstart.

'In the afternoon,' wrote Blanc, 'Theodore, as it had been his former habit, tired and weary, would retire for rest in the queen's tent; but he found no cordial welcome there. His wife's looks were cold and full of pride; and she even went so far as to receive him without the common courtesy due to her king. One day when he came in she pretended not to perceive him, did not rise, and remained silent when he inquired as to her health and welfare; she held in her hand a Book of Psalms, and when Theodore asked her why she did not answer him, she calmly replied, without lifting up her eyes from the book, "Because I am conversing with a greater and better man than you – the pious King David."'

One of the few first-hand sightings of the queen was recorded by Henry Dufton, another British adventurer passing through the region. He got the briefest of glimpses of her eyes behind her royal robes. 'As she was muffled up to the eyes with a superabundance of rich garments, my view was confined to the two brilliant orbs, which, if report be correct, have often returned the withering fire of her royal husband's. Theodore gives little love to the beautiful daughter of Oubie ... Nor has she herself much affection for the man who dethroned her father.'

Around a year after their marriage, the couple managed to have their one child, another son for Tewodros, called አለማየሁ, a name most often transliterated into English as Alemayehu; 'Alem' meaning 'the world'; and 'ayehu' meaning 'I saw'. 'I saw the world', typically with a broader sense of 'I enjoyed life and lived it to the full', was more often than not meant as a kind of boast by the parents – that they have enjoyed life and lived it to its full. There's no need to overthink this. It is just a name, not a destiny.

The Prince and the Plunder

But later, the British press would never let Alamayu forget its strange echoes, given the amount of the world that he would go on to see.

The child had not seen much of anything yet. The first place he saw with conscious eyes was the place where Tewodros put him – the place where Tewodros put all of the people and things he wanted to keep secure and out of the way. Ethiopia's King of Kings kept his son and his proud second wife safe in his mountain fortress of Maqdala, east of Lake Tana, as he rode around the land, pressing on with his campaigns.

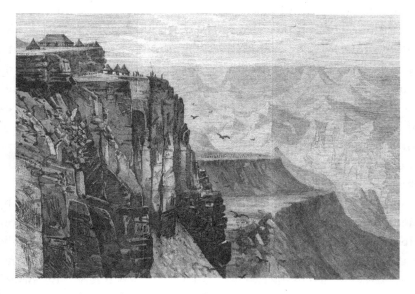

View from a point near the King's House, Maqdala.

◉ ◉ ◉

Samuel Johnson's fictional Prince Rasselas lived in 'a spacious valley in the kingdom of Amhara, surrounded on every side by mountains', a place of luxury and endless diversions that the young man eventually came to see as a gilded prison. The only way in and out of the valley was a hidden cavern, blocked with 'massy' iron gates. The book *Rasselas* is about his adventures as he escapes the valley with a group of companions and sets out to see the world, think for himself, act for himself and make his own 'choice of life'.

Flip Rasselas's valley inside out and you have Alamayu's home. The prince lived on a mountain in the region of Amhara, surrounded on every side by valleys and twisted ravines. His immediate world was the mountain's flat summit, a spacious plateau less than a mile long and half a mile across. Most of it was bounded by sheer black basalt cliffs. The main way in was a land bridge up from two lower peaks, then up along a path blocked by soldiers and two sets of gates protected by stone walls and thick thorn hedges. From that approach, Maqdala is still an ominous place, a long rock monolith looming dark on the horizon even in the bright midday sunlight. Seen from any other perspective, from across the gorges and chasms and ravines, it was nothing short of an unassailable fortress, towering over a biblical landscape of near-perpendicular cliffs.

Beyond those were the expanses of the Ethiopian highlands. It is a landscape you really have to see for yourself. Words will only go so far. That whole part of northern Ethiopia is already a vast plateau, the 'roof of Africa', thousands of feet above the surrounding deserts and plains. When you finally clamber to the top of that plateau, you find more hills and mountains on top of hills and mountains. The forces of nature have carved out huge gulfs between sections of land that stand out like islands and headlands. There was one 'joke' that quickly wore thin when the British soldiers invaded a few years later and marched up from the coast – that if these were the tablelands of Ethiopia, then someone had stacked the tables upside down, with their legs stretching up into the sky. Young Alamayu stood on one of those promontories.

If you can take one more fictional counterpart, picture Antoine de Saint-Exupéry's Little Prince, out on his tiny planet, surrounded by the huge gulfs of space.

When I climbed up to the flat top of Maqdala with a small group in 2004, the path was open and the thorn gates were gone. It still had its brooding presence. There was one church next to a small rise in the ground, a cluster of huts and a large expanse of open ground. A ragged gang of boys charged across it, singing, shouting and chasing a small ball with bent sticks, playing the ancient hockey-like game of *genna*. There was less room to play in Alamayu's day. The summit was surrounded by barricades and large parts of it were clustered with buildings, small round huts and larger structures, packed with soldiers, camp followers, court spies and more soldiers. There was a bit more room around the royal compound where Alamayu lived with his mother. A few years later, the British geographer Clements Markham got a last glimpse of their home before his country's troops blew it to pieces:

> The King's house, where the Queen Tirunesh dwelt with her little boy, was an oblong building of two stories. The ground-floor was used as a granary, and was full of grain, and a staircase outside the building led to a large upper room, supported by pillars down the centre, which had been used as a sleeping apartment. By the side of this large building there were two ... circular houses, for the use of female attendants. A row of wooden pillars supported the roof, and between every two pillars there were wooden bedsteads, with a tumbler and decanter in neat baskets, and a small bow for carding wool, hanging on the wall at each bed head.

A childhood surrounded by women. Home – a bedroom raised high above the press of humanity in the crowded camp, with the smells of grain and coffee mixed in with the spiced dust coming up through the floor. A jug and a glass by the bed. Some more details to add to the queen's portrait: she paid attention to the small, comforting things in life and liked things kept tidy.

Like in the 'happy valley', there were darker sides to this royal retreat. Maqdala was Tewodros's stronghold, storehouse and treasure house. It was also the holding cell for the barons and princes he had conquered on his way to the top. Close by the king's house was Maqdala's prison. The inmates were an odd mix of common criminals and languishing Ethiopian nobility, among them Alamayu's own grandfather and two of the boy's uncles. (In the end Tewodros decided not to free them after his marriage to Tirunesh.)

It is not clear how much this strangely divided family saw of each other or whether they even interacted. There were other characters too in the royal soap opera, including Meshesha, Tewodros's older son from his days back in Kwara, and reports of more women, courtesans and other children packed in close to the royal enclosure.

This is the first world that Alamayu knew – a flat-top mountain in the region of Amhara where his mother was queen and his grandfather was captured and the horizon was bounded by barricades. Beyond were the highlands of Ethiopia. Unlike Rasselas, when he finally came to leave, it was nothing to do with his choice.

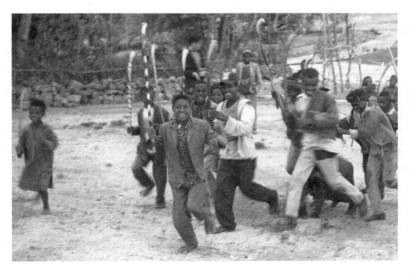

Boys playing genna *on top of Maqdala, January 2004.*

◎ ◎ ◎

Tewodros flashed in and out of Alamayu's life, making fleeting appearances in a rush of horses and spears and shields that could have only added to his aura of glamour in his young son's eyes.

When Tewodros came back from his campaigns, he stayed in a scarlet tent pitched near the two-storey imperial residence and grain house. Alamayu wouldn't have been able just to wander in – everyone had to wait for the summons before approaching the entrance. Tewodros would call him in and play with him a while.

According to the stories in the camp, Tewodros slept every night with loaded pistols by his bed. In his later years, the stories went, he only ate meals prepared by his aides or by the woman the British described as his courtesan Yatamanyu. Fearing poison, he had them taste his food.

Most of the time he was out beyond the horizon, on the move from campaign to campaign, preferring the fresh air of camp life to stagnation at home. Out there, the barons and princes kept plotting and rebellions kept building north, south, east and west. There was always another uprising to crush, another disease in the Ethiopian body politic to purge. 'When all of the Ethiopian people leave justice, good works and the fear of God, when the ones who are called Christians, instead of the Gospel of Jesus engage in fornication, drunkenness and licentiousness, God's messenger being jealous caused Negus Tewodros to rise, the punisher of all.' Those were the words of his own official chronicle, written by Alaqa Zanab, the keeper of his royal archives. The story covered Tewodros's ascent to the throne, the early glory years of his rule and the lengths he would go to to keep his country together. Sometimes his punishments had to be harsh. Many accounts described his sudden moments of mercy and generosity. Many others, including his own chronicle, described his summary executions and mutilation of captives, sometimes of his own soldiers. It was the unpredictability, the quick switches between magnanimity and menace, that made him so formidable.

Adding to his troubles and responsibilities, European missionaries, adventurers and random officials were coming in ever greater numbers over his borders and getting more troublesome day by day.

Chapter Two

Breakdown

'Misfortunes, answered the Arab, should always be expected ...
The angels of affliction spread their toils alike for the virtuous
and the wicked, for the mighty and the mean.'
The History of Rasselas, Prince of Abissinia

Plowden and Bell, two young men forging ahead with imagination and nerve, looking for new horizons, not conquest, had represented the European A-team at that point in the middle of the nineteenth century.

In their wake came the B-team. And things started to go very wrong indeed, thanks to a sometimes bewildering conflagration of clashing personalities, circumstances and unfortunate events. Hold tight.

It took almost two years for Britain to find a replacement for its consul, get him packed up and equipped with the right letters of instruction and landed at the parched port of Massawa. There had been a change of leadership in Britain's Foreign Office and a change of tone. This time it wasn't going to take any more chances on adventurers.

Captain Charles Duncan Cameron had come up the unspectacular and proper way with a stretch of military service in the Cape and the Crimean War, a pause to pass his civil service examination and a brief burst of diplomatic service in the Caucasus. His instructions were clear. His title may have included the word Abyssinia but his base of operations was in Massawa on the Red Sea shore. On arrival, he should check on the political scene in Ethiopia and make a quick

trip inland to hand over the presents to Tewodros. Then, he should head back to the coast, stay there as much as possible and keep an eye on the Red Sea itself, which was the most direct route between Britain and its Indian possessions. Above all, Britain wanted to keep that route clear and free from trouble. If Cameron wanted to get tied up in intrigue and politics, he should concentrate on watching the comings and goings of the other growing imperial power interfering in the region: the nefarious French.

The new consul headed up into the highlands and caught up with Tewodros's roving camp near Lake Tana in early October 1862. Tewodros greeted him with a twelve-gun salute and a vast escort of 6,000 infantry and cavalry. Lying on a couch with two loaded pistols by his side, Tewodros thanked him for the presents, in particular the engraved guns from Queen Victoria, and described the actions he had taken to avenge Plowden and Bell. In another meeting a few days later, in front of a packed audience of Ethiopian courtiers, Tewodros picked up the conversation where Plowden had left it, again raising the prospect of an exchange of ambassadors and asking how Christian Britain could help out in his campaigns against the encroaching Muslim 'Turks'.

Where Plowden might have pushed on, Cameron rowed back and fobbed Tewodros off with empty replies. Would Britain be able to help Ethiopia's ambassador get through Ottoman-controlled territory on his way to London? That all depended, said Cameron. Would Britain be able to hold off 'the Turks' on the coast while Ethiopia's forces pushed north? Britain wanted peace, replied Cameron. What a comedown! The courtly poetry of Plowden and Bell had crashed into the prose of a career diplomat. Britain had started something with Ethiopia. But now, clearly, it wasn't so sure. All the more galling for Tewodros, Britain's envoy had rebuffed his advances in front of his court.

Cameron left the meeting and waited for his next invitation. It didn't come. 'My food became scant and bad ... I was hourly asked when I was going,' he wrote back to London. There were a few more attempts to rekindle the spark in the British–Ethiopian relationship, a few more gifts and letters exchanged by messengers. But all the chemistry

had gone. Tewodros offered Cameron some money to pay his expenses on his way back to the coast. In the past, Plowden had accepted such gifts, then made sure he gave something back of even greater value. Cameron just rejected the cash, saying he had plenty of funds on hand. 'His Majesty made no reply for half-an-hour. He then said that all he wanted was friendship.'

By the end of the month, Tewodros came out with it and told Cameron directly to head back to the coast. He had written a letter to Queen Victoria and wanted Cameron to deliver it. You can still find the letter in The National Archives, handwritten in the Ethiopian language Amharic, with an English translation by one of his secretaries underneath it to make sure the message got through. Tewodros's voice rings out urgent and clear:

IN the name of the Father, of the Son, and of the Holy Ghost, one God in Trinity, chosen by God, King of Kings, Theodorus of Ethiopia, to Her Majesty Victoria, Queen of England. I hope your Majesty is in good health. By the power of God I am well. My fathers the Emperors having forgotten our Creator, he handed over their kingdom to the Gallas and Turks. But God created me, lifted me out of the dust, and restored this Empire to my rule. He endowed me with power and enabled me to stand in the place of my fathers. By His power I drove away the Gallas. But for the Turks, I have told them to leave the land of my ancestors. They refuse. I am now going to wrestle with them. Mr. Plowden, and my late Grand Chamberlain, the Englishman Bell, used to tell me that there is a great Christian Queen, who loves all Christians. When they said to me this, 'We are able to make you known to her, and to establish friendship between you,' then in those times I was very glad. I gave them my love, thinking that I had found your Majesty's goodwill. All men are subject to death, and my enemies, thinking to injure me, killed these my friends. But by the power of God I have exterminated those enemies, not leaving one alive, though they were of my own family, that I may get, by the power of God, your friendship.

The courtly poetry still had some life in it after all. A royal message stamped with the imperial seal, a direct appeal for equal friendship. Who knows where it might have led if Cameron had followed the instructions to head back to the coast, jump on a ship and hand it over in person. Unfortunately, this was the moment when Cameron, after months of diplomatic abstinence, launched himself off the wagon. After leaving Tewodros's court, he palmed the letter off on a messenger with a bundle of other correspondence and decided it was *his* time for a little diversion. The 36-year-old career public servant ignored the orders from both Tewodros and London and headed off towards the regions controlled by 'the Turks'.

The letter did eventually make its way back to Britain in February 1863, more than three months after it was written. It landed in London on its own, without the company of an enthusiastic envoy to explain its importance and context. There have been endless arguments over what happened next. Some say the Foreign Office took a look, took alarm at the bellicose anti-Turkish language and decided there was no workable response. Others say it simply got overlooked in the daily flood of deliveries. At one point a copy was passed from the Foreign Office to the India Office and sat on someone's desk, unloved and unanswered. A year later the India Office sent the letter back to the Foreign Office without comment.

Meanwhile Cameron was out on his own, freewheeling. Again, there have been many attempts to work out why he chose to stray and head towards what he called 'the neighbourhood of Bogos', part of modern-day Eritrea, and further on into Sudan. He had been suffering from a series of fevers – perhaps he had just wanted to spend a bit more time in the cool air of the highlands, away from the blistering coast. In other dispatches, in between passages arguing about his expenses and garbled reports on Ethiopian affairs, he said he had felt honour-bound to check on Bogos, 'whose inhabitants have long been under our special protection'. It was all very vague. And it was certainly not in his brief.

A closer idea of what he was really up to may have come from a search of his baggage. In later letters to friends, when he was less able to roam, he described the sizeable 'collection, geological, botanical, and zoological'

28

that he had built up along the way. He had a small team working with him, stuffing every creature that he found. Cameron, a fellow of the Royal Geographical Society, had a sideline as a natural philosopher. Some Britons went to Africa seeking adventure, others went seeking specimens.

While he was away, Cameron missed a string of increasingly irate messages from London asking him what he thought he was doing. They said he should head back to his post at Massawa and stop meddling in Abyssinia. Instead of going down to the coast, he went up and around Ethiopia's northern borders through Egyptian-controlled Sudan, meddling as hard as he could along the way. Eventually he caught another fever and turned south to climb back up into Ethiopia. Around June, he went to recuperate in Djenda, in the base of the Reverend Henry Aaron Stern and the other missionaries from the London Society for Promoting Christianity amongst the Jews, the ones focused on the Beta Israel.

Unsurprisingly, he did not get a very warm welcome when he finally met up with Tewodros. He found a glowering monarch with a few sharp questions, chiefly: what had Cameron been doing so long in the lands of his enemies, and why had Britain's consul come back without an answer to his letter?

◎ ◎ ◎

On 7 January 1864, the antiquarian William Harrison sent a short note from his home on the Isle of Man to Britain's Foreign Secretary asking if there was any truth to the reports he had seen in French newspapers 'that the English Consul [in Massawa] had been imprisoned by the Emperor Theodore'. Harrison got an even shorter note back saying they had had no reports of anything of the kind.

In March, a messenger handed a slip of paper to the authorities in Massawa, marked with the consul's initials. It had a short message written in pencil: 'Myself, Stern, Rosenthal, Cairnes, Bardel, McCravie, and McKilvie are all chained here ... No release until civil answer to King's letter arrives.' The French newspapers had been right.

When that slip finally made its way to London, the Foreign Secretary Lord Russell scrawled a short memo of his own to his underlings. 'Is there any letter of the King of Abyssinia unanswered?' The civil servants scurried around and finally found it, a year and three months after it had arrived.

And with that discovery, Britain found itself in the middle of an international crisis. Here's a quick rundown of how it had got there:

- As Tewodros battled to hold on to his gains inside Ethiopia, his eyes kept turning to the old threats that had always haunted him from outside his borders. Reports were coming in of Egyptian forces massing to the north and 'Turkish' agents landing at Massawa.
- The British, once so reliably loyal, suddenly wanted nothing to do with him. They had ignored his letter seeking friendship. Their consul had snubbed him in public, then headed off into enemy territory. This sudden about-face pointed to betrayal. And Consul Cameron had been spending a lot of time recently with Stern and his band of foreign missionaries ...

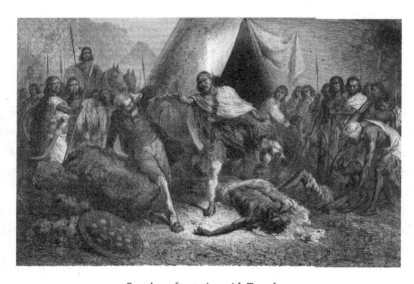

Stern's confrontation with Tewodros.

Breakdown

- The French had gone further and rebuffed the letter he had sent them. There was evidence that they were backing one of his northern rivals. Enemies were cropping up everywhere he looked.
- Even, perhaps, in Ethiopia's national church. Tewodros had long railed against the power of the Orthodox priests and their claims on his subjects' lands and loyalties. Now his suspicions were building around the head of the church, a post always filled by a cleric from Egypt. And Abuna Salama III had been spending a lot of time recently with Stern and his band of foreign missionaries ...
- One day in October 1863, Stern himself rode past Tewodros's camp on his way back down to the coast and went in unannounced to pay his respects. He interrupted a rowdy drink-fuelled feast. During an increasingly heated exchange, Tewodros picked a fight with one of Stern's attendants and ordered him savagely beaten, then another attendant standing nearby. Stern raised his hand to his mouth in horror as he watched the men die from their injuries. The missionary inadvertently bit his finger, a gesture widely seen as a sign of defiance.
- Tewodros had Stern beaten, seized and detained. A search of Stern's belongings found a clutch of incriminating writings, including a copy of the missionary's memoirs that repeated a piece of embarrassing gossip about Tewodros's mother – that she had been so poor that she had been reduced to selling dried kosso flowers, used to treat worms. Not what you would expect of a descendant of the Queen of Sheba. Another passage in a letter suggested Ethiopia might be better off under a foreign power. They found similarly compromising passages in the writings of fellow missionary Mr Rosenthal. He was also arrested and locked up with Stern.
- Tewodros called all the Europeans to a meeting. What was billed a trial of the two men turned into a diatribe against the whole lot of them. He said he had welcomed them, given them love, honour, respect and everything else they could have

wanted. But all he had got in return was evil and betrayal. His beloved John Bell had always spoken the truth. All they had given him was lies.

Days later, an Irish teenager came into the royal camp carrying some letters and a carpet.

The Irish youth was Laurence Kerans, an 18-year-old doctor's son from the village of Ahascragh in Galway, recently taken on as Cameron's secretary.

The letters included dispatches from London – the orders Cameron had missed to return to the coast and an acknowledgement of the receipt of past reports, but no actual response to the Ethiopian offer of friendship and cooperation. Tewodros had the papers translated, then threw them to the ground in anger. 'Who is that Queen of England – that woman, does she not condescend to answer my letter?'

Kerans thought he would calm things down by handing over the presents he had brought up from the coast, including a carpet decorated with an innocent enough theme, a hunter killing a lion. Tewodros received the presents and thanked him, but about an hour later sent them back again with a group of his officers and a short, sharp message: 'The carpet means war.' Why had Kerans insulted him like that, Tewodros demanded. The hunter was clearly meant to be Britain, or France or 'the Turks'. The lion, which he used for his imperial seal, was obviously meant to be him. One more great insult from the Europeans and a not-so-veiled threat. Kerans protested his innocence. 'I said, the carpet meant nothing of the kind of course – & tried to persuade him, but it was all no use,' he later wrote to his brother.

Tewodros cut off all communications with Cameron and ordered all the Europeans in the region to his camp, where they stayed under guard. The consul waited until the new year then asked for permission to leave. As far as Tewodros was concerned, this was the final insult from Britain. And there was still no letter from London. The next day, 3 January 1864, the consul and his retinue were taken to a tent with two

Breakdown

guns pointing at them through the opening. The royal guards came in and loaded them all with chains.

And with that, Her Majesty's official representative and his staff, including his teenage secretary only a few weeks into the job, joined Stern and Rosenthal as prisoners up in the Ethiopian highlands, hundreds of miles out of Britain's reach. For month after month, they stayed in the roving royal camp, locked down in huts or chivvied from post to post in the lands east of Lake Tana. Finally, the court struck out further east. The Europeans joined a line of other convicts and hostages on a week-long trek that ended in a final climb up the side of a near-perpendicular wall of black basalt rock. Looking around them, they found themselves in the place where Tewodros kept all of the people and things he wanted safe and secure and out of the way, on top of the mountain fortress of Maqdala. They ended up barricaded in huts, close to Alamayu's royal residence.

For the want of a better carpet – and a better consul and a better set of circumstances – the fantasy of a great British–Ethiopian alliance was lost. Tewodros had given up courting his foreigners and was trying out a different tactic to get Europe to engage with him. His message: respond or watch your envoys rot away in captivity.

◎ ◎ ◎

It took a while for Britain and her representatives in Cairo and London to digest the full implications of Cameron's pencil note. Then came the face-saving, the mudslinging and the back-covering.

The first thing to work out was who to blame. There were questions about Tewodros's letter in Parliament and letters about the intricacies of Ethiopian politics in the press. Slowly the guns of the government turned their sights on Cameron and his hare-brained diversion through Bogos and Sudan.

The second thing to work out was what to do. Cameron's note had said the captives would not be released until Tewodros got a civil answer to his letter. The easiest and cheapest thing to do would be to send a civil answer. After much agonising over the wording, one was drafted

and signed by Victoria. Who should deliver it? How to get it there while avoiding the obvious trap of sending British subject after British subject into Ethiopia, only to have Tewodros put them in chains and add to his stock of captives and hostages? It is no doubt just a coincidence that Britain chose a foreigner and, eventually, two equally foreign-sounding representatives for the risky mission.

◎ ◎ ◎

Hormuzd Rassam, the Mosul-born first assistant political resident of the British-administered port of Aden, crossed the Red Sea in July that year and landed in Massawa. He was accompanied by French–British doctor Henry (sometimes Henri) Jules Blanc, staff assistant-surgeon to Her Majesty's Bombay Army. They found the temperature soaring, the port's vice-governor sick in bed with a fever and contradictory rumours spreading everywhere that the Europeans had been freed, that they had been chained, that they had been stripped of their European clothes. Rassam sent a letter up into the highlands announcing his presence, then another letter, and waited, and waited for a reply.

They started to get intermittent updates direct from the captives, who paid messengers to smuggle down short notes and letters hidden in amulets, sandals or the wrappings of bandages. Cameron asked for money and supplies. 'Money, money, dear Rassam, again send us money; also chocolate, preserved fish, or meat, or vegetables, and simple medicines for eye diseases or stomach complaints.' The consul rambled on, but kept returning to the same warning, that Rassam and Blanc would be captured if they came up to the highlands. 'God bless you, dear Rassam, but don't let me see your face here.' The only solution, Cameron said, was for Britain to send in a military force. The prisoners were prepared to take the risk of repercussions.

It wasn't until a whole year had passed, in July 1865, that an unsigned message finally came down from Tewodros. It told Rassam to come up, but via an oddly circuitous route, skirting Ethiopia's northern border then continuing up into the highlands.

'Be it known to Hormuzd Rassam that there exists just now a rebellion in Tigre. By the power of God, come round by way of Metemma. When you reach Metemma, send me a messenger, and, by the power of God, I will send people to receive you.'

An admission, albeit unsigned, that something big had changed up in the highlands in the year and a bit since Tewodros had alienated his strongest international ally and locked up its consul. After his long, long, stratospheric rise, things had stopped going Tewodros's way. It was worse than a single rebellion in Tigray. The rivalries that had driven the Zemene Mesafint, the Age of Judges, were still churning and the rebel princes were fighting back. In one seismic reversal, Tewodros's troops had failed in a big battle further south and lost the whole region of Shoa. One of Maqdala's key royal guests/hostages, a 20-year-old prince from the region of Shoa – in the years to come Ethiopia's Emperor Menelik II – had found a way out of the impregnable fortress and escaped. Tewodros lashed out where he could, at one point picking a fight with the people of Gondar, destroying their houses, raiding their churches and taking their riches. But day by day, his realm was shrinking back to the patch of territory east of Lake Tana, then further and further, back towards Maqdala.

After much agonising and a trip to Egypt for consultations, Rassam and Blanc – now accompanied by the very British Lieutenant William Francis Prideaux of the Bombay Staff Corps – complied with Tewodros's request to come to his camp and set off on a month-long journey, dodging outbreaks of cholera, malaria, smallpox and man-eating lions along the way, carrying presents and the now rather aged letter from Queen Victoria in their baggage. They made it to Metemma, headed over the border into Ethiopia, and finally, in their crowning moment, approached the imperial camp on 25 January 1866.

Tewodros had arranged a grand panoramic stage for their reception: two conical hills, one covered in his court's black and white tents, the other studded with thousands of armed soldiers, with the valley in between filled with his cavalry.

Blanc's first-hand account gives us one of our last visions of Alamayu's father in his full Arthurian splendour. After a pause for refreshment, the party was ushered towards a 'beautiful durbar-tent of red and yellow silk between a double line of gunners' and there was Tewodros himself at the opening, asking after their health and, after some more civilities, formally accepting the reply from Queen Victoria, just a matter of three years late. It was almost too good to be true – even more so when they heard Tewodros promise to free the captives.

The week that followed passed in a technicolour blur. The prisoners had been released on Maqdala, a few days' march away, and would be with them shortly, the monarch promised. Tewodros's mobile court moved on, taking their foreign visitors with them. There were gifts and more gifts, long marches, trips across Lake Tana in reed boats and visits to island monasteries. And then on 12 March 1866, unbelievably, all remaining doubts lifted as Cameron and the rest of the captives walked into camp, finally freed from their chains. There was another formal 'trial', a rehearsal of Tewodros's complaints, and the captives were finally and formally forgiven.

Throughout, Tewodros seemed particularly taken with Rassam. The two met regularly and discussed international affairs – the American Civil War, the chances once again of some sort of treaty with Britain. Tewodros showered Rassam with letters, visited him in his tent and, like he had done with Plowden before him, took him by the hand.

He introduced Rassam to his eldest son Meshesha and had them shake hands 'in the English fashion'. 'Mr. Rassam, I wish this son of mine, and another at Magdala, to be adopted children of the English; and when you go back to your country, I want you to recommend them to your Queen, in order that, when I die, they may be looked after by the English, and not be allowed to govern badly.' That other son on Maqdala would be Alamayu. It was now the second time Tewodros had asked a British representative to look after and educate his progeny. Almost word for word what he had asked of Plowden. It is worth quickly noting that Tewodros was not suggesting that his sons should stay in

England forever. The idea was for them to head over, learn the ways of the English and then head back to Ethiopia to govern well.

There was something a little manic, a little too pressing in Tewodros's attentions, so Rassam pressed on with his plans to get everyone back down through Sudan then back to the coast as quickly as he could. On Friday 13 April, the overjoyed captives packed up their camp and headed off down the road.

Rassam, Blanc and Prideaux split off to say goodbye to Tewodros. It was obvious as soon as they entered his compound that something was wrong. There were no tents set aside for them to change. When they got into the royal hall, it was packed with nobles, but the throne was empty. One of the senior officials bent down and kissed the ground, 'we thought out of respect for the throne,' wrote Blanc. 'But it was the signal for an act of base treachery. No sooner had the Ras prostrated himself, than nine men, posted for the purpose, rushed upon each of us, and in less time than I can express it our swords, belts, and caps were cast to the ground, our uniforms torn, and the officers of the English mission, seized by the arm and neck, were dragged to the upper part of the hall, degraded and reviled before the whole of Theodore's courtiers and grandees.'

Behind the scenes, behind the handholding and the courtly display, Tewodros had been agonising. He had demanded Britain answer his letter. Britain had answered his letter. Now the British captives, his big bargaining chip, his last tie to Europe's technological skills and advanced weapons, were about to leave. 'If I let them go,' he told his courtiers, 'what have I left in my hand?'

He would have had nothing left and all the time his enemies were circling, his territory was shrinking and his soldiers were deserting. His rise to power had been swift but the speed of his fall was bewildering. At the last minute, Tewodros sent men ahead to stop Cameron, Stern and the rest of the prisoners on the road. He invented a charge against Rassam and his crew: they had allowed the captives to leave without letting him have one last goodbye, one last reconciliation. It was, he said, another great calculated insult from the foreigners, enough to justify what happened next.

There was another grand trial, which kicked off with a recitation of Tewodros's Solomonic family line and a repetition of the charges against the Europeans, together with the new ones against Rassam. 'Where are the prisoners? Why have you not brought them to me? You had no right to send them without my permission.' Rassam, shocked, manhandled, only just kept his anger in check. He answered politely but directly, stating his case: the prisoners had already been freed and reconciled with the king. But it was no use.

A few days later Tewodros wrote yet another letter to Queen Victoria. He had decided to keep Rassam with him, he said, so he could consult with him as he kept up his communication with Britain. What he now wanted, in exchange for the prisoners, was a group of trained and skilled artisans including two gunsmiths, an artillery officer and an iron founder, together with an ever-lengthening list of equipment including a small blast steam engine for foundry, machinery for the manufacturing of gun caps, some double-barrel guns and pistols and two good regimental swords.

To deliver his new letter, Tewodros chose Martin Flad, another of the European missionaries. This time he was sure the messenger would not abscond or return without a reply. This time the messenger had a wife and children left behind in Ethiopia.

As he travelled, Flad sent his own letter ahead of him to the Earl of Clarendon, Lord Russell's successor as Foreign Secretary. 'My Lord, I Deeply regret that I have to report, for your Lordship's information, the melancholy events ...'

Flad reached London with his letters and messages and dark forebodings on 10 July 1866. He didn't know it at the time, but thousands of miles away in Ethiopia, Rassam and the prisoners had just started their trek eastwards towards the mountain fastness of Maqdala.

The European prisoners on Maqdala.

◎ ◎ ◎

Tewodros headed off again to fight his fights. In the weeks and months that followed, the captives made themselves as comfortable as they could. They were spared the main prison and lived in huts, separated off in a compound. Money and extra provisions trickled in from the Protestant missionaries who were still working away in their base in Gafat, free as long as they kept turning their artisanal skills to the manufacture of weapons. Rassam, Cameron and the rest were still chained – a ring hammered around each ankle with three short links between them – but they had found ways to use bandages to protect their legs against the iron bonds. They got some seeds, grew vegetables and passed the time playing whist and reading and re-reading the random collection of books that the Europeans had brought on their travels, including Adam Smith's *The Wealth of Nations*, the Bible and some of John Ramsay McCulloch's door-stopping dictionaries of commerce and geography.

By September 1866, Blanc wrote in a letter that reached the British authorities that they were all keeping relatively cheerful apart from Stern. 'He worries too much. Cameron is picking up wonderfully – eats like ten men and absorbs liquid in the same proportion. Mr Rosenthal is quite well, and Rassam is fat and well, though much older ... We are all getting grey, even Prideaux.'

By March the next year, the British consul's excesses were starting to show. 'We are all pretty well,' wrote Blanc. 'Cameron is rather seedy; he is not careful enough about himself.'

They were always listening out for news of Tewodros and how he was faring against the increasingly rebellious princes over the horizon. At one point at the end of November 1867, they got a ringside seat on the last gasps of the Zemene Mesafint when Menelik, the escaped prince, now king of Shoa, brought a host of his own troops close to Maqdala and announced his arrival and challenge with a salvo of musket fire.

It was at this point that our prince, Alamayu, took his first recorded steps on the political stage. The generals and nobles left at the top of Maqdala gathered for a mass show of loyalty to their absent ruler. Some reports say Queen Tirunesh put her differences with her husband behind her, bought *tej* and food for the troops and brought out her son. En masse the men swore allegiance to the young boy, and through him, to Tewodros. The European prisoners, in their compound, did not see it for themselves, but heard the roar of the guns and the answering roars of the faithful.

'They say that the boy, who is only six or seven years of age, and the image of his father, behaved with becoming dignity at the reception,' Prideaux wrote in a letter that eventually made its way down to the coast, to Britain and, months later, into the pages of the *Pall Mall Gazette*.

Picture the scene: a tableau stage managed so it was visible or at least audible to Menelik watching Maqdala from across the ravines. A mass of men dressed in scarlet robes, spears and shields glinting in the sun, the cheers and toasts of *tej* and at the centre of it all, one small child.

'These demonstrations [of loyalty] are said to have been witnessed by Menilek through a spy-glass and appear to have produced the desired

effect, as on the following day he marched off with all his baggage in the direction of his own country,' Prideaux wrote. Even in his weakened state, Tewodros's reputation still cast an imposing, menacing shadow. The mere sight of his supporters had been enough to see off a challenging army for one more day.

Soon after, in early December, a messenger arrived on Maqdala from Tewodros. He had burned his bases at Debre Tabor and Gafat and was heading back, to make a stand against anyone who would face him. His progress was slow. His men were carving a road out of the mountains as they went, sometimes making barely a mile a day. Inch by inch, step by step he was dragging his brand-new artillery – the cannons and mortars cast by the Protestant missionaries and a small group of other European and Ethiopian craftsmen – across the peaks and ravines.

◎ ◎ ◎

Back in Britain, in between debates on the expansions of the railways and the ever-present Irish 'Fenian' threat, Parliament agonised over what to do now in Abyssinia. Tewodros wanted them to send in still more Europeans, more craftsmen, but they surely weren't going to fall for that one again. (As it happens, a small group of artisans was recruited and quietly sent to Massawa, though events soon overtook them and they went back home.) What had started as an embarrassing tangle in an obscure corner of Africa had turned into a full-blown challenge to Britain's international standing.

You can follow the mounting indignation and anger in the pages of the satirical weekly magazine *Punch*. It had started its coverage of the Abyssinian crisis with a few nonchalant references to the goings-on at the court of the 'dusky tyrant'. By 1866, Tewodros was 'an Abyssinian demi-savage'; by 1867, there was no 'demi' about it: Tewodros was a 'savage King'. Towards the end of that year, as the war drums mounted, *Punch* dropped all its urbane irony and called in verse for a full-blown lynching. Its song 'King Theodore' is meant to be sung to the folk tune 'Brian O'Lynn':

The Prince and the Plunder

King Theodorus sits out in the sun,
Trousers, or waistcoat, or coat, wearing none;
But he sports a cocked hat which a beadle once wore –
'Tis a crown for a monarch,' says King Theodore.

King Theodorus roars, dances and raves,
When he gets into a rage with his slaves:
He kicks 'em a tergo, and cuffs 'em afore –
'Gorrawarragawraw!' bellows King Theodore.

King Theodorus puts Britons in chains,
On his black hands, if their blood has left stains;
Catch him, and then at his own palace door,
Aloft on a gallows hang King Theodore.

THE ABYSSINIAN QUESTION.
Britannia. "NOW, THEN, KING THEODORE! HOW ABOUT THOSE PRISONERS!"

Britannia confronts Tewodros.

We are a long way away from the courtly dreams of Plowden and Bell. Back home in Britain, there were other images of Africa and Africans for the press and public to tap into.

◎ ◎ ◎

Britain's politicians endlessly rehearsed past events and bickered over who was to blame. Behind it all, there was one priority driving debates in Parliament. Britain urgently had to do something to save face, not so much in Africa, but further east in India, the jewel of its imperial possessions. In a moment of frankness, laying bare the workings of the confidence trick behind much of Britain's imperial project, Henry Rawlinson, MP for Frome in Somerset, told the House of Commons in July 1867 that Britain had to act in Ethiopia to protect its 'prestige' further afield and nip any other acts of defiance in the bud.

> Prestige may not be of paramount importance in Europe, but in the East, Sir, our whole position depends on it. It is a perfect fallacy to suppose that we hold India by the sword. The foundation of our tenure, the talisman – so to speak – which enables 100,000 Englishmen to hold 150,000,000 of natives in subjection, is the belief in our unassailable power, in our inexhaustible resources; and any circumstance therefore which impairs that belief, which leads the Nations of the East to mistrust our superiority and to regard us as more nearly on an equality with themselves, inflicts a grievous shock on our political position.

Politicians imagined scenarios of Indian Muslims going out on pilgrimages to their holy sites on the other side of the Red Sea from Ethiopia and coming home with tales of Britain's humiliation at the hands of one African chief. Britain was still smarting from the narrow escape of 1857's Indian Mutiny or, as many in India these days prefer to call it, the First War of Independence.

The new Foreign Secretary, Lord Stanley, echoed Rawlinson's fears about Britain's prestige in a decisive debate in November 1867. 'Whatever it may cost ... we cannot accept an insult from any uncivilized tribe.' After more wrangling, Parliament approved funding for a military expedition into the heart of Ethiopia to free the captives. By that stage, the government and the army had already been making their plans for months.

Punch magazine kept up with the debate and mused on how Britain might recoup the cost of what was going to be a hugely expensive expedition. If Tewodros managed to escape the lynch mob and the invading troops, it suggested, Britain could always put him on show and get people to pay to see him. 'First catch your NEGUS, of course; but having caught him, bring him away and constitute him an exhibition. In so doing there would be no need to keep him in a cage or den; he might be made perfectly comfortable, only open to public inspection during certain hours daily at the Egyptian Hall, Piccadilly, or some other place equally commodious ...'

Chapter Three

War

'I conversed with great numbers of the northern and western
nations of Europe, the nations which are now in possession of all
power and all knowledge, whose armies are irresistible, and whose
fleets command the remotest parts of the globe.'
The History of Rasselas, Prince of Abissinia

Britain's 'Abyssinian Expedition' – its move to save the hostages and
its own reputation in one bold strike – was by all accounts a military
marvel. Under the methodical leadership of Lieutenant-General Sir
Robert Napier, a veteran of a string of conflicts including the Indian
Mutiny and the Chinese Opium Wars, it massed thousands of British
and Indian soldiers together with mountains of supplies and shipped
everyone and everything across the map from Britain and British India
to the east coast of Africa like the pieces of a giant game of Risk.

A reconnaissance party arrived in October 1867, scouting for a spot
with good anchorage in Annesley Bay, south of Massawa. Then more
ships came and more men and more ships. Crates piled up on crates,
tents spread out in ranks and in a matter of weeks, a vast new basecamp
started springing up on the edge of the wide sandy bay. Brand new
wharves and piers stretched out into the water in front of the camp and,
behind, rail tracks slowly extended, section by section, 20 miles across
the plain towards the mountains on the horizon.

Whole chapters can be and have been written about how the expedition gathered pack animals from all points of the compass, plotted routes and collated travellers' accounts as it laid out its plans. The mission was straightforward but daunting: to climb up into the highlands of Ethiopia, take on 'mad king Theodore', free his prisoners and then march back out again.

Every detail of Napier's feat is set down in the two-volume, lovingly bound *Record of the Expedition to Abyssinia*, compiled by order of the Secretary of State for War by Major Trevenen J. Holland of the Bombay Staff Corps and Captain Henry Hozier of the 3rd Dragoon Guards. It was published when everyone's memories and records were still fresh just a few years later in 1870. You can get it online for free or pay hundreds if not thousands of pounds for an original copy on the rare books market – even more for the three-volume version with a full set of maps. It is worth the full price for its lists alone.

Supplies pouring into the basecamp on the Red Sea shore included:

Warm clothing, waterproof sheets, leggings, waterproof covers, bell tents, hospital marquees, boots, socks, portable cooking ranges, portable ovens, portable filters, armourers' forges, armourers' tools, forges, farriers' tools, sheet-iron, iron ridging, cooking kettles, canteens, mess tins, spirit kegs, watering troughs, buildings, hand mills, sieves, axes, grindstones, water hose, signal rockets, charts of the Red Sea, shells, fuzes, Abyssinian vocabularies, medicines, surgical appliances, compressed forage, preserved potatoes, compressed vegetables, desiccated milk, yeast, hops, preserved meat, cocoa, salt beef, salt pork, rum, flour sacks, and meteorological instruments.

No detail was too small for the official account. Each ship that came over had its own official expedition library – 80 volumes of general literature as well as 250 Bibles, 250 prayer books and a *Pocket Communion Service*. The expedition's forty-four elephants – brought in to carry the British artillery up the mountain passes – tramped into the ships' holds two by two. During the voyage from India, across the Arabian Sea into the Gulf

of Aden and the Red Sea, they stood on a temporary flooring of stones and shingle, back to back, with their heads facing the ships' sides and a gangway 'left between them, broad enough for the attendants to pass to and fro for the purpose of clearing away the droppings &c'.

Holland and Hozier admirably detailed the early days of chaos, the water shortages, the outbreaks of disease and the blistering heat. By the time Napier arrived on Her Majesty's ship *Octavia* on the afternoon of 2 January 1868, a marginally more orderly, militarised corner of England had sprung up on the shores of Annesley Bay near the settlement of Zula in what is now Eritrea. The 57-year-old commander-in-chief sent out dispatches and officers to iron out the problems with the supplies and the mule trains, and soon the well-oiled machinery of Imperial Britain started to hum.

As Tewodros dragged his cannons inch by inch, day by day, along the 100-odd miles to Maqdala, Napier's men started carving out their own route from the coast. In total, around 13,000 British and Indian soldiers and 26,000 camp followers were caught up in the mission to extract what had by now grown to a group of about forty hostages, when you included stragglers and everyone's families. The British–Indian troops had to cover more than 300 miles of narrow tracks and mountain passes and perpendicular ravines. They also had to keep up lines of communication and supply and make sure they had the infrastructure to get back out again. As they moved, they dug wells, set up way stations and rolled out mile upon mile of telegraph wire. It was going to be a very slow, meticulous and close-run race. But Napier's forces had the full force of the British Empire behind them, and another major advantage. Tewodros's rivals, the warring princes, let the British troops pass by unmolested and, in many cases, actively helped. Step by step, the Brits agreed contracts with local leaders along the way who supplied food and transported goods through their territories. 'Thus the endless train of asses, mules, cattle, or burden-bearing Tigray people moved through the country and punctually delivered grain and flour in large amounts to the designated large storage sites,' wrote Baron Ferdinand von Stumm of Prussia, one of a handful of European military observers on the expedition.

There are plenty of other near-contemporary accounts to choose from beyond Holland and Hozier, many of them also free online. If you like your Victorian military history told with open-mouthed *Boy's Own* wonder, try *The March to Magdala* by G.A. Henty. If you like your facts spiced up with a bit of tabloid invention, try *Coomassie and Magdala* by Henry Morton Stanley, the *New York Herald*'s correspondent on the expedition, who was still a few years off his coup in 'finding' the lone missionary Dr David Livingstone and his later career as explorer and despoiler of the Congo. If you want your facts served up with whole slabs of fiction – with some leather-clad, whip-wielding femmes fatales added into the mix – try *Flashman on the March*, the twelfth volume of the memoirs of the cowardly bounder Harry Flashman, as imagined by George MacDonald Fraser.

One part of the expedition, which most accounts tend to gloss over or overlook, was in its way as outlandish as anything Flashman ever encountered. Along with the soldiers, mule drivers and camp followers was a crack unit of collectors and boffins – representatives of the British force's official 'scientific departments' – hitching a ride on the invasion with missions of their own.

◎ ◎ ◎

About three weeks after Napier's arrival, Richard Rivington Holmes, assistant in the Department of Manuscripts at the British Museum, stepped out onto the Red Sea shore. A mass of gleaming white tents spread out all around him and the ensign of England floated from a flagstaff over his head as soldiers and muleteers rushed by, dodging past crates of cargo piling up on the docks.

Holmes was the russet-haired scion of a family of librarians and booksellers, an aesthete, a watercolourist and a bookbinding enthusiast. Portraits show a long-faced, languid figure with the kind of long flowing sideburns known at the time as Dundreary Whiskers or Piccadilly Weepers and later sported to great effect by Noddy Holder of Slade. A watercolour of Holmes by Dante Gabriel Rossetti a few years earlier

showed him striding down a blustery beach in Devon, hand in hand with a Pre-Raphaelite beauty, stretching out his cane to sketch a woman's profile in the sand.

He was now on another beach, about 3,500 miles to the southeast, with his kit, his £2-a-day in expenses paid by the British Treasury and a whopping £1,000 credit line – around £63,000 in today's money[*] – to spend as he saw fit. The museum had sent him along to be its man on the expedition, and the government had agreed to give him recognition as the official 'archaeologist'. His mission was to follow the troops as they charged into Ethiopia and look out for any interesting treasures along the way that he could bring back for the display cabinets back home.

The British Museum had commissioned digs and accepted trophies from soldiers returning from far-flung campaigns in the past. But it had never been out on its own on the frontline like this before, picking up its own plunder on the battlefield. As soon as Holmes could, he was out on the trail, leaving Camp Zula behind him, speeding over the plain and heading towards those mountains on the horizon.

For the first time in its history, with its Dundreary whiskers flying in the breeze and its sketchbooks and pencils stuffed into its baggage, the British Museum was riding out to war.

◎ ◎ ◎

A month to the day after Holmes's arrival, William Jesse, Corresponding Member of the Zoological Society of London (CMZS), landed in Annesley Bay. He pulled out his gun as soon as he got ashore and started blasting away at anything that moved. A flock of crab-plovers – elegant black and white wading birds with long grey legs, as beautiful as ballet dancers – pecked away for food in the surf. He took aim and shot one dead.

[*] That is according to the historical currency converter on The National Archives website, based on purchasing power. The writer Sathnam Sanghera recommends using a different calculation, based on average nominal earnings, in his book *Empireland*. Using that method, Sanghera says Holmes's £1,000 would be worth £638,000 today.

It was a painstaking business. After each hit the flock took to the skies in a frantic, cawing swirl and settled somewhere else on the bright, sand-blasted plain. Jesse reloaded, stalked the flock again and took out another victim.

Jesse kept shooting and stalking the crab-plovers. His gun brought down eight of them, one after the other. A hornbill flew by – drab grey and white body, a small head overwhelmed by its huge bill, the shape of a cow's horn. An easy target. Then there were the clusters of francolins, striped chestnut-brown and white birds, a bit like pheasants. Again, easy pickings.

A triumph. None of the dead birds piled up at his feet were unknown to science. They were all from relatively common species, spotted in other parts of Africa and beyond. But that didn't matter. Within hours of setting foot on the shores of East Africa, before any of the soldiers on the expedition had managed to fire off a shot in anger, William Jesse, CMZS, had got his hands on some actual specimens, no doubt the first parts of a career-making collection.

Like Holmes, he had his £2-a-day expenses on top of free board, rations and equipment. Instead of artefacts, he was hitching a ride on the invasion to watch out for any interesting creatures flying or wandering around on the edge of the battlefield to add to the Society's collections and growing menagerie, the precursor of today's London Zoo.

These days zoologists talk of conservation, preservation and protection. Back then, their discipline was more like a bloody version of the Japanese creature-collecting game Pokémon – you had to catch them all, dead or very occasionally alive, and collate their skins, skeletons and spirit-preserved corpses to build up an ever-expanding catalogue of all God's creatures. Jesse gathered up his first few corpses, loaded them onto his launch and set off on the two-hour trip back to the *Great Victoria* steamship that had brought him from Suez down to this spot on the Red Sea coast in the dying days of February 1868.

Then the rain came down and the wind whipped up. A sudden storm swept in and picked up his small craft and crew and carcases, hurling them past the bemused troops on their anchored ships and off to the other side of the wide, wide bay.

It was all the small team could do to stop the boat dashing against the rocks. By the time the storm had died down a little, the boat was swamped, the dead birds soaked and the rest of the British ships far away.

'The energies of our crew and ourselves were so severely tried by wind and rain that we with difficulty, and utterly exhausted, reached the fleet at the end of twenty-four hours,' Jesse later wrote in a forlorn report to his sponsors. 'My specimens being spoiled, this was rather a discouraging commencement of my duties.'

Discouraging, but there was no time to mope. Jesse jumped up on deck, got his baggage together and headed to the main camp on shore. The officers told him there were plenty of animals out there in the plains around the camp.

'I obtained a few specimens, when an attack of sickness put an end to my endeavours and compelled me to go on board the hospital ship,' Jesse wrote. A few days later he was back on shore. 'But in the course of a few hours I had a relapse, which induced me to leave the plain and head up towards the highlands.'

On the way up to the mountains, he saw some interesting rodents. 'I should have procured more specimens had not my taxidermist fallen ill with fever.' His own health improved by the time he reached the British staging post of Senafe. But bandits attacked one of his assistants, stripping the man of rifles and clothes. Finally, a breakthrough came when Dr Knapp, the surgeon attached to the 25th Bengal Native Infantry, presented Jesse with a living young male kudu – a striped woodland antelope that the Society currently did not have in its collection back in London. 'Unfortunately, two consecutive attacks of dysentery reduced the animal to such a state of weakness that it was impossible to save it – a fact which I much regretted.'

Around the camp, he found some rabbits, a bit like the ones back home, but smaller. 'A small sandy strong-haired rat I also procured a specimen of, which was unavoidably lost.'

Other representatives of the scientific departments were scattered up and down the route.

Ethiopia had seen a small but growing number of foreign explorers, hunters and other visitors in the last few years. The Royal Geographical Society estimated that forty-two European travellers had passed through in the first four decades of the nineteenth century, up from just a handful in all of the eighteenth. So far they had come in ones and twos and only taken away as much as they could carry on a few mules or the backs of their servants. Excursions like Cameron's into Bogos had barely made a dent on the landscape. But now Ethiopia was about to experience its first coordinated scientific assault, by a body of men from across the main disciplines, backed by the full logistics and funding of an army and government.

Some of the men were primarily interested in extracting data, not things. Ethiopia and Eritrea wouldn't feel a thing. Others had lots of empty crates to fill.

Representing meteorology was Dr Cook, a surgeon from the Bombay Army. He climbed up into the highlands and set up an observatory equipped with two mountain barometers, two thermometers for solar radiation, two for terrestrial radiation and one Regnault's hygrometer complete with aspirator jar. The report he drew up on his work gives a calming parallel narrative of the whole campaign with day-by-day updates on breezes, passing dust storms, hoar frosts, estimated mean temperatures and 'thin green herbage [making] its appearance on the loose dusty soil'.

Clements Markham, assistant secretary of the Public Works Department in the India Office, represented geography; Lieutenant T.T. Carter led a trigonometrical survey of the route; and Mr W.T. Blanford of the Geological Survey of India was there to examine the rocks of the Ethiopian highlands. But Blanford's work only really kicked into gear when he put down his pickaxe, took up his gun and joined forces with the beleaguered official zoologist along the route and, later, on a diversion through Consul Cameron's old stomping grounds. You can read about their two-month-long zoological bloodbath up into Bogos and beyond in the Plunder section of this book.

There was also another archaeologist who actually did some archaeology. You can also read all about Captain W. Goodfellow's hit-and-run dig at the ancient Axumite port of Adulis in modern-day Eritrea later on.

But the man at the head of the scientific departments, the one with the biggest pockets by far, was the British Museum's Richard Rivington Holmes. Together with his budget, he had a long shopping list.

Before the bulk of the troops had even landed on Annesley Bay, Britain's more scientifically minded grandees were already fantasising about what their mission might find. Sir Harry Verney, MP for Buckingham and in his spare time a member of the Royal Geographical Society, told the November parliamentary debate which authorised the expedition's budget that he hoped the scientific gentlemen who accompanied the soldiers would 'have every facility for investigation, and all the assistance that the British authorities could give them'.

'The country was the earliest Christian country in the world,' Verney said. He 'believed it was the only Christian country in the East that had never been conquered by Mahometans. There were still existing in different parts of Abyssinia Christian monasteries, and no doubt manuscripts were likely to be found there, and information collected both as to Christian history and scientific matters that might prove to be of the utmost importance,' according to the Hansard account of his speech.

Around the same time, the members of the British Museum's Standing Committee were dreaming similar dreams. As news of the looming Abyssinian storm spread in the newspapers, they met to make their plans.

For them, the Ethiopian highlands were a sealed time capsule, separated from the changes of the world down below by the accidents of history and several thousand feet of geography. They had all read the beautiful but wholly incorrect passage in Edward Gibbon's *The History of the Decline and Fall of the Roman Empire* about the 'Aethiopians' who had 'slept near a thousand years, forgetful of the world, by whom they were forgotten'. For the museum's grandees, Ethiopia was just the kind of place where an undiscovered classical text might be lying around on a monastery shelf or buried somewhere forgotten in some ancient ruins.

'Innumerable objects will, doubtless, come into the possession of the forces, which, if duly preserved and collected, may prove of great advantage to science, especially in the promotion of historical, biblical, and philological knowledge, but which, unless rescued at the moment, will be lost or destroyed, or dispersed as curiosities,' the museum's principal librarian, J. Winter Jones, wrote to the Secretary of State for India in October, after the meeting.

The trustees weren't envisioning any random act of plunder, carried out in the heat and bloodlust of battle. They wanted to send a man along to carry out a systematic search. Ruins spotted by past explorers appeared to be on the soldiers' most likely route. 'The presence of British troops in these places would afford peculiar facilities for rapid excavations, and for the removal of any monuments of antiquity which might be discovered.'

Holmes, the man they eventually chose for the mission, had a sideline as a man of action. In his spare time, he was a keen volunteer for the Berkshire regiment. 'Mr. Holmes was a specimen of the British volunteer, on all occasions ready to uphold British dignity,' wrote Henry Morton Stanley. You can still hear the newspaperman's sneer in that quote and get a sense of what must have been Holmes's rather wearing sense of mission.*

Holmes caught up with the headquarters staff at the highland way station of Senafe, then travelled on with the troops, checking the villages and churches that they passed. His early searches were disappointing. It turned out that no one along the route was holding onto a secret stash of lost Sibylline sayings. The few things that he did see on the way up to Maqdala left him less than impressed.

'In only one or two instances ... was he able to make any discovery of antiquarian interest,' wrote the official account of his mission in the closing chapters of Holland and Hozier. Most of the church books he

* In the end, Holmes did his job so thoroughly that some were shocked at the size of his haul, particularly the more sacred items. Their removal was 'utterly unworthy of the British arms and name', former British Museum librarian Edward Edwards wrote in his 1870 history of the institution. More than 130 years later, the British Museum's official historian and former director David M. Wilson acknowledged that the trustees' direct military involvement, the first and last of its kind, was 'one of the less glorious episodes' in the museum's history.

found were disappointingly modern. Much of the church art was, in his eyes, beneath contempt, interesting only as an example of a degraded form of an archaic tradition. 'A profusion of rude pictorial decoration covered the interior of the modern churches, and was interesting to the archaeologist as it exhibited in a fossilized form the traditionary types of the earliest Byzantine school of painting.' Open any illustrated book on the wonders of Ethiopian ecclesiastical painting, gaze up at the massed angels on the ceiling of Debre Berhan Selassie Church in Gondar or take a close look at the icon of Mary at the Debre Stefanos monastery at Hayq and see if you agree with Holmes's assessment.

On the route, Holmes and some officers repeatedly lobbied for a diversion in the march so they could have a poke around the ancient city of Axum in search of some more impressive treasures. But Napier was determined to stick to his timetable and vetoed the trip. A lucky escape for Axum. It would be spared for another seventy years until soldiers from another invading foreign army – sent by Italy's fascist leader Benito Mussolini – made off with one of its famous obelisks. Napier and his troops passed by Axum – and unbeknownst to them a host of other potential treasure houses including the rock-hewn churches of Lalibela – and pressed on with the route through way stations and camps whose anglicised names have gone on to be recorded in a host of military accounts and battle honours: Zula, Kumayli, Undul Wells, Senafe and then, crossing what is now the border into Ethiopia, Adigrat, Antalo, Ashangi, Dildi and the Dalanta plateau.

On 4 April, they found the road that Tewodros had carved for his troops and his cannons on his tortuous march, harassed all the way by increasingly confident rebels and increasingly rebellious villagers. In the end he had fought through and beaten the British to Maqdala by a matter of weeks. Napier's men still had a way to go, across Dalanta, down the 3,000 or so feet to the bottom of a ravine carved by the Beshilo River on its way to join the Blue Nile, then up the other side of the ravine to the plain, following Tewodros's new road, and finally up to the foothills of his fortress.

◎ ◎ ◎

Towards the end of Tewodros's march, he had kept up a remarkable cordial long-distance conversation with Rassam through messengers, couriers and letters. The increasingly volatile monarch glossed over his earlier decision to imprison Rassam and reverted to the intimacy and courtly words that they had exchanged almost two years earlier on the shores of Lake Tana. Tewodros pulled his guns to the Aroge plain under his mountain fortress on 18 March and sent up a message ordering that Rassam, alone, be released from his chains. In the days that followed, Tewodros sent his valuables – including a 14-inch-long bar of gold – ahead of him to be placed in his treasury. (Don't bother looking for the gold bar in the list of Maqdala treasures at the end of this book. It disappeared in the fighting that followed.) On 25 March he ordered his wife Tirunesh and his son Alamayu to come down to meet him, along with his 'courtesan' Yatamanyu. At the last moment, he said only Yatamanyu should come, putting off the family reunion for a few more days.

On 27 March, Tewodros made it to the top of Maqdala, sent more polite messages to Rassam, but still held off from seeing him and immediately strengthened the guard surrounding the prison compound. There followed two more days of mixed messages and manic activity. Outside the prisoners could hear the rush of men and arms as Tewodros redeployed his forces and artillery, then countermanded those orders, called mass meetings and trials and handed out summary justice.

On 29 March, he called Rassam to a meeting. The ground outside the prison compound was laid with carpets and there was Tewodros rising to greet him and shake him by the hand in the British fashion, all smiles, in front of an audience of 400 nobles. Tewodros joked that Rassam had barely aged a day while his own hair had turned grey. He ordered Blanc and Prideaux to be unchained and the two joined the party. There was *tej* and more banter, even about the approaching British forces. During their exchanges, Tewodros said he had only mistreated Rassam to force the British to engage, to send in their forces – and that aim was now achieved. Towards what end, he still did not know. Time would tell. 'I am like a woman in the family way, who may bring forth a son, a daughter or die of a miscarriage. I wish you to assist me to bring forth a son,'

Rassam remembered Tewodros saying. The old poetry was still there, just on the right side of coherence.

Tewodros remembered he had asked Rassam two years earlier to care for his sons, Meshesha and that other one up on Maqdala.

'He inquired whether Dejazmach Alamayo had been introduced to me,' Rassam wrote. 'On my replying in the negative, he said to the lad, "Alamayo, why do you not go to your father, Rassam?" Whereupon the boy approached and kissed the pillow on which I was leaning. After some further friendly conversation my companions and I were dismissed, his Majesty directing the young Prince and the European artisans to escort us back to our prison-house.'

And so Alamayu finally, formally met the strange foreigners who had been mouldering away for years a mere stone's throw from his residence. It was a relationship that started with a kiss and a courtly greeting. There is no record of a significant exchange. He was still only six, maybe just turned seven. But Alamayu still made a good impression. 'He is a nice youth ... and promises to be of greater weight than his eldest brother,' Rassam wrote. And, for the third time on record, Tewodros had asked a British representative to take a paternal role with his sons – 'why do you not go to your father, Rassam' – a gesture only slightly undermined when the mercurial Tewodros sent the envoy back to his cage.

In the days that followed Tewodros grudgingly agreed to unchain Cameron, Stern, Rosenthal and Kerans. He invited Rassam to come and watch as the Ethiopian soldiers dragged the largest of the new cannons into place, using leather straps to haul the wagon that was carrying it up the last 45-degree slope. Tewodros told Rassam he would have gone down to the coast himself to confront the approaching British but he was no longer strong enough. All that remained of his empire was a rock, he said, pointing to Maqdala. His mood darkened when he talked about the other captives and the insults he had suffered from the still-hated Cameron and Stern. He said he had had his first glimpse of the British troops in the distance out on the Dalanta plateau. For all the relaxed chats and released chains, a shadow hung over every conversation, every movement.

A few days on, more idle chat, and then the storm broke. As Tewodros redeployed his men and munitions around Maqdala, the Islamgie land bridge and the two lower peaks of Fahla and Selassie, he ordered the release of some of the Ethiopian prisoners, the women and children and then some of the chiefs – to clear space, to show magnanimity, or just on a whim, who knew? On the afternoon of Thursday 9 April, Rassam and the rest of the Europeans suddenly heard the crack of gunfire close by. The shooting and commotion carried on for about two hours. Rassam later said some of the Ethiopian prisoners had dared to complain about the amount of time it was taking for the guards to release them from their chains. Blanc said they were crying out for water and bread. Tewodros, who had been drinking, had overheard them. In a rage he rushed out of his tent, sword in hand, calling for his soldiers as he strode towards the compound where the Ethiopian captives were held.

He cut down the first two that he saw with his sword. Then 'the unfortunate prisoners were dragged before him, one by one; and after the name and offence of the individual had been repeated, he ordered the victim to be thrown over the precipice', wrote Rassam. 'Those who did not die by the fall were to be shot by the musketeers, who had been sent below for the purpose. After this indiscriminate slaughter had continued for two hours the King cooled down, and said "Enough"; not, however, until he had caused the destruction of no less than 197 hapless victims.' Rassam concluded that Tewodros had simply, finally gone mad.

Tewodros went back to his tent, slept for three hours and then spent the rest of the night praying. One of his servants overheard him confessing in his prayers that he had been drunk when he ordered the massacre and he prayed that he wouldn't be held responsible.

The next day – 10 April, Good Friday – Rassam, Cameron and the rest of the foreign captives were back in their barricaded compounds at the top of Maqdala, sitting and waiting for any hint of their fate. One of the nobles had told them to keep quiet at all costs. Through the morning there was the sound of the movement of soldiers as Tewodros ordered his forces down to the lower slopes, leaving only a handful behind to guard the flat summit of his fortress. Clouds gathered and a thunderstorm

burst over the mountain. In between the claps of thunder, the huddled European prisoners thought they could hear answering bursts of distant gunfire. As the storm subsided the thud of mortars and the cracks of small arms rang out more clearly. Twice they heard what sounded like victorious cheers from Tewodros's forces, answered by cries from the soldiers' families. Then, about two hours later, the shooting stopped and everything fell silent. The captives hunkered down and went to sleep.

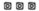

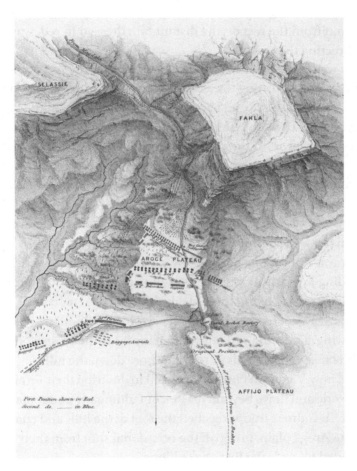

Action of Aroge.

The line of ragged, khaki-clad British soldiers struggled to the top of the slope around 4 p.m. on Good Friday and sank to the ground, exhausted. They had climbed down from Dalanta that morning and forded the river, then finally made it up the other side. Stretching out in front of them was another plateau leading up to another stiff climb, up through a pass between the two bare hills – Fahla and Selassie. Beyond the horizon, the scouts had promised, was Maqdala.

As the British troops sat and watched, they spotted something moving around on the top of Fahla. Not one thing but many things, tiny stick figures running to and fro. One figure – perhaps Tewodros himself – stood out from the rest on the distant hill, dressed in red, waving his arms, directing the crowds.

There was a puff of smoke, then a loud crack, and a speck rose up in the air then came rushing towards the foreign invaders. More puffs and more cracks and the round shot and chain shot kept on flying down from the hill straight onto the British and Indian troops on the plain.

The stick figures on the distant hill pulled back for a second then swarmed down the pass and other parts of the slope. What had been a single line of animated silhouettes turned into thousands of Ethiopian fighters, led by the king's favourite general, Fitawrawi Gabriye, throwing themselves down, some running, some dressed in scarlet robes and riding on horseback.

'Their war songs came pealing towards us. We could see their cavalry ... bounding joyously along; the foot soldiers leaping and brandishing long spears and swinging their black shields. Horsemen and foot soldiers vied with each other,' wrote Henry Morton Stanley. 'They flung their flowing symas, their bezans, and many flung their loin cloths away, and with lances and shields in rest they bore down the hill.'

This is how Victorian chroniclers liked to describe their foreign enemies – exotic and brave beyond reason, but ultimately and romantically doomed. Tewodros's troops reached the foot of the hills and charged on across the Aroge plain, firing off the occasional shot from their rifles as they headed towards the British positions.

The Ethiopians could only shoot sporadically with their matchlock guns and other antiquated firearms. The best of them might get off two shots a minute if they found somewhere to stop and reload.

The British soldiers from the King's Own Royal Regiment jumped to their feet to meet the charge and started a murderous returning fire. Most were armed with that era's weapon of mass destruction, the Snider–Enfield rifle. All they had to do to operate their guns was shoot, tip out the empty shell, slide a new cartridge into the side, re-aim and fire.

Soon after the first shots rang out, the storm broke over the plateau. An intense rain and hail shower darkened the sky. Thunder boomed as the shots from Tewodros's artillery thudded down.

There was the cracking of the rifle fire and above it all a strange, unnerving screaming. A British naval brigade had set up their own position and started shooting off rockets – missiles designed to take out ships* aimed straight into masses of Abyssinian fighters. Looking down from Maqdala, one witness said they looked like 'smoky serpents flying over the battlefield'.

There were the yelps of a range of British artillery guns, firing shells that burst and showered the advancing Abyssinian fighters with shrapnel. Pretty much everything that industrialised Britain had come up with in terms of high-tech warfare was thrown at a group of men armed with spears, swords, shields and comparatively useless rifles.

The rain soaked the ground, making it even harder for the Ethiopians to set off their guns. Part of their force tried to get around the side of the British front lines but were held back by the rockets and more rifle fire. Another group went straight for the point where the British baggage was coming up through a ravine onto the plain and charged on in the face of the artillery shells. They crashed into a force of Punjab Pioneers, left with inferior muzzle-loading rifles by their British colonial employers. After the first round of shots, the Pioneers had to make do with their bayonets. In the only equal clash of the battle, they finally managed to force the Ethiopians back, hundreds of them, into another ravine where they were trapped as the shells piled into the thick of them.

* Successors to the missiles the British had used against the Americans in the War of 1812, the ones immortalised in the 'rockets' red glare' line from 'The Star-Spangled Banner'..

The main Ethiopian charge ran into the Snider bullets. The British reloaded so fast there was a continuous rolling of gunfire. Ethiopian commanders kept rallying their troops to mount another failed charge. But the men of the King's Own just kept walking on slowly and firing.

Huge numbers of Ethiopian fighters fell, horses and men rolling over together. The British and Indian soldiers kept pushing on over the plain to the foot of the hills until the sun went down and then they started pulling back. Tewodros's men tried one last attack, shouting out and waving their swords.

A line of British troops lay down behind a piece of rising ground, then jumped up as the Ethiopians approached and fired one last volley with their rifles.

By 7 p.m., around three hours after the British troops had first scrambled to the top of the slope, the only real battle of their Abyssinian Expedition was over. Tewodros had lost the core of his army and the advantage of Maqdala's height in one mad dash. For the British, months of preparation and marching had ended in a quick, brutish massacre – up to 20 wounded British and Indians, only 2 of them fatally, against as many as 700 dead Ethiopians, another 1,200 wounded and thousands more who had fled.*

Tewodros had unleashed his missionary-made artillery, fighting the kind of battle he had dreamed of fighting ever since his first jolting defeat by 'the Turks' in Sudan, twenty years earlier. Thanks to his forced march, he had got his guns in place in time and was firing down on the invaders from his unassailable heights. But the truth is none of his missiles had hit home – the sighting was off – and there were other mistakes. One of his largest guns had exploded as it took its first shot. The dash down the slope had been a huge miscalculation. And the Sniders and the rockets had just been too much.

* The British death count was so low and the battle – from the British side of things – such a non-event that a few months later, London's Albert Life Assurance Company sent out a notice to the soldiers who had taken out its policies, saying they could get some of their money back. The firm had originally charged them extra for life insurance covering active service, but it had been 'decided, looking at the small number of casualties, to REFUND these EXTRA PREMIUMS', the firm announced in *The Times* on 20 July 1868.

War

After the sun went down, the British and Indian troops pulled back over the plain and slept out rough on the ground. Through the night, watchers saw lights coming down the hills and moving over the battlefield. At first they feared another attack. But they soon realised it was just small, silent search parties, carrying lamps and combing the plain for the missing and the dead.

◎ ◎ ◎

The next morning, small groups of British and Indian soldiers went out with stretchers, looking for anyone who had managed to fend off the hyenas and survive the night. They found one small ravine jammed with around a hundred corpses piled on top of each other. The marines' rocket fire had hit some of the Ethiopians square on. Seven bodies lay in a row, their heads blown off with one missile. General Fitawrawi Gabriye was found lying dead in a silken robe embroidered with gold, a bullet hole in his temple.

'The ground was strewn with the slain,' Herbert Borrett, a 26-year-old lieutenant from Saxmundham in Suffolk, told his new wife Annie in a letter written on the battlefield. 'Muskets, swords, spears and shields were lying all over the ground, and horses were rushing about the place, there were also many dead and wounded animals. The effect of our snider rifles had been fearful, but I must not tell you of the awful, ghastly, and horrid sights we encountered in our search.'

Somewhere out on the plain, Borrett saw a ring glinting on the finger of a dead Abyssinian soldier. He pulled off the band and shoved it into his pocket.

◎ ◎ ◎

Tewodros sat on a rock the day after the battle and looked over the landscape beneath him. After a few minutes he got to his feet and took a drink of water. Theophilus Waldmeier, one of the Gafat missionaries, faithful and unchained to the last, was standing nearby. He saw Tewodros make the sign of the cross on his chest, bow low three times and start praying. Tewodros

straightened up again, took a pistol out of his belt and pushed it into his mouth. Courtiers rushed forward. One grabbed the gun as it went off and a bullet nicked the monarch's ear, just missing his skull. Tewodros covered his head with a cloth and lay down on the ground, breathing deeply.

He slowly recovered and his lieutenants started circling again. There was still time to strike one decisive blow against the British troops, they told him, by taking away the whole reason for their mission and killing all the prisoners. Tewodros stayed silent, waited for them to stop talking, then beckoned Waldmeier over:

'Sit down, be not afraid,' he said, according to the missionary's rather breathless memoir. 'I was advised to kill you and all the Europeans, but you have not done anything against me, and I shall not kill you. My death is near at hand, and I do not like that you should go before and accuse me in the presence of God. Go, and get your friends Rassam and party, and accompany them to the English camp.'

◎ ◎ ◎

At sunset, the bulk of the prisoners came down into Napier's camp on the Aroge plain. More came the following day – Easter Sunday. The British troops were a little put out by how well the hostages looked, given all the effort made to rescue them. They were now around sixty Europeans and Ethiopians (some of the men had married local women), their children and servants, all a bit ragged but well-fed and largely healthy, despite all that talk of chains and tortures.

Napier received a letter from his foe. 'When I used to tell my countrymen, "Submit to taxation and discipline", they refused and quarrelled with me. But you have defeated me through men obedient to discipline. The people who loved me and followed me fled, abandoning me because they were afraid of a single bullet. When you attacked them, I was not among the people who fled. Alas, believing myself to be a great man, I kept on fighting with worthless artillery.'

It wasn't signed Tewodros or *negusa nagast*. All that was gone now. The name at the top read simply 'Kasa'.

**

Attack on Maqdala.

It was a total success from the British point of view, the story over, apart from the question of what to do with Tewodros. They couldn't just leave him in his mountain fortress, at least nominally in control of the country. 'It was essential for the vindication of national honour, which Tewodros had so grossly insulted, that he should be removed forever from his place,' Napier wrote in one of his dispatches.

So the British and Indian soldiers pressed on the following day, past crowds of thousands of Ethiopians fleeing down the mountain sides. The road twisted up between the two hills onto the wide land bridge of Islamgie. And there at the end of it, finally, was Maqdala.

The soldiers could see around a hundred Ethiopian soldiers and a small group of horsemen charging backwards and forwards across the open ground at the far end of the plain, bright robes flowing behind them. One of them turned his white horse, then galloped straight at the British frontline. And there, the soldiers suddenly realised, was Tewodros, King of Kings of Abyssinia, pulling in his reins, firing his rifle into the air and shouting out a challenge. By this stage he was around 50 years old, out there at the front of his troops, urging them on, channelling the rage of Kasa the *shifta*.

The monarch and his men withdrew up a twisting path onto the top of Maqdala and shut a heavy set of thorn gates behind them. There was a long pause as the British troops got their artillery into position then opened fire. Every shot missed. There were other pauses as the guns were manoeuvred, and more firing, again with no visible effect. Through all the noise and smoke it was impossible to tell if anyone was shooting back. Occasionally you could see a single figure between the thorn bushes but there was no other indication of the size of the defence. When the firing stopped there was nothing, silence.

Yet another long pause as Napier and his commanders reworked their plans and then, at around 4 p.m., the final charge began. A small storming party was supposed to blow up the gates, under the cover of artillery shells and rifle fire. When they got there, they could not find their powder bags. If there had been any decent force inside, the British would have been stuck. Their soldiers were backed up along the path with no way of pushing forward.

As it was, someone behind the thorny gates managed to get in a few shots, wounding nine British officers and men. Then an Irish private and a drummer got a scaling ladder up against a low section of fence leading up to the gate, scrambled over and took on the handful of Ethiopians defending the entrance from the other side. Close behind

War

them came the rest of the force from the 33rd Regiment of Foot, who charged onto the flat summit.

Tewodros was found lying dead, halfway up a path to the second line of thorn defences. One of his servants later said he had kept under cover with a handful of his most loyal followers during the artillery barrage. He knew it was all over when one shell landed inside the gate and killed one of his generals. Tewodros moved the men further into the fortress then took off a gold-brocaded mantle he had been wearing throughout the day and told his troops to flee. He put a gun in his mouth and pulled the trigger. This time no one stopped him.

Chapter Four

Plunder

'Then will my enemies riot in my mansion, and enjoy the gardens
which I have planted.'
The History of Rasselas, Prince of Abissinia

Several engravings later printed in the British press show Tewodros
stretched out on the ground, dressed in a dark robe and white undergarment,
one arm across his stomach, his feet crossed like a carved effigy on
a church tomb. Two small groups of British soldiers keep a respectful
distance in the background, taking one last look at their fallen foe.

That is not how it happened.

Major-General Sir Charles Metcalfe MacGregor, then a young captain
on Napier's staff, was looking at the body 'when a rush of fiends,
vultures, dressed like Englishmen, broke through and tearing the
clothes off the corpse, fought for bits of mementoes!' (He was sickened,
he wrote in his diary. 'I never saw anything more completely disgusting
and unmanly in my life.') Officers and men jostled around him, pushing
each other out of the way to get at Tewodros, who was lying on his
back inside the gate. Some ripped off strips of stained material from his
robe and ran on. Others paused to dip their pieces of cloth in the blood
coming out of his head wound, the ultimate primal battle souvenir, a
piece of the enemy. The men were riding on the high of an easy victory
after weeks upon weeks of building tension and hard marching.
There had been little actual fighting, particularly on the last day. But
the thought of plunder and the rush of conquest was all they needed.

The men kept on ripping off souvenirs until the body was a mess of rags, then peeled off in groups to search the huts that crowded the summit. Shouts rang out when one party stumbled onto a storehouse filled with 20-gallon jars of *tej*, and some eggs. 'Being awfully hungry we ate them raw,' wrote another member of Napier's staff, Captain Cornelius 'Frank' James. The regimental order of the marching columns had broken down into total chaos and there was no one at that moment to bring it back into order. One group of men dug frantically in the royal compound, searching in vain for buried gold ingots. Others ransacked Maqdala's Church of Medhane Alem – 'the Saviour of the World' – pushing past the British Expedition's own Catholic chaplain, who was doing his best to defend the building. There was a ring of small huts around the main church holding bodies waiting for burial. Two witnesses described how the soldiers ripped off the coffin lids and took what they could find inside, including crosses from the corpses. An observer said one of the bodies belonged to Abuna Salama III, the head of the Orthodox Church, who had come down from Egypt, crowned Tewodros then fallen out with his protégé and died a semi-captive on Maqdala a year earlier. (It might be best to treat this last account with a bit of caution. It would be unusual, to say the least, for a body to lie unburied for so long.)

And close behind the soldiers came Richard Rivington Holmes of the British Museum. He made it into the fortress minutes after the main charge and started casting around for loot. A soldier ran past, weighed down by a gleaming golden crown and a golden cup. Holmes did a quick cash deal on the spot and secured his first major treasures. At one point, and it's not quite clear when, Holmes came across the body of Tewodros and paused to make a quick sketch. It was an unforgiving portrait – only the head, with the torn and mauled clothes conveniently out of the frame. One half-closed eye suggested the trauma of the brain injury – the bullet had passed through the palate and out the back of the head. The hair in the drawing is cropped and torn; clothes weren't the only mementos taken by the soldiers. Ever the archivist, Holmes annotated and signed his work to establish its provenance: 'sketched

immediately after the capture of Magdala'. It is one of a very few direct portraits of Tewodros, and looks nothing like the superhero graffiti in Addis or, of course, the racist caricatures in *Punch*. His true face was captured forever moments after his death, the ultimate defeat.

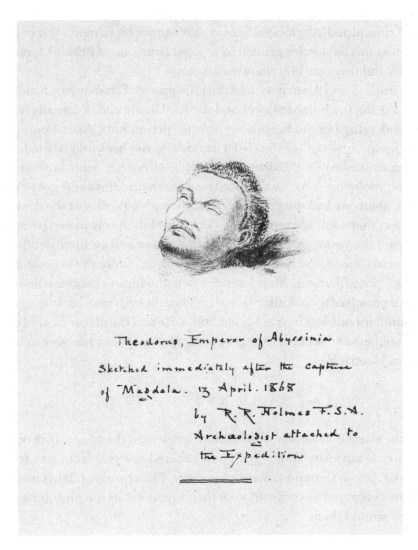

'King Theadore after death.'

After they had emptied the treasury, drunk the *tej* and ransacked the church, some of the soldiers, according to the anonymous correspondent writing for Germany's *Allgemeine Zeitung*, turned to the Ethiopian women and girls left on the summit. 'Their silver necklaces, arm and ankle bracelets were torn from them, even their clothes,' read the report. The soldiers 'feasted on the sight of the defenceless creatures' and committed 'disgraceful acts ... that cannot be named'. You could dismiss this as slander printed by a paper from one of Britain's foreign rivals. But there are hints in other accounts.

Tirunesh and Alamayu – and the ever-present Yatamanyu – had lain low during the bombardment and the final battle and eventually tried to seek refuge in the Europeans' former prison huts. At one point in the melee, one soldier slapped Tirunesh on the back and bawled out in scrambled Arabic 'Tédros ... mafeesh' – effectively 'your husband is gone, you're on your own'. Once the women and the child got to the huts, someone had the presence of mind to post a sentry at the door to protect them. But some of the soldiers forced their way in and pressed around the young queen. 'Luckily Mr. Rassam and an English officer came in time to save her from further outrage,' wrote the expedition's geographer Clements Markham. Rassam, the former captive who had twice promised to look after Tewodros's family, had come back up to the summit for one last look at his old home. He and the officer cleared out the soldiers and set up a stronger guard. Alamayu must have been close by and seen it all.

◎ ◎ ◎

As the afternoon wore on, the summit 'presented the appearance of an immense curiosity shop which had suffered severely from an earthquake', wrote Captain James in his diary. The correspondents on the scene competed to come up with the longest list of the plunder scattered around them.

'In one of the tents was found the Imperial standard of Ethiopia – a lion rampant, of the tribe of Judah, worked in variegated colours,' wrote the clear winner in the list-writing contest, Henry Morton Stanley. 'In another was found the Imperial seal, with the same distinctive figure of a lion engraved on it. A chalice of pure gold was secured by Mr. Holmes ... The Abuna's mitre, 300 years old, of pure gold, probably weighing six or seven pounds troy weight; four royal crowns, two of which were very fine specimens of workmanship, and worth a round sum of money; were worthy things to be placed in the British Museum.' He was just getting started.

'A small escritoire, richly ornamented with mother-of-pearl, was found also, full of complimentary letters from European sovereigns, and state papers; besides various shields of exquisite beauty.'

The presents and messages that European powers had sent in the days when they were courting Tewodros were piled up on Maqdala and taken back. Stanley continues his list:

> There was also an infinite variety of gold, and silver, and brass crosses, and censers, some of extremely elegant design; golden and silver pots, kettles, dishes, pans; cups of miscellaneous descriptions; richly chased goblets of the precious metal; Bohemian glasses, Sèvres china, and Staffordshire pottery; wine of Champagne, Burgundy, Greece, Spain, and Jerusalem; bottles of Jordan water; jars of arrachi and tej; chests full of ornamental frippery; tents of rose, purple, lilac, and white silk; carpets of Persia, of Uschak, Broussa, Kidderminster, and Lyons.

The wine, arrachi (the distilled drink *araki*) and *tej* did not last long. The troops were parched after their days of scrambling and battling. There is no record of any fragile Sèvres china or Staffordshire pottery surviving the melee, though the King's Own Royal Regimental Museum in Lancaster does still have one '18th Century European glass tumbler' in its Maqdala display case.

Stanley continued:

Robes of fur; war capes of lion, leopard, and wolf skins. Saddles, magnificently decorated with filigree gold and silver; numerous shields covered with silver plates; state umbrellas of gorgeous hues, adorned with all the barbaric magnificence that the genius of Bejemder and Gondar could fashion; swords and claymores; rapiers, scimitars, yataghans, tulwars, and bilboes; daggers of Persia, of Damascus, and of Ind, in scabbards of crimson morocco and purple velvet, studded with golden buttons; heaps of parchment royally illuminated; stacks of Amharic Bibles; missals, and numberless albums; ambrotypes and photographs of English, American, French and Italian scenery; bureaus, and desks of cunning make. Over a space growing more and more extended, the thousand articles were scattered until they dotted the surface of the rocky citadel, the slopes of the hill, and the entire road to camp two miles off!

Stanley, writing for an American newspaper, and the anonymous correspondent of the *Allgemeine Zeitung* were free to describe the excesses. Other frank accounts came from the men's private diaries and letters, never meant for publication. But the plundering posed a problem for all the British journalists and chroniclers gathered on the summit to bear witness to the victorious conclusion of a noble rescue mission. How to squeeze the loot into their narratives? Some chose not to mention it at all. The ones that did typically fell back on three techniques, all used concurrently in the work of the anonymous staff officer reporting for Edinburgh's *Blackwood's Magazine*.

One, they could shrug and dismiss the plunder as trash, barely worth mentioning so barely worth mourning. 'Hardly anything of value was found in the place,' the staff officer wrote. 'A trumpery crown [was] the most costly object,' wrote Sir Charles Metcalfe MacGregor. 'No booty found at Magdala' was how Napier put it in a telegram sent back from the final battlefield.

Two, they could say the plunder was already stolen – and stealing a stolen thing cancels out the crime. 'The collection was, at all events, a most discreditable one to its late owner, since it consisted partly

of crosses, paintings and sacred vessels plundered from Christian churches, and partly of the weapons used by himself and his soldiers in mauling the priests,' wrote the staff officer.

Three, they could affect their own air of disdain and write the whole thing off as a base aberration: 'The way that some men will scramble for a piece of silk or an old sword, such as few gentlemen would think worth carrying home if found anywhere else, merely because it happens to be booty, is a remnant probably of the old predatory instincts of the species.'

Towards the end of the day, Napier took in the scene at the summit and, for all his talk of 'no booty', posted guards at the gates to restore some sense of discipline and stop anyone taking plunder down to the British camp at the foot of Maqdala. Orders were issued to halt the unlicensed, drink-fuelled pillaging. The senior officers had something more licensed, more respectable in mind.

◉ ◉ ◉

That night, the men were told to start handing over anything they had grabbed. When that order was ignored, they were lined up and searched. The only treasures they were allowed to keep were things they had taken 'at the point of the bayonet', as in things they had grabbed off an enemy during active combat – a kind exemption for acts of ultra-violence. The fact that there was actually very little hand-to-hand combat at Maqdala did not stop the British soldiers walking away with a good number of Ethiopian muskets and shields and other pieces of memorabilia. Stories later spread of one member of a regimental band who had got a handful of jewels back to Britain by covering them in mud then sewing them into a cricket ball.

Colonel (then Ensign) W.A. Wynter told his son years later he had had to hand over a silver processional cross that he had found. He made up for the loss by buying a large rhinoceros-hide shield from a passing British sergeant who assured him a bayonet had been involved in its acquisition. (The cross, according to Wynter, later turned up as

a centrepiece at the Royal Artillery Mess at Woolwich.) Even Holmes handed over his crown and chalice, on the understanding that they could be kept to one side, taken back to Britain and saved for the nation. The British nation, that is.

Most everything else that was collected was going to be auctioned off to raise 'prize money' for the British and Indian soldiers, a practice dating back to Roman times, and no doubt earlier, that gave a veneer of respectability to the basic business of grabbing things during war. The treasures would be gathered up, sold off and the proceeds shared among the troops as a reward or bonus for their victory, in the same way that the navy had been slicing up the value of captured ships and handing out prize money to their crews for years.

Up on Maqdala, the job of collecting all the valuables and getting them ready for the sale went to one Lieutenant-Colonel Thomas Walter Milward. 'I am put on the Committee for prizes ... it gives me a great deal of trouble,' the artillery officer wrote in his diary the day after the final battle. He was no happier a day later. 'We are collecting the loot, and I am much bothered with it.'

Tewodros was buried in the grounds of Maqdala's church. Four days after his fall, the British blew up his treasured guns, destroying them and one passing cow in the process. The ground around the fortress was still covered in torn manuscripts, loose pages and scraps of parchment. That didn't last for long. Before pulling out for good, the troops set fire to the main structures, igniting a blaze that ripped across the summit, sending up a cloud of dense smoke that could be seen for miles around. They had meant to spare the church but the flames spread too quickly.

'We are burning large quantities of corn ... which we cannot carry away, but we are taking a good deal of other loot for sale for the good of the men,' wrote Milward. 'Being on the Committee gives me very much bother.'

In the days that followed, as the British pulled back to the Dalanta plateau, commanders were allowed to choose items from the collected treasures to take back to their regimental messes as trophies. Hundreds of brightly illuminated manuscripts, handwritten on goatskin in red and black ink and bound in wooden covers, as well as some of the larger

items, including a huge gold crown, were set aside for the British state. Napier later said he felt honour-bound to take the manuscripts to keep them out of the hands of Tewodros's Muslim enemies.

And then on the afternoon of 20 April, the auction started out on the plateau. The commentators may have dismissed Maqdala's treasures as valueless trash, but the bidders wanted as much of it as they could get their hands on. Competition was fierce. There was so much of it that the auctioneer had to call a pause and start again the next day. Everyone with spare cash wanted a souvenir of a battle in such an exotic location, ideally a portable souvenir – swords, censers, goblets, shields and cow-horn drinking cups all got snapped up, piece by piece. Milward got so carried away that he ended up buying an armlet and a cross for himself. A shield described as 'Theodore's shield' went for £41. Anything described as the personal property of 'Emperor Theodore' went for a premium; museum and auctioneer catalogues to this day are littered with confident references to 'Theodore's drinking cup', 'Theodore's sword', 'Theodore's necklace' and 'Theodore's shield'. It seems he owned lots of cups and shields.

As the prices mounted, a handful of bidders started to dominate the proceedings. Stanley mentions Colonel Charles Craufurd Fraser, commanding officer of the 11th Hussars cavalry regiment, snapping up treasure after treasure for its wealthy regimental mess. But leading the field, with the deepest pockets – with most of his £1,000 credit line unspent on the way to Maqdala – was Richard Rivington Holmes who, 'as the worthy representative of the British Museum, was in his full glory'. Stanley estimated the sale raised a much higher than expected £5,000 for the men. And as we shall see, there were still a few accounts to settle.

Everyone was thrilled. The expedition had found a way to civilise the primal urge to plunder in battle. It had also found a way to compensate the men without adding to the considerable bill building up at the British Treasury. The whole thing was paid for by the senior officers – who bid to raise cash for the lower-ranked soldiers – and by the Ethiopians themselves, who provided the prizes.

◎ ◎ ◎

You can still see pieces on offer, as they were soon after they were found, through the work of another of the British Expedition's departments: its official photographers attached to the 10th Company Royal Engineers. There had not been enough time to lug all the heavy equipment up to the top of Maqdala to capture the battle, or the face of Tewodros before he was buried. But they had everything set up in time to capture some of the key buildings before they were destroyed – the church, the prison – and some of the treasures found inside those buildings. Around eighty of the best photos were later issued in limited-edition albums. One shot shows a close-up of a metal hand cross. Others focus on pages from illuminated manuscripts: paintings of St George, the crucifixion and Mary, and a section of the Gospel of St Mark.

And there, suddenly, filling the frame on the next page in the album, is our prince. Up to now he has been a fleeting presence, mentioned in passing or playing out a cameo in other people's scenes.

He makes his first full appearance on his own, posed outside on a flat piece of ground. His clothes are askew, his chains in a tangle. There are bags under his eyes. But for all the disorder, he is part of a carefully constructed scene, a tableau of plunder, human and otherwise. He holds a sword and sits next to a lion's-mane shield, both too big to have been his own. Not for the last time, Alamayu is propped up next to exotic accessories on his own little stage, a couple of crates draped over with a cloth.

It is a portrait of a little boy, days after his world exploded. It is also a portrait of trauma. His face tells the real story. You might have expected him to look scared, cowed, overwhelmed by his new surroundings, the masses of strange white soldiers pressing around him, the strange contraption – the 11 x 9in brass-bound camera – placed in front of him on a tripod. But he is barely there. His eyes are open but he's not engaging with anything around him, just staring into the middle distance. Whatever is going on is going on deep inside.

In the background, out of focus, you can barely make out what might be tents. All around him, the soldiers would have been rushing about, celebrating their victory, comparing their loot and, in the days that

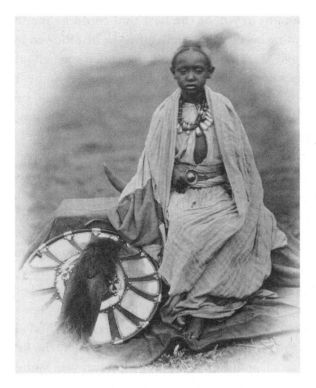

'Son and heir of King Theodore.'

passed, packing up their camp for the march back to the coast. He may not have realised it yet, but he was going with them.

There had been hurried consultations with Tirunesh in the immediate aftermath of the fall of Maqdala. As she sat recovering her composure in Rassam's former prison hut, officers had sent in messages asking about her intentions.

One letter from Napier asked the key question: 'We would like to know your wishes also regarding the son of his late Majesty. It is to be feared that, in the present state of Abyssinia, the youth's life will be in danger at the hands of many persons who will aspire to the empire of Abyssinia. We are willing to take the child under our protection, and send him to England or Bombay to be educated, and we would suggest

this arrangement to you as the best that could be made. Your own wishes regarding his disposal shall, however, be followed by us.'

According to Markham's account, the queen seemed torn. She sent out messages saying she wanted to go back to her home. But she also wanted to honour Tewodros's wish that their son should be taken in by the British. Asked if she was prepared to part with the boy, she simply answered that she would honour her late husband's wishes. That wasn't 100 per cent clear, but time was pressing and there were a thousand other things to consider, so they left it at that. One of the most important decisions on the future direction of Alamayu's life was left hanging in the air.

Napier asked Rassam to take care of the diminished royal family. The plan, as far as it went, was for Tirunesh and Alamayu, along with Yatamanyu – whom the Brits, delighting in slander and gossip, described as Tewodros's 'favoured queen' – to be escorted off the mountain and accompanied along the way for as long as their roads led in the same direction. Tirunesh's two brothers, who had survived the massacre of the prisoners and then been released by the British, would come along too. Her father, Ras Wube of Tigray and Simien, had died in prison.

Tirunesh kept out of sight during her last hours on Maqdala. Lieutenant Borrett – the finder of the ring on the battlefield – caught one brief final glimpse of her sitting on a mule, watching the British soldiers from a distance, her face hidden in a black hood.

They slept their first night off Maqdala in Rassam's tent on Aroge plain, cushioned by the carpets that Tewodros had presented to the envoy during their rollercoaster relationship. When Rassam moved them across to the Dalanta plateau, he pitched their shelter close to the tents of the freed European captives. From there, they had a perfect view of the inferno sweeping across Maqdala's surrounding hills. 'Now that our lord has gone, may all Abyssinia be consumed by fire,' Yatamanyu said as she watched. Tirunesh said nothing. She just sat close to her son, silent and dejected.

Maqdala in flames.

Rassam tried to cheer her up later, along the way, telling her she was safe and could not have hoped for better protectors than the British. 'She said that she entertained no doubt whatever on that point, but she felt that her days were numbered, for which she was not sorry; and then added, "Mine has been a miserable existence since childhood, and I am now looking forward to that happiness which is promised me by our Saviour."'

Before the expedition's forces finally left Dalanta, the British and Indian troops lined up for one last general parade. Napier prepared a final message to the force which was read out by one of his senior officers.

> I congratulate you, with all my heart, on the noble way in which you have fulfilled the commands of our Sovereign ... The remembrance of your privations will pass away quickly; your gallant exploit will live in history. The Queen and the people of England will appreciate and acknowledge your services; on my part, as your Commander, I thank you for your devotion to your duty, and the good discipline

you have maintained throughout. Not a single complaint has been made against a soldier, of fields injured, or villagers wilfully molested, either in person or property.

◎ ◎ ◎

From that moment on, everything accelerated. The force wanted to get out of Ethiopia as soon as possible, primarily to escape the rains that could turn into flash floods and swamp the narrow mountain passes in a matter of minutes. They also did not want to outstay their welcome. The warring princes who had let them in so easily might not feel so motivated now that Tewodros was gone. Napier's men left some artillery, mortars and muskets with the prince who had been the most help, Kasa Mercha of Tigray, and then kept on going, rushing through the way stations in reverse, reeling in their telegraph wire as they went, pressing on through heavy rain and thunderstorms.

Wherever he could, Rassam set up camp with a separate guard away from the main body of the troops. Yatamanyu soon left the march, heading back to her people. So eventually did Alamayu's uncles. They wanted to go back to Simien, but said they didn't have the money or arms to protect Tirunesh or her son. So that left the queen and her boy and a few other attendants with the troops. The general talk in the camp that seeped into the foreign correspondents' reports was that Alamayu would go back with the bulk of the soldiers and end up in a mission school in British India. It was still very vague and there was no definite word on the queen. The official accounts and the telegrams and dispatches have whole passages on the organisation of land transport and the commissary department alongside occasional sentences on Alamayu and Tirunesh. The strain of the journey was starting to take its toll and Tirunesh had started to feel unwell, showing the first signs of a bad cold.

There was a pause in the march on the first day of May near a settlement called Marawah. It had rained in the morning, soaking the tents so they were too heavy to carry. The march had also grown over-extended.

The rear brigade was a whole day behind the advance. As everything dried out and the expedition reassembled, an artist travelling along with the expedition, William Simpson, went over to Rassam's tent to sketch the prince.

Alamayu came in 'dressed and with a shanah all over – that is the white sheet with a broad red stripe near one of its edges – a necklace and the matab, or blue cord of his baptism,' Simpson wrote in his diary. 'The finishing touch, according to the Abyssinian ideas of the toilet, had been given to him, by putting some butter or grease on his head. A small stream of it was trickling down the side of his face.'

In other words, Alamayu's mother or one of her helpers had done their best to make him look nice for his portrait. Just over two weeks after his world had disintegrated, the 7-year-old boy sat still under the artist's gaze. The photograph taken by the Royal Engineers gave us our first look at the prince. The drawing by Simpson, which was turned into an engraving and published on the front page of the 13 June edition of the *Illustrated London News*, would be his first introduction to the broader British public.

You can see how Alamayu turned into a totem, an icon. He had artists and photographers working on him from the start. In the engraving – which Simpson later acknowledged was, through some freak chance in the reproduction process, a better likeness of the prince than his original drawing – the boy sits on the floor in half-profile, his clothes draped artfully around him, set against a background of looming shadows. The outline of his robes forms a basic triangle, rising up from its base, to his narrow shoulders and then his face, a classic composition. The details of Alamayu's iconography are already developing – the bare foot, the disproportionately tiny hand, the flash of the exotic with the now neatly arranged pendants and chain. He is looking out into empty space, the light catching his features, a figure fixed forever on its base, expressing melancholy and resignation. Tirunesh was also supposed to sit for Simpson but she kept missing appointments because of her illness, and the portrait never happened, robbing us of our last chance to see her face.

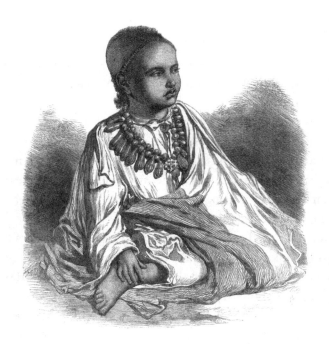

Alamayu.

The rain let up, the tents dried out and they were off again, charging north towards the coast. By 10 May, the queen 'was reported to be seriously unwell', according to one line in the expedition's official chronicle. She 'had been ever treated with universal courtesy, and had been attended by the medical officer attached to the personal staff of the Commander-in-Chief', it added, a little defensively.

Napier arranged for her to be carried in a covered litter, but her health fluctuated with the weather. She felt better when it was fine, and struggled to breathe when the rain came down and the damp seeped in. By contrast, all around her, the mood of the march was getting cheerier by the day. Every way station they passed brought in more supplies and more congratulatory telegrams and more men to join the victorious march back to the coast. By mid-May they had reached the fortified camp of Antalo, where Lieutenant Borrett, the ring-finder, bumped into Alamayu and found him 'a sharp little fellow' who could already speak a few words of English.

Soon after, Rassam decided it was time to host a small party, a 'dinner in the Abyssinian fashion' for the officers of the 4th (King's Own) Regiment. Around forty guests sat on carpets in a tent as a parade of servants brought in baskets covered in red cloth and filled with *injera* bread, 'curried soups and stews', ribs of beef roasted until they were black and the best bits of the meat served up raw. Alamayu, taking some time away from his mother's sickbed, was the star attraction. He ate a few bits of the raw beef and many more of the cooked bits, cut up into small pieces for him by his servants.

The officers of the 4th finished their meal, thanked Rassam for the interesting cultural display and headed back out to pack up their baggage, ready for the next stage of the march. There is no easy way to build up to the jolt of what happened next. The soldiers' and journalists' diary entries, focused as they were on the drama and celebrations of the withdrawal, gave no warning as the troops moved on to the camp of Ayqulat. There was a particularly heavy fall of rain on 15 May that erupted into a full-blown thunder and lightning storm as the sun went down. Around 9 p.m., Rassam asked someone to prepare Tirunesh a bowl of arrowroot mixed in with port wine, something easy to digest that might help her get some sleep. Her attendant came out of the tent and said the queen felt too ill to eat. The attendant went back in and found her dead. Rassam rushed in when he heard the outcry and saw the queen in her bed. 'There lay the lifeless body but the features were unchanged, and seemed composed as in a quiet sleep.' Tirunesh had barely outlived her husband by a month.

Holland and Hozier's account said she had died of a disease of the lungs. Others suggested a sudden haemorrhage brought on by consumption or, as it is better known these days, tuberculosis. Back then medical science had barely started to get a grip on the condition. The French army doctor Jean-Antoine Villemin had only just published the first proof, at the time widely dismissed, that it was infectious. He was vindicated when scientists reproduced his results in the years that followed and showed how easily it could be passed on from person to person through hacking coughs, particularly to family members and others who came into close contact with patients. Once

established in a host, it could lie latent for years before emerging to claim another victim.

There was no time to spare as the rain clouds kept building, so plans for the funeral started within an hour of Tirunesh's death. By this time, the march was deep in Tigray, close to the Church of the Trinity at Chelikut, or Calaqot, not far from the site of what would become the region's modern-day capital of Mekele. The priests came to the camp and started their ceremony in the early hours of the next morning.

'In front of the tent where the corpse was lying I found the Queen's female attendants going through the custom of wailing for their mistress,' the artist Simpson wrote. 'Each had some article belonging to the Queen: one had her robe, another her silver chains; and her charms, slippers, articles of dress, drinking-cup, teff bottle etc were in the hands of these dark, almost negro-looking creatures, who held them up over their head, the articles being in some cases attached to sticks. They stamped on the ground with their feet and moved about in something like a dance with tears in their eyes crying to the Queen, "Anatee! My mother!"'

Somewhere, someone else must have been crying for his mother. Simpson's account is typical of other European descriptions of the funeral, with its racially tinged fascination with the exotic detail in the ceremony and its apparent lack of interest in Alamayu. I haven't managed to find a single mention of him in the accounts of the immediate aftermath of his mother's death. Perhaps he was kept out of the way. Perhaps the sight of a destroyed little boy was just too jarring for the grand romantic narratives of thunderstorms and ritual.

The band of the 4th (King's Own) Regiment played the 'Dead March' from Handel's *Saul* and followed the funeral procession as it took the queen's body to the church. But after half a mile the British troops turned around and headed back to the trail, leaving the queen on her trip to the graveyard. Now there was just Alamayu and an ever-shrinking retinue of servants. (The queen's attendants packed up and left after the funeral.) Just hours after he'd lost his mother, the British troops picked the boy up again and swept him along as they resumed their race to the coast.

Before they left, Napier presented a large selection of the sacred manuscripts taken from Maqdala to the priests at Calaqot, and from that church, over the years, many were distributed to surrounding congregations. Maqdala-minded academics have been tracking them ever since. Napier still had plenty left over: around 350 of the oldest and most richly illustrated psalters, prayer books and gospels were still packed in with the baggage.

Rassam reached camp Zula on 27 May, 'where in pursuance of instructions to that effect, I consigned the young prince to the care of the local political officer'.

◎ ◎ ◎

It is time to make a very belated introduction to one of the main players in our story – the blue-eyed, red-headed and magnificently named Captain Tristram Charles Sawyer Speedy, who walked in at this point and took charge of our prince.

We need to rewind a bit to cover his full story in Ethiopia.

He had arrived in the country not long after Bell and Plowden's deaths, around the time of Alamayu's birth. At 6ft 6in, Speedy was yet another tall Englishman in his twenties chasing adventure. Like Plowden before him, he had quit his job in India (in his case in the army) and sailed up the Red Sea, where he had a life-changing encounter. In early 1861, he was walking through the bazaar in the Arabian port of Jeddah when a man accosted him and asked him for alms in the name of the Father, the Son and the Holy Ghost. He told Speedy he was a Christian pilgrim from Abyssinia and went on to spin a string of tales about his mountain home. 'All that he told me awoke within me a strong desire to go to Abyssinia,' wrote Speedy. So he took on the pilgrim as a guide, sailed across the Red Sea to Massawa and started to clamber up the passes.

After a few weeks of hunting and other adventures, a messenger caught up with him. Tewodros, still mourning Plowden and Bell, wanted to meet the new Briton in town. Speedy reluctantly travelled to Debre Tabor, east of Lake Tana, and there was the King of Kings

back in his glory days before the fall, in his scarlet tent in his roving camp. The monarch 'was reclining on a couch in the porch of his tent, and from under the cushions protruded the hilt of a sabre, and the butt of a brace of pistols, the prized gifts as I afterwards learnt of the late Consul Plowden,' wrote Speedy. 'He said he liked all Europeans, but loved the English.'

These quotes, by the way, don't come from the usual letters or diaries or memoirs. In his later years, Speedy toured Britain and further afield with an illustrated talk about his experiences. Ever the showman, he pepped up his presentations with impersonations, costume changes and dramatised scenes. The notes he kept for those talks, still owned by his relatives, sketch out his story as he performed it to packed village halls and venues into the early days of the twentieth century. So bear in mind at the moment we are hearing his version of things, and an amplified version at that.

Speedy described how his host showered him with gifts: 30lb of honey, 30lb of butter, 30lb of red pepper, 200 cakes of bread, 8 sheep and 2 cows. Tewodros talked about England, asked questions about military discipline and cavalry tactics, and invited Speedy to join his service. Speedy declined, saying he wanted to spend his time big game hunting. 'Well! Well!' answered Tewodros. 'We will talk of this another time – you must be fatigued. Retire and rest.'

Speedy stayed and the days turned into weeks into months. At one point, while Tewodros was away fighting rebels, Speedy set off with some of the European missionaries to have a look at Gondar. Tewodros's guards chased him down, told him he could not leave camp without permission and threatened to put him in chains. Speedy pulled out his sword, swearing he would rather die than be captured and yelling an Ethiopian war cry, 'Zeraf, zeraf, enye Fellika Ya Teodros Barya' – something like 'Forward, forward, I am Fellika [Speedy], the slave of Tewodros!' (Imagine the older Speedy acting this out years later in English town halls.) Tewodros's men backed down but, at the bidding of the missionaries, Speedy returned to the royal camp. In Speedy's account, the bromance continued and he suggested he train up a body

of Tewodros's men to demonstrate how a well-drilled infantry unit could beat cavalry in open battle. When the day came for the demonstration, Speedy proved his point, but too well. His soldiers humiliated the horsemen. The next day Tewodros suggested that perhaps, after all, Speedy should now leave. 'Go in peace. Let us be friends,' the emperor said, according to Speedy's record. The British adventurer said he would go the next day. '"Go at once," Tewodros exclaimed – "Tomorrow Satan may change my heart!"'

Speedy rode off and continued his wanderings. Like Bell before him, Speedy started picking up Amharic and developed a love of Ethiopian clothing. As the notes to his illustrated talks show, he revelled in role-play. At some stage in his adventuring and big game hunting, he was joined by his teenage Irish cousin, one Laurence Kerans.

◎ ◎ ◎

The second time that Speedy crossed paths with our story was just a few months later. He bumped into Cameron, who had just fobbed off Tewodros's letter to Queen Victoria and was setting off on his wayward mission through Bogos and on to Sudan. Cameron told Speedy all about his various schemes and asked Speedy to become his deputy and hold the fort at Massawa while he was away. Speedy took the job and waited in the sweltering port for his boss to come back. It was Speedy who gave Kerans the connection to start working in Cameron's service. And it was Speedy, some reports suggest, who sent Kerans up into the highlands with his letters and his fateful carpet. In January 1864, two years after getting the job, the ever restless Speedy got tired of waiting for his boss to come back down to the coast. He quit and packed his bags, and sailed off to spend some time with his family in New Zealand. He left on 4 January, unbeknownst to him the day after Cameron and Kerans were taken into a tent and loaded with chains.

◎ ◎ ◎

Speedy made his third major intervention at the direct invitation of Sir Robert Napier. The British Expedition's commander-in-chief had heard of the Amharic-speaking Tewodros-meeting former British Army officer and sent a telegram out to New Zealand asking him to return to join the mission and work with the Intelligence Department as an interpreter. Speedy accepted and sailed back to Africa. He made an unlikely intelligence officer – a bespectacled giant with a muscular build whose habit of wearing full Ethiopian warrior gear, complete with shield and spear, did not help him blend in with any crowd. Not that he was ever supposed to be undercover. He translated along the way, helped negotiate supplies and witnessed the final fall of Maqdala.

We get our first looks at him in Abyssinia through the lenses of the expedition's official photographers. One of his portraits was taken at the same photo shoot as Alamayu's, with what looks like the same shield

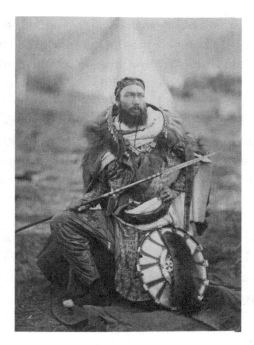

'Captain Speedy.'

and the same tented plain. Unlike the prince, he is clearly loving every minute of it.

He was a showman, always ready for his next grand role, his next adventure. The next great role that he found himself in, his fourth in this saga, was as the towering guardian for the little lost prince of Abyssinia.

At the beginning of the return march, it had been Rassam overseeing Tirunesh and Alamayu. The boy, everyone said, was bound for a Christian mission school somewhere in Bombay (now Mumbai). By the end of the march, an Englishman had taken charge. And Alamayu's life was heading in a totally different direction.

Here is how Speedy later described what he said was the decisive moment that moved Alamayu under his protection. Alamayu's own mother, who had got to know him during his first visit to Ethiopia around the time of her marriage, he said, had called him to her bedside and asked him to take in her son.

'He had to take a solemn oath to the dying mother before he took the Prince under his care,' one reporter later wrote after hearing Speedy's account. 'The Queen said to him "Have you a mother?" The answer was "Yes." "Then," said the Queen, "swear, may God cause my mother to die a bitter death if I do not act towards this child as my own son." He swore he would so act towards the boy to the best of his ability, and the poor dying mother was satisfied. Since then the child has been under his constant care.'

The queen had begged him to take her son and he had accepted. Simple as that.

Here is how Rassam responded a few years later when he heard someone repeat Speedy's 'dying wish' story.

'As I was the person who had charge of the Queen until her death, and her son also intrusted to my care by Sir Robert Napier until we reached the coast, I trust you will allow me to give my version of the story,' Rassam wrote in a letter to *The Times* in 1872. 'There is evidently a great mistake as to the alleged request of the Queen of Abyssinia that Captain Speedy should take charge of the Prince, and it may be that Captain Speedy, who is not very well acquainted with the Amharic language,

misunderstood the unfortunate lady's wishes.' That was clearly meant as a dig, as Speedy prided himself on his Amharic.

According to Rassam's account, it hadn't been the queen who had asked Speedy to take charge. It was the other way around. It was Speedy who had been pushing for the influential role, even as Tirunesh lay dying, said Rassam.

> I know it as a fact that a few days before her death the Queen complained to me twice of the importunity of Captain Speedy regarding the custody of her son when he used to go to her in my absence with inquiries from the Commander-in-Chief. One day she lifted up her hands to heaven and implored me to save her from being questioned about her son. She said that she had already communicated her wishes to Sir Robert Napier ... and she could not, therefore, understand what Captain Speedy wanted.

What she wanted, Rassam said, was not any particular guardian.

'The only wish which the poor Queen expressed on her deathbed was that her son should continue his Amharic studies which he then was pursuing.' She had chosen the man she wanted to teach Alamayu – Alaqa Zanab, the writer of Tewodros's official chronicle, who had come down from Maqdala with what was left of the royal family. And that was her sole dying request.

As we said at the start, other people made decisions for Alamayu, other people spoke for him. All that we are left with much of the time are other people's conflicting accounts of what happened to him. And there are few more conflicting accounts than Rassam and Speedy's.

Was Speedy pushing his way into another attractive and prestigious role, embroidering a story in order to open the door to further opportunities and adventures? Or was Rassam embittered that the authorities had passed him over and, a few years later, taking the opportunity to vent some bile, to slander the one man who took care of the prince? From the distance of more than 150 years, there is no way of knowing for

sure. Speedy energetically rejected Rassam's account. For now, let's just leave it as a question mark hanging over the story.

In the final days of the Abyssinian Expedition, the version that became canon was the description of the queen's emotional deathbed request. When they got to camp Zula, it was Captain Speedy who took charge. It is worth noting that at this stage there were no orders from London on what to do with the boy, no grand national scheme or plan. Decisions on his future were made on an ad hoc basis on the ground, and he was just picked up and carried along.

Chapter Five

Exile

'When I first entered upon the world of waters, and lost sight of
land, I looked round me with pleasing terrour, and thinking my
soul enlarged by the boundless prospect, imagined that I could gaze
round for ever without satiety; but, in a short time, I grew weary of
looking on barren uniformity, where I could only see again what
I had already seen.'
The History of Rasselas, Prince of Abissinia

Now would be a good time for a brief recap of events, from the point of view of 7-year-old Alamayu. At the beginning of April he was where he had always been, a prince running free in his mountain kingdom. Most young children think the world revolves around them. In Alamayu's case, it did. He could turn on the spot on the summit of Maqdala and see the whole known universe, his father's realm, spread out at his feet in a panorama of peaks and gorges bounded by one horizon. At the centre of that universe was his home, a refuge where his father was king and his mother was queen and pretty much everyone else was there to do their bidding. To cap it all, his father had just returned after months away with a flurry of bright-coloured robes and flashing swords and a caravan of fantastical machines, huge mortars cast by those strange, white-skinned servants.

Then, on 10 April, hundreds more of those aliens came out of nowhere, swarming over the plain at the foot of Maqdala, armed with their own machines – rifles that never stopped firing, rockets that yowled and shining steel cannons carried on the backs of huge Indian elephants. In a matter of hours, the Ethiopian army was gone and his all-powerful father had been brought to his knees. Days after that his father was dead and his home was in flames. The foreign army then picked him up and carried him away as they charged out of the country as fast as they could. The horizon that had been fixed around him for as long as he could remember lurched and kept on shifting. There was barely a pause in the march when his mother suddenly died. Then the foreigners were off again, racing him north to escape the rains and the flash floods. Everything kept changing.

At one point on a mountain pass, the solid world and its horizon would have melted away altogether, and the prince would have got his first full view of the sea. Then down from those mountains, and down on the plains, and the trip shifted from horseback to steam train. Napier, Speedy and the whole senior leadership made the last leg of their journey on the tracks the invading troops had laid from near the foot of the hills to their pop-up basecamp at Zula. The officers sat on makeshift seats draped in the Union Jack. One wagon was packed with the men of Kasa Mercha of Tigray, wondering at the new technology and laughing as one of their comrades tried to run alongside and keep up with the speeding engine. Even Alamayu's countrymen seemed to be celebrating as the air around them filled with the clank of pistons and the roar of the furnace. Alamayu's shift out of the courtly world of steeds and lances into the industrial age of compressors, valves and blast pipes came in a matter of minutes in one steam-powered rush to the coast.

No word, again, from Alamayu himself on how he felt as his world exploded around him. But something had to give. His silence could not last forever. The first sound we hear coming out of his mouth is a scream.

◙ ◙ ◙

Exile

At Zula, the officers and men rushed to lift up the train tracks, pack up the boxes, fire off telegrams to ministries and head home. Ships sailed south to India and north to Suez on the first stop to Europe, dropping off captives and envoys and officers along the way. Milward, the reluctant organiser of the plunder auction, was entrusted with the best bits of the loot, including the gold crown and the royal robes and seal, and told to sail back to Britain as quickly as he could to present them to Victoria. For once, he was delighted at the opportunities for advancement offered by his mission. 'This is glorious, and will do me much good.' Not everyone was so keen to go. Some of the missionaries protested that Ethiopia was their vocation, where God wanted them to stay. But they had little choice. The orders were out. Everyone had to leave. The first press reports, syndicated across all of Europe's major newspapers, followed every move of their journeys home.

In all, 42,699 people (troops and followers) left Annesley Bay for Suez or India during and after the campaign. The British and Indian casualties, as we have seen, were negligible, so pretty much everyone who had come in headed out again.

The animals were not so lucky. A total of 36,094 of them arrived at Zula throughout the campaign, but only 7,421 left at the end of it, according to Holland and Hozier's official count. Thousands of mules had succumbed to sickness and overwork. The British left a trail of dead and dying animals behind them all the way back to Maqdala. At some points, the corpses and abandoned baggage, tents and provisions lay so thickly that they blocked the road. Five of the forty-four elephants had died, suffering from exhaustion and lack of forage and water.

Alamayu, out of sight for so long, started to make fleeting appearances in soldiers' and journalists' reports in the last days of the expedition. None of them dwelt on the loss of his mother or the trauma of his rush out of Ethiopia. Instead, they used descriptions of the little prince of Abyssinia to add touches of colour, pathos and sometimes condescending humour to their articles and accounts.

'The boy was placed in charge of Captain Speedy, and at Zoulla, the two joined our mess,' wrote Simpson in his autobiography. 'This was a great change for the little fellow, as a European table and all its details were new to him. His fingers had been his knife and fork previously. He chanced to sit beside me on the first morning at breakfast, and I remember how I gave him his first lesson in manipulating bread and marmalade. He had not the faintest notion what to do with these articles when placed upon his plate.'

◎ ◎ ◎

Alamayu left his land for good at 7 a.m. on 11 June 1868, on the Indian steamship *Feroze*. On board with him were many of the expedition's leading actors, Napier, Speedy, Count Seckendorff of the Prussian Army, Austria's representative Captain Kodolitsch and Richard Rivington Holmes of the British Museum, alongside the cream of the embedded press corps – Dr Austin of *The Times* and Simpson of the *Illustrated London News*.

On day one of the journey, camp Zula disappeared into the distance. On day two, the whole coastline of Africa faded away in the haze. Their boat followed the route the fictional Prince Rasselas had taken on his escape from the 'happy valley', up the Red Sea towards Suez. The wind blew strong all night, and on day three the weather turned cooler, but most of the passengers still slept out on the deck. Around 10 p.m. on 15 June, Simpson described a 'considerable noise'. Speedy was roused by what he described in his account as an 'agonised scream'.

This is how Speedy described what happened. The scream was followed by 'a cry for me in Amharic', wrote Speedy. 'I found Alamayou in the arms of Lord Napier suffering from the greatest agitation – after quietening with some difficulty his distress, the only solution the boy would give as to the cause of his distress was that Alaca Zarat had the evil eye!'

'Alaca Zarat' was a mangling of 'Alaqa Zanab', the court chronicler and cleric whom Tirunesh had chosen to be Alamayu's Amharic

teacher. He had stayed with the boy through the march and stuck with him on the *Feroze*. The consensus of the Europeans on board was that the cleric had done something to spook him, something appropriately dark, something menacing. Speedy said Alamayu had mentioned the ancient, deep-rooted belief in the malignant power of the evil eye – a curse that, according to some versions of the myth, could be transmitted with a malignant glance.

Alamayu was clearly in a fragile state. Back then, there was next to no understanding of trauma and its associated symptoms, among them night terrors – a condition associated with children aged up to 7 or 8 that can jolt them screaming out of their sleep. Sufferers are often incoherent and inconsolable, without a clear idea of what alarmed them. You can imagine the passengers on the boat – even Alamayu himself – floundering around for an explanation. They settled on blaming an Ethiopian cleric and a belief in exotic curses.

Alamayu 'slept beside Speedy that night', wrote Simpson, 'and next morning would not look at one of his people. Speedy asked him what was to be done with his servants. He [Alamayu] gave a significant jerk with his hand to the gunwale of the vessel, and said, "Throw them into the sea."'

When they got to Suez on 18 June, that is pretty much what happened. The Europeans summarily dismissed Zanab and what was left of Alamayu's little retinue and sent them back down the Red Sea on a boat. The implication of the Europeans' accounts was that they were following Alamayu's wishes, as if that was a decision that should have been left to a traumatised 7-year-old.

◎ ◎ ◎

That was Speedy's account. But here comes the second big question mark over what transpired on Alamayu's journey out of Africa. Zanab himself had a slightly different account when he wrote to the Protestant missionary–explorer Johann Ludwig Krapf a few days later. In his letter, Zanab went back in time to the march down from Maqdala and said the

Europeans had steadily tried to scale down Alamayu's retinue. Rassam had agreed that eight men should accompany the prince, but after Rassam left, orders came down from someone that only two – Zanab and another – should carry on with the journey.

Then came the moment on the boat on the way to Suez. 'When we were still at sea they (Capt. Speedy) told us he (Alam-Ayahoo) does not like us,' Zanab wrote. Speedy told him: 'Remove, do not come near him.' (The letter is filtered through Zanab's Amharic original and the German Krapf's English translation.) 'Then the next day they sent Alam-Ayahoo on shore.' No mention of any confrontation or falling out between the boy and his servants. Over the next few days, Zanab said, Speedy gave them evasive answers, but no full explanation for Alamayu's rejection. According to Zanab, Speedy sent them on their way back to Massawa a few days later. The two Ethiopians never got to see their prince again. 'We have been wrongly treated with great injustice,' the scribe complained to Krapf.

◎ ◎ ◎

How to choose between these differing versions? The case for the defence of the Europeans would argue that their actions at all times were motivated by compassion. They couldn't leave Alamayu behind on Maqdala at the mercy of his father's enemies. When his mother died on the way back, asking Speedy to take care of her boy, their duty to protect him became ever clearer. They had no option but to take him with them as they left. When he was upset by an interaction with his Ethiopian servants, they got rid of those servants and kept on going.

The case for the prosecution might say that there seemed to have been at least a little jostling over who would become the prince's guardian, over who would have full charge of the boy. It was a post that came with serious responsibilities but also substantial opportunities for advancement, as we shall see. If Alamayu was ever to return to Ethiopia, a close association with him would also open up the chance of a future engagement in that romantic land.

Whatever the verdict, the end result was the same for Alamayu. He was now effectively on his own with his European conquerors. Over the past two months, the prince had lost his home, his father, his mother and his country. Days after entering 'upon the world of waters', he had lost his last link to his court and his home with the departure of the man his own mother had picked out to teach him Amharic.

Speedy was clearly in charge. According to his own account: 'The distressing alarm that then seized [Alamayu] rendered him so timid that for the following three months no persuasion could induce him to sleep out of my arms, and so great was his terror that if he happened to wake and find me asleep although still in my arms, he would awake me and earnestly beg me to remain awake until he should fall asleep; and it is only by continued care and tenderness that he is gradually losing his timidity.'

◎ ◎ ◎

Back in Suez, there was no time to worry about former tutors or the last wishes of dying queens. There was a day's stopover in the port, a chance for the Brits to go shopping and record more amusing anecdotes of Alamayu.

'I went on shore with Speedy and Alumaya at Suez,' Simpson wrote. 'We soon had a crowd at our heels when it was known that we had the son of Theodore with us. Speedy's object was to buy some clothes for himself and for Alumaya, so we entered a shop; but the difficulty, in a place like Suez, was to find garments for two such extreme customers. Speedy was 6 feet 6 inches, and the boy was only seven years. Speedy did find a pair of trousers that he could wear, but they suggested to my eye that he had grown a little out of them. Alumaya was more easily rigged out, and in that shop I saw him for the first time in elastic side-boots. A curious change for a young savage.' From that day on, he was plagued with curious crowds and glances whenever he went out in public. Particularly in Europe, there was always an audience keen to catch a glimpse of the African orphan, the refugee prince, the poor little 'savage'.

The Prince and the Plunder

Back on the trail. A night train to Cairo left at 10.30 p.m. on 19 June, arrived in the city at 3.30 a.m. the next morning, then sped northwards to get to the ancient port city of Alexandria by 9 a.m.

Another couple of days and they were off again, just after dawn, on the aptly named steam-powered troop ship the *Urgent*.

Just over a week after Alamayu had left the shores of his country for good, he was out in the middle of the Mediterranean, stuck on a ship with his father's conquerors. They made awkward playmates.

'Sir Robert had a ball made and tried to get Alumaya to play with him,' Simpson wrote. 'If Sir Robert threw the ball, the youngster scarcely tried to catch it, and Sir Robert had to go and pick it up himself. Speedy asked him why he did not run for the ball. His answer was, "Am I not a king's son, why should I go and fetch it?"'

◎ ◎ ◎

On the evening of Friday 25 June, the *Urgent* reached John Bell's old home of Malta, one of the jewels of Britain's possessions. Time for another photo session.

That weekend Alamayu was taken to the quiet shaded alley of Frederick Street, Valletta – number 28, the studio of the island's first professional photographer, Leandro Preziosi. An attendant came with him carrying a change of clothes. Alamayu was halfway in his journey from Ethiopia to Britain. Two photos that emerged from the session caught him in that transition. In both he is sitting against a bare wall on two large cushions or rolled-up carpets. In both, for the first time, he is also staring into the camera.

In the first he is wearing his trademark shell-pendant necklace and his white-bordered Ethiopian *shamma* robe. The Maltese writer Giovanni Bonello described what he saw as 'the tragic, defeated look etched on the child's face'. I see something a bit more like anger and a touch of defiance. He rests his chin on his fist to help him sit still through the long exposure. The anger – perhaps also seen in some of the interactions described by Simpson on the ship – would have also

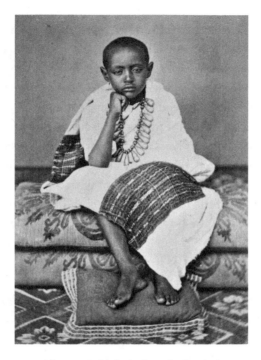

Alamayu in Malta by Leandro Preziosi.

helped him maintain a regal pose amid all the turmoil and trauma. Compared with the Royal Engineers' photo near Maqdala, he looks collected, controlled. Overall, he looks like a prince.

In the next shot, with exactly the same backdrop and framing, he looks smaller, ill at ease, like a little boy. He is wearing a European knickerbocker suit and his new elastic-sided boots. On his lap rests a sailor's straw boater with the name HMS *Urgent* on the silk ribbon.

Alamayu spent more than a week on Malta as the *Urgent* made a quick round trip to Marseille, where it left Napier and his entourage. They jumped on a train and sped across France and the Channel and on to their heroes' welcome in London.

The prince, his new guardian and Speedy's Ethiopian servant, another man called Kasa, lodged at Malta's Union Club, one of the centres of the island's establishment. At the beginning of their stay, Lord

Clarence Paget, Britain's commander-in-chief in the Mediterranean, invited the party to his house to meet his wife and children.

'The children brought in all their toys, and even offered them to Alumaya, but he sat calm and sedate, not unlike the figures of Buddha,' wrote Simpson. 'He appeared to take no notice of anything. Among the toys was one of a cat that played on a harp. The children thought it would interest, but he only gazed at it with an expression of supreme indifference ... When we left, Speedy asked him if he was not surprised at the cat, and he said No, he saw it went with a screw, because he had given a slight wave of the hand, and the cat did not wink, so he knew it was not real.' For now, the boy's composure was holding.

◎ ◎ ◎

Then they were off again on the *Urgent*, past another jewel in Britain's crown, Gibraltar, round the west coast of Europe, over the English Channel and into the natural amphitheatre of Plymouth Sound. Reuters news agency got the scoop on Alamayu's first sighting of Britain, just three months and a day after the fall of Maqdala.

ARRIVAL OF KING THEODORE'S SON
Plymouth, July 14
The Urgent, last from Malta ... arrived here today with Prince Dejatch Alamayou (I have seen the world), the son of King Theodore by Queen Terr Uwork, in charge of Captain Speedy, and attended by an Abyssinian man servant, Shellika Kasa.

The Prince and Captain Speedy landed, and breakfasted with the Port Admiral, Sir W.F. Martin, visited General Spencer, the military commander-in-chief, and then went over the dockyard, lunching with Admiral Superintendent Drummond, and dining with the Port Admiral in the evening.

No direction has been received up to a late hour as to the Prince's immediate movements. He is an interesting little lad, tall for his

age (7-years last April), and already much delighted with England, exclaiming 'Oh this beautiful country. I shall never go back.'

The servant, who is a very intelligent man, on going over the Arsenal, observed with regret 'Theodore should have seen.'

A little Abyssinian slave girl, a protege of Sir Robert, was also brought by The Urgent.

◎ ◎ ◎

We should stop to notice that at least *two* Ethiopian children arrived in Britain on the *Urgent* that day. A 'little Abyssinian slave girl' travelled with Prince Alamayu, though they didn't get a chance to offer each other much company or comfort. A married couple on the voyage told the waiting reporters the two children had been kept apart during the trip as the girl was not of 'blood royal'. Reuters called her Napier's protégée. Another short news story described her a little more oddly as 'the little Abyssinian girl presented to Sir. R. Napier'. Presented like an award? Presented by whom? There's no detail. And that's that. With those few fragments of newsprint, she disappears from the stage. The modern-day Napiers have no record or family memories of her.

She wasn't the only Ethiopian child to make fleeting appearances in the records as the steam launches and troop ships came back from the campaign to ports across Europe. Other youngsters were brought in with the baggage. These days, some might call it child trafficking. In those days, people used jauntier language. The German explorer Gerhard Rohlfs, who had accompanied the expedition, 'brought the King of Prussia a rather curious present from Abyssinia – namely an Abyssinian boy,' London's *Daily News* wrote in a one-paragraph item. 'His Majesty accepted the young gentleman, and has entrusted the care of his education to Professor Strack.'

In Britain, another Ethiopian youngster was less a present, more a household accessory – the ultimate accessory for a fashionable establishment, a little Black pageboy. England's 1871 census recorded a

13-year-old boy called Woolda Somsale (perhaps a mangled version of the name Wolde Selassie), birthplace Abyssinia, working as a page for the Richardson family of 5 Hyde Road, Ardwick, Manchester.

Around the same time, newspapers reported that a Mr Cameron had brought two boys back with him from Ethiopia. At Suez, he had handed over one of them to the wife of a Merchant Navy captain who had brought him to their home in south-east London. That unnamed boy got his moment in the headlines when he dared to take his employer to court, accusing him of cruelty.

According to syndicated press reports in January 1870, the Merchant Navy officer, Captain Jones of Granville Park, Blackheath, turned up at Greenwich Magistrates' Court to defend himself. He told the magistrate the 14-year-old had had it coming.

The boy 'had been taught to read and speak English, and had been petted in various ways, but he had begun to show a violent disposition. On Sunday he struck the cook eight blows with a spoon, and afterwards a blow on the face, blackening her eye. Captain Jones told him he must not strike a woman, when he replied that in Abyssinia they always struck a woman if a woman struck a man, saying that the cook had struck him. He then told the lad to go into the pantry, which he refused to do, and after being put in he made a rush to a basket of knives, conducting himself so violently on being confined as to alarm a visitor, on whose suggestion his legs were tied. The magistrate admonished the lad for his violent conduct, and advised him to return with Captain Jones.'

There were no details on what had provoked the confrontation between the boy and the cook in the first place. From his actions it looks like he was channelling his near-contemporary Oliver Twist, outraged at his harsh treatment in the household of Mr Sowerberry the undertaker.

Yet another boy, a toddler, was found crying in the wreckage of Maqdala. A European officer of one of the Indian regiments scooped him up and brought him back to India, where he got a missionary then a medical education. Years later, Hakim Wärqenäh, also known as Dr Charles Martin, made his own way back to Ethiopia, where he worked as a doctor and, eventually, as Ethiopia's ambassador to Britain.

Dr Charles's story makes a compelling parallel to Alamayu's, offering an idea of what could have happened to the prince if he had turned right towards India rather than left towards Suez when the British ships left Camp Zula.

All the other children – Napier's slave girl, Rohlfs' Abyssinian boy, the pageboy Woolda Somsale, the Greenwich complainant, Cameron's other boy – also no doubt deserve books of their own. It would take a better researcher than this one to track them through the archives. And there is yet another Ethiopian lost boy to come before the end of this story.

◎ ◎ ◎

Alamayu, being royalty, at least got some decent column inches in the newspapers and a line of his own to say on his arrival at Plymouth: 'Oh this beautiful country. I shall never go back', his own version of Miranda's 'O brave new world' in *The Tempest*, and his first recorded words in English. You can't doubt a Reuters reporter, so take it as read that those were the exact words that came out of the boy's mouth. But it is safe to say that the scripted soundbite was not a spontaneous out-pouring of emotion.

He must have been overwhelmed by his first sighting of the huge dockyards, armouries and barracks of Devonport, if not by their beauty, then by their teeming, clanking rush of activity. He had seen the sharp end of Britain's imperial power at the top of Maqdala. Now he was getting a glimpse into the engine that powered the spread of Britain's reach across the globe – the rush of passengers and goods, the dockland trains, the packed streets, the cutting-edge technologies of the steamship yards and the smells and sounds from the bakeries, flour mills and slaughterhouses of the Royal William Victualling Yard from across the water in Stonehouse, pumping out provisions for the Royal Navy's ships. Alamayu had reached one of the epicentres of the British Empire.

He got the full VIP treatment, a welcome breakfast at Admiralty House and then two days of tours of all the main landmarks, including

a steam ship trip up the River Tamar to have a look at Brunel's Royal Albert Bridge, a bit of target practice at a rifle shooting range and another journey across the water to Mount Edgcumbe Park, where he drove around in an earl's carriage then went through the theatrics of inspecting a troop of volunteers and receiving their salute. Alamayu got his first glimpse of Victorian Britain, and Victorian Britain got its first view of him. His visit to the clothes store in Suez had drawn crowds. But that was nothing to the interest he attracted now, even in Plymouth, which was more than used to foreign faces.

◎ ◎ ◎

It is time to pause the narrative for the perennial reminder that for the most part, all we are hearing are other people's accounts of Alamayu – accounts from people who may have had an interest in presenting the image of an over-awed though essentially cheerful and grateful little boy.

As Alamayu did not write his own story, the only way forward is to keep reading even more accounts from even more people, and to highlight some of the ones that don't quite fit in with the prevailing narrative.

More than seventy years later, a man called George Best wrote to the *Picture Post* magazine, reminiscing about when he met Speedy, the prince and Kasa the servant – 'as polished black as was the boy' – on the day they landed in England. 'The little boy was six or seven years old, and I have wondered many times if he tried to carry out his awful threat – when he was a man he would go back to Abyssinia and kill all the Englishmen who were so cruel to his father.'

It is one off-note recalled by an elderly man many years later. But it rings truer than much of the official account. Why wouldn't Alamayu have been angry and dreaming a small boy's dreams of vengeance so soon after he was dragged out of his kingdom by his father's enemies? All around him, those enemies were celebrating his defeat and showing off their battlefield trophies.

'A few words more,' Mr Best of Parkside Villas, Hornchurch, Essex, told the *Picture Post* in 1941. 'I wonder if this article will catch the eye of

anyone who was present when Captain Speed [sic] cut up the pieces of Theodore's tent and gave us each a fragment as a souvenir. Although it is all those years ago, I cannot believe I am the only one left to tell the story.'

◎ ◎ ◎

On the morning of 16 July, Alamayu put on his knickerbocker suit and his HMS *Urgent* straw hat and headed to Plymouth's Millbay train station with Speedy and Kasa. The small party caught the 10.25 South Devon Railway service heading east. Crowds gathered on station platforms to watch the prince go by. The march out of Ethiopia had whisked him through the well-worn list of way stations – Dalanta, Ashangi, Antalo, Adigrat, Kumayli. After his brief interlude at sea, his journey continued past the resorts, market towns and way stations of south Devon – Plympton, Ivybridge, Totnes, Newton Abbot, Dawlish, Exminster. There are worse introductions to England than a winding journey through some of its most bucolic stretches of countryside and coastline at the height of summer. If Speedy had had his *Bradshaw's* guidebook to hand, he could have given Alamayu a garbled English/ Amharic commentary on the passing sights. But Alamayu would have been more consumed with his immediate surroundings – the carriage and the rush and roar of the locomotive as it barrelled him through the foreign landscape at what must have felt like impossible speeds. Today, the steam trains that pull tourists along Devon's heritage trails evoke a slower, simpler, almost pastoral age. But back then, the rail line named its locomotives after menacing classical beasts and speeding wild animals. Alamayu, exiled prince of Abyssinia, may well have spent his first journey through Britain pulled along by the *Lion*, the *Antelope*, the *Gorgon* or the *Tiger*.

Around 12.30 p.m., the train pulled into Exeter St Davids station and the party took a break in the first-class refreshment saloon as they waited for a connecting service. Even there, Alamayu couldn't escape the obsessive gaze of the foreigners pressing around, among them the correspondent of the *Exeter and Plymouth Gazette*. The unnamed

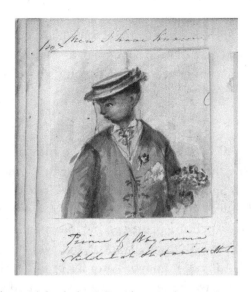

'Prince of Abyssinia' sketched at St Davids station by an artist named Tucker. It is marked 1871, so could be from another visit. But his youthful appearance, straw boater and outfit suggest it could have been mislabelled and could come from this trip.

journalist spent more than an hour chatting to Speedy and staring at the prince for the benefit of the newspaper's readers.

'His name is Dejatch Alamayon, meaning "I have seen the world" – a prophetic name likely to be fulfilled,' read the article, which was syndicated widely in the days that followed. 'He is tall for his age, but touchingly childlike in manner; dark copper-coloured, with jet black hair cut close to the head. He has thick, prominent lips, but in all other respects his features are of the pure Caucasian type, and he is beyond question a pretty, pleasing child, and such a one as attracts in a moment the sympathy of all who love children.'

And here starts what will become an all-consuming British obsession with the size of Alamayu's lips and his exact placing on the racial scale from African 'Negro' to 'purer' Caucasian. In this case, the correspondent felt that the lips counted against the boy while the rest of his features moved him into safer, whiter territory. The journalist was capable of even finer demarcations in the description of the rest of Alamayu's features.

'His forehead is rather high, broad across the upper part of the brow, and largely developed at the centre and in the region of the frontal sinus, so that a phrenologist would assign him good reflective faculties, very large memory of events, and an unusual bias for perception and observation, while the calculating and musical organs are very low,' read the article. 'He has a fine, keen temperament, and a large, high brain, especially marked in the seat of self-esteem, love of approbation, and imagination, according to Spurzheim. His eyes are intensely black, large, and singularly striking; he has, in spite of the prominence of the lips, a small mouth, and his chin and cheeks are rounded off in the dainty pretty manner, which is so very interesting in young children. His ears are larger than those of an average English child, but not large enough for a personal defect, if his hair were grown.'

Again with the lips, and now with the ears and the brain. Welcome to the weird and bigoted world of phrenology, the then largely respected pseudo-science that set out to read a person's essential characteristics, and often their racial ranking, from the bumps and shapes on their skull and other physical marks and characteristics. Spurzheim was the German doctor Johann Gaspar Spurzheim, who had popularised the name phrenology and spent much of the early nineteenth century promoting it throughout Europe and then America, where it was enthusiastically used by some to demonstrate the superiority of European skulls over those of 'lesser' races and to justify prejudice and slavery.

Let's turn the gaze away from Alamayu for a bit and onto the reporter from the *Exeter and Plymouth Gazette,* sitting in the hot station for more than an hour, scribbling manic notes and staring at a little boy's head. The local newspaper hack had the son of the Emperor of Ethiopia, one of the key players in the story of the moment, sitting right there, with an Amharic speaker in Captain Speedy who could have interpreted. But instead of trying to interview the prince, the article focused on the size of the boy's sinus.

After a while the reporter noticed the boy was getting restless:

The Prince and the Plunder

During the hour he waited the little Prince showed no sign of irritability of temper or any trait that might indicate he could make himself troublesome or become difficult to manage, and Captain Speedy speaks of him in the highest terms as an affectionate, gentle, and manageable child. Shortly after one o'clock the poor little thing sitting in a chair by himself, grew uneasy at the delay, and getting down from the chair spoke to the captain in a plaintive tone, and he was hardly reassured until the captain took him caressingly to him.

Alamayu may have had enough of the strange person staring at him. Like millions of children before and after him, he may have also been wondering when the journey would be over, when they would get there. Either way, he was saved when the news came that the London and South Western train was approaching the station. Alamayu formally shook hands with and said goodbye to everyone he had met, then headed to a first-class waiting room and finally, into the carriage.

And then they were off again on a summer afternoon's charge through the West Country. Debre Tabor, Qorata, Massawa, Maqdala and the mythical home of Prince Rasselas were far behind him. Now it was Honiton, Axminster, Chard Road, Crewkerne, Yeovil, Sherbourne, Tisbury, Salisbury, down to Bishopstoke junction and down further to another epicentre of empire, the naval powerhouse of Portsmouth. They got in at 6.30 p.m., around eight hours after leaving Plymouth, and got on the tram to the waterfront. There they stepped into an even more exclusive carriage, Her Majesty Queen Victoria's sleek-lined, mahogany-hulled, steam-powered yacht *Elfin*, which paddled them regally across the waters of the Solent to the Isle of Wight.

Chapter Six

Arrival

'After this [the prince] lifted up his head, and seeing the moon
rising, walked towards the palace.'
The History of Rasselas, Prince of Abissinia

Queen Victoria had been following the reports of the Abyssinian
Expedition in her daily dispatches and the newspaper stories, and had
picked up on the few passing references to a child, Tewodros's son. She
got her staff to send out a telegram expressing an interest in the boy,
which reached Napier in Alexandria.

Victoria, of course, would not come to Alamayu. So Alamayu came
straight to Victoria. He had seen Britain's full military force in action and
taken a peek behind the curtains at the machines that powered it. Now,
just two days after docking in Plymouth, he was brought straight to the
centre of that power, to the emblematic commander of Britain's armies
and ships, and the mother of all its dangerous romantics and dreamers.

Alamayu got off the *Elfin* and, like Prince Rasselas before him, lifted up
his head and walked towards the palace – in this case Queen Victoria's
seaside retreat on the Isle of Wight, Osborne House. This royal residence
could not rival Maqdala for panoramic drama. But he must have still been
overwhelmed as he looked up across the expansive luxury of the grounds,
past the statues and terraces and fountains, up to the glowing peach-
coloured facades of the staterooms and Italianate towers. Victoria, who
had been sitting out painting under the trees as the sun slowly headed
to the horizon, came down to the lower terrace with her daughters, the

113

princesses Alice and Helena, and other members of her family to meet Alamayu and Speedy. Napier, who had caught a train down from London to the Isle of Wight, was there to formally introduce them.

More than ten years after Tewodros's earliest diplomatic entreaties, the representatives of the royal houses of Abyssinia and Britain finally got together in a holiday estate set above a quiet bay off the south coast of England, its gardens leading down to the shores of the Solent.

Victoria's imagination was stirred by the picturesque sight of the little orphan next to his giant protector.

'Little Alamayou is a very pretty, slight, graceful boy of 7 with beautiful eyes and a nice nose and mouth, though the lips are slightly thick,' she wrote in her journal that night. Again with the lips. 'His skin is a dark bronze. His hair, which has been shaved, is crisp and curly. There is nothing of the negro about him. I kissed him which he returned. He can say one or two words in English.'

Victoria's romantic side had always drawn her to tales from the furthest reaches of her empire and beyond, particularly when it came to stories of orphans and other stranded children. She found her new visitors particularly compelling.

'Captain Speedy, who has brought him, says the poor boy will never leave him for a moment, and always keeps near him,' Victoria wrote. 'They are an extraordinary contrast, Captain Speedy being 6ft. 6! and having red hair.'

The queen was then in her fiftieth year – she had been born around the same time as Tewodros – and had taken only tentative steps back onto the public stage since the death of her beloved husband Prince Albert in 1861.

Beyond the shores of the Isle of Wight, her country was in a state of political tumult. It was on its third prime minister, the Conservative Benjamin Disraeli, in less than three years, and he would be gone by December, replaced by the Liberal William Ewart Gladstone. Huge political forces – from Irish nationalism to the 1867 Reform Act that had opened up the electorate – were transforming the country around her.

She kept up with everything, but at the time her most pressing concerns were personal and internal. Since her bereavement, she had suffered from sleeplessness, anxiety and a range of psychosomatic

ailments. The thought of appearances at public ceremonies left her in a panic. She stayed in Osborne and other estates, and surrounded herself with her family and close confidantes. Seven years after Albert's death, her world was still drenched in the dark poetry of the protracted grief that would dominate her reign. She dressed in black and almost revelled in her bereavement. 'The violent grief is past – I almost grieve for that, for there is a sweetness even in that, but the constant black and constant clouds are ever abiding,' she wrote to her attendant and fellow widow Lady Waterpark.

This was the queen that met Alamayu on his third day in Britain in 1868. As Speedy started telling her his stories of the last few months – his tales of Tewodros's massacres and cruelties, of Tirunesh's deathbed plea, of the sensitive boy's traumas and strong attachment to his new guardian – Victoria proved a particularly engaged and empathetic audience.

That evening, Alamayu withdrew while Victoria dined with Napier and her family, then Speedy brought him out again for a final meeting. After the last goodnights, he was taken to the adjoining Osborne Cottage where, presumably, he spent his first night on the island.

The next day, she wrote to Sir Stafford Northcote, the Secretary of State for India, who was in charge of deciding Alamayu's fate. From that moment on, the vagueness over Alamayu's future cleared. Victoria told Northcote how important it was 'to the wellbeing of the dear and interesting son of Theodore' that he should on no account be removed from 'the kind, judicious and almost maternal care of Captain Speedy'.

'The child is extremely nervous and his reason even might be endangered if the poor little helpless orphan was removed from the one person to whom he seems to cling most tenderly,' she added. And that was that. Speedy was guardian. More immediately, Victoria also felt Alamayu should stay for a while, close by on the Isle of Wight, a holiday island of beaches, bracing blue-grey seas, long blustery walks and healthy childhood adventures.

That same morning, as the summer heat started building after breakfast, Victoria met Alamayu again and gave him a peach. He was 'so nice and gentle' and seemed to enjoy the fruit. Less than two weeks later Alamayu and Speedy were back again at Osborne, both of them

wearing 'Abyssinian dress'. Victoria gave the boy a watch and chain and the man a diamond scarf pin. Alamayu later also got a photograph of the queen signed 'From his affectionate friend, Victoria'.

The government soon nailed down the legal and financial details in London. Given 'the great delicacy of Alamayou's constitution and his extreme excitableness', read Northcote's memo on the issue, the boy would stay on the Isle of Wight. Speedy would get a salary of £300 a year to act as the prince's official guardian, on top of expenses 'which he has been desired to keep down to about £400 a year'. Together, in today's terms that is about £44,000 a year, not a bad income.*

◎ ◎ ◎

The *Isle of Wight Observer* had taken only a passing interest in the nation's Abyssinian crisis over the past months and years. Its pages had been dominated by local affairs, church fetes, tide tables and listings of the guests at the major hotels. From time to time, it had reprinted some of the international coverage and lobbed in a bit of its own invective in the editorial columns, decrying the 'African tyrant' and celebrating 'one of the most just wars in which England has ever been engaged'.

Everything changed at 6 p.m. on 17 July 1868 when two notable visitors arrived in the island's small port of Yarmouth, fresh off the boat down the coast from Osborne. 'Prince Alamayou, the youthful son of the late King Theodore', would be staying at the Royal Hotel in Alum Bay for his health, accompanied by Captain Speedy, the local newspaper reported.

And with that, the western tip of the Isle of Wight, with its great houses and tree-lined lanes and chalky cliffs, took centre stage in the grand geopolitical tale.

The prince spent his first few days in his new home getting to grips with 'the fashionable game of croquet', the *Isle of Wight Observer* reported. He played cricket on the green with the local gentry, who gave the young visitor a 'hearty welcome'. On Sunday he went to church in

* That is using The National Archives calculator. Using the method used by Sathnam Sanghera in his book *Empireland*, we are talking closer to £450,000 a year today.

the village of Freshwater and a day later met more of the great and the good at a reception at Norton Lodge. In the days and weeks and months that followed he learned blind man's buff and a game called 'touch and away', took up horse riding, went fishing near The Needles and grew to love watching and following the hunt. It must have been something of a relief as his day-to-day life switched from macro to micro, from the broad sweep of imperial manoeuvres to the minutiae of the parish pump. He had another photo session, back in Ethiopian dress, in the studio of the renowned portrait photographer Cornelius Jabez Hughes in the seaside town of Ryde.

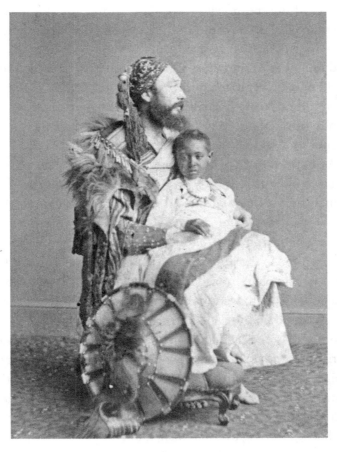

Speedy and Alamayu photographed by Cornelius Jabez Hughes on the Isle of Wight.

The Prince and the Plunder

Speedy, in his position as official guardian, sent back reports to the India Office. 'The boy is in very good health which may be owing to the enjoyment of sea air, as well as of sea bathing,' he wrote. 'I have also occupied myself in teaching him to swim, he having lost his repugnance to sea water. His disposition is excellent and his former shyness is replaced by a most winning manner. He is remarkably intelligent for his age and makes rapid progress in English.' Speedy also started keeping a careful record of expenses. One black velveteen jacket, vest and knickerbockers by John Morgan & Sons Tailors and Habit Makers, by Appointment to the Queen, £2 and 12 shillings. Another entry listed lodging, washing, boot repair and beef alongside the perfect *Just William* touches, half a pound of sausages and the repair of a broken window – total cost £6 15s 6½d.

Speedy spent more and more time at Afton Manor, the grand wood-panelled home of wealthy landowner and local master of the hounds Benjamin Cotton, a relation of his former commanding officer in India. And in the blink of an eye, or so it seemed, the dashing 31-year-old giant found himself engaged to the daughter of the house, 26-year-old Cornelia Cotton, known to her friends and family as Tiny.

By 15 December 1868, Speedy's whirlwind romance reached its whirlwind conclusion with a wedding at All Saints parish church. Alamayu was one of the groomsmen, 'a part which he performed admirably – looking and behaving extremely well', Cornelia's mother, also called Cornelia, wrote. As the Speedys headed off to the Continent for their honeymoon, Alamayu moved in with his new quasi-grandparents at Afton, where he got to wander and ride around relatively freely in its wooded parkland on the bank of the River Yar. His first-floor bedroom looked out across trees and lawns to an ornate pond. He celebrated his first Christmas under the Gregorian calendar surrounded by presents. (Ethiopian Orthodox Christmas falls on 7 January without the orgy of gift giving.) He particularly bonded with Mr Cotton, through their shared love of horses. '"Me ride today?" was often the first question he asked when appearing for breakfast, and great was his joy when told that a canter would be a reward if lessons went well,' Mrs Cotton wrote.

Arrival

He took a few falls following the fox hunts on his horse 'Blackie' but got back on again and kept going.

His progress in English was shown in his first recorded piece of writing, a letter to a friend that somehow made it into the local press:

> My dear ---, --- You got plenty butterfly in the school? no got in here. too much cold. Did you see snow and make snowmen. me like it very much. me ride one pony oh so very nice. One day me go to hounds. the fox run away and the dogs kill him Give my love to Charlie Good bye.
> Alamayu Simyen

No more 'Prince Alamayu'. His mother's homeland was now his surname, a curious choice as the usual Ethiopian practice would have been to call him Alamayu Tewodros, using the father's name. No doubt it was imposed on him, as his new guardians tried to distance the boy from Tewodros, who was still portrayed as an unstable monster in the British accounts of the campaign. Alamayu's repeated use of 'me' is also curious – presumably it would have been an easy enough error to correct, unless that is what his guardians thought a little African boy should sound like.

◎ ◎ ◎

So far, so picture-postcard, so idyllic. But where was Alamayu's mind in all of this? As ever, we have to catch hints through other people's accounts.

He still drew crowds and felt increasingly uncomfortable whenever he was out in the public gaze. Mrs Cotton had been among the gentry that had welcomed him at Norton Lodge in the days after his arrival. She remembered the 'peculiarly tall form of the guardian, bending over the tiny child, whose hand grasped that of Captain Speedy's in a sort of bewilderment and terror, while his eyes bent on the ground with a painful expression of timidity'. The writer of an article in the *Cheltenham Chronicle* recorded how tourists and other rubberneckers dogged the

boy whenever he left his hotel. Alamayu would keep 'up with Speedy by semi-run, holding his hand timidly, as children usually do when followed by strangers'. A crowd rushed at him at Yarmouth when he was coming back from one of his trips to Osborne. He turned round and bowed at all of them. Mrs Cotton hardly helped by publishing her own memoirs of her time with the boy a couple of years later. She gave a half apology for the encroachment on his privacy at the back of *Anecdotes of Alamayu*, then rowed back slightly. 'Alamayu can scarcely be considered as a private individual: rather must he be regarded as somewhat of public property.'

It is thanks to those memoirs we know he continued to suffer from sporadic panics and terrors, even during the day. That winter, the Cottons told him to go outside and play with his hoop:

> He bounded out ... perhaps imagining that we were going to accompany him, but scarcely had a minute elapsed when we were horrified by hearing screams such as we never heard before, shrill, piercing and harrowing. We rushed out and found the dear child apparently paralysed with terror, trembling from head to foot ... We took him in our arms, soothed, quieted, and then questioned him, but nothing satisfactory could be learnt. He had seen nothing, heard nothing ...

Speedy told Queen Victoria he thought Alamayu was haunted by his father's massacre of prisoners on Maqdala. Check back a few pages and there are plenty of other bad memories to choose from.

Speedy, with no experience of bringing up children and his own fractured childhood behind him, may not have been best placed to help Alamayu deal with his day terrors, night terrors and trauma. Years later, the artist and socialite Dorothy Tennant (later the wife of Henry Morton Stanley) wrote a diary entry recording a conversation she had had with Speedy while visiting the Isle of Wight, when he described his parenting style.

Speedy told her that Alamayu was always brave, but sometimes a little less than truthful. (Unlike every other child his age, of course.) At one point Alamayu broke a window, and then swore he hadn't. Speedy's

response? The giant bearded captain picked up some stones and started smashing windows himself. The windows weren't important, Speedy told the boy. It was the lie that mattered. From that moment on, whenever Alamayu broke anything, he rushed up to his guardian to confess. Another time when Alamayu told a fib – according to Tennant's journal – Speedy had someone take the boy's clothes off, wrapped him in a blanket and set the trousers, shirt and jacket on fire. The clothes, Speedy explained, had been polluted by Alamayu's lies. A distraught Alamayu hugged him and promised to be honest. Yet another time, Tennant wrote, a nurse was brushing Alamayu's hair and snagged some of it in the comb. Little Alamayu turned round and bit the woman. Speedy stepped in to administer his own brand of discipline. He did not believe in corporal punishment, he explained. Instead of beating the boy, he said, he would beat himself whenever Alamayu was naughty. Speedy took out a whip and started doing just that. Later on, when they were both out swimming, Alamayu came to Speedy in tears, crying out, 'Drown me, drown me. I make you unhappy with my badness.' Speedy may not have believed in corporal punishment, but there are other ways to leave a mark on a child.

From other accounts – no surprises here – it was clear that Alamayu hankered after his first home. Two of his treasures were his mother's old Bible and Book of Psalms, which he took out proudly to show to visitors.

He spent some time playing with local children, but never really understood their fascination with toys. The bulk of his world was populated by Victorian adults and Victorian giants – not just in stature. Victoria's regular residence in Osborne had turned the island into one of the centres of high society. Alfred, Lord Tennyson – the poet laureate, whose family was close to the Cottons – lived nearby in his Farringford estate, with its beautiful drawing-room and French windows opening out onto stretches of the lawn sweeping down to the sea. Speedy and Alamayu were regular visitors. The first time Alamayu saw the profusely bearded Tennyson sitting in the garden, he shouted out, 'Papa, papa, papa' and warned the poet's wife there might be an elephant hiding in the holly bush.

The young boy and the eminent author of 'The Lady of Shalott' and 'In Memoriam A.H.H.' (one of Victoria's favourites) found things to talk about. 'There's one thing I don't like in England. We Abyssinians look angry at a man when we hate him, but you English smile at people while you are hating them. You don't speak the truth with your faces,' Alamayu told the poet. 'He is quite right,' Tennyson told his family later. 'There are some people who even kiss to disguise their hatred. The deeper the hate with such folks, the heartier the kiss.'

Alamayu was back in Farringford in September, while Tennyson was busy working on his idyll 'The Holy Grail'. (I've checked: the poem has a bright boy-knight, an Arthurian pavilion and a lightning storm on a Maqdala-like mountain, but no specific mentions of Abyssinian princes.) The Irish poet William Allingham was there to watch and play. 'Little Alamayu sits on my knee and looks at a book of animals. Zebra especially interesting to him ... The Elephant he calls "zoon".'

Allingham, today better known for his journal than his poetry, makes an invaluable witness. In October, he spotted Alamayu out in the street. 'Two of the De Havilland children came up, whom he kissed, and then came the snuffy old postman with his bag, and the little prince kissed him too.'

The young poet reported a snatch of conversation that showed Alamayu and the servant Kasa were more than capable of turning the tables and laughing at the inane conversation of their bearded old guardians and crinolined hosts.

Speedy the other day overheard [Alamayu and the servant Kasa] amusing themselves by mimicking English people.
Attendant comes up in the character of an English lady, shakes hand – 'How you do?'
Alamayu replies – 'How you do?'
Attendant. – 'How you like this country?'
Little Prince. – 'Ver' mush.'
Attendant. – 'Ah! you like ver' mush' And so on.

Arrival

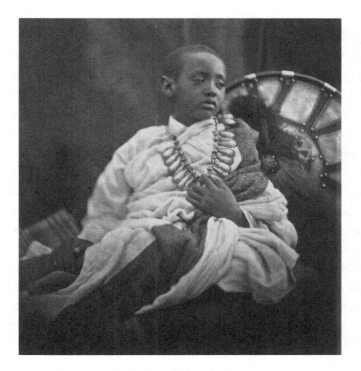

Alamayu on the Isle of Wight by Julia Margaret Cameron.

Allingham also popped by when Alamayu was preparing to sit for another set of portraits, these ones by another Victorian giant, the pioneering photographer Julia Margaret Cameron.* The Irish poet played around for a while in Cameron's studio in Freshwater Bay, bounced Alamayu on his knee, then sat back as the shoot started to take shape. Alamayu dressed up in a purple shirt and his famous teardrop necklace. His guardian climbed into his full Abyssinian costume, including lion-skin mantle and curved sword, with Kasa alongside in similar attire.

* Julia Margaret Cameron was the great-aunt of Virginia Woolf. Just over forty years later, in 1910, the writer took part in the infamous *Dreadnought* hoax – a high-society prank where Woolf, her brother and a group of friends blacked up and dressed as a party of visiting Abyssinian royalty to trick their way onto a British battleship. 'Abyssinian' was a costume for the British upper classes – across the generations.

Speedy grumbled a bit, but Julia Cameron quickly moved them all through a series of poses – one with all three of them in what is almost a family grouping, at least three with Alamayu on Speedy's knee, another four with the boy on his own and one extraordinary shot with Speedy crouched over a prone Kasa with a spear pointing at the servant's neck. With that last one, titled *Spear or Spare*, you couldn't ask for a better illustration of the overblown Victorian imagination. It shows an almost pornographic interest in man-on-man violence – specifically white man on Black man violence – and peril. The others are more tableaus of heightened sentiment and exoticism – the contrast of the tiny boy with the towering man, the careful arrangement of Alamayu among the other props, the same lion's-mane shield, sword and spear as the photos near Maqdala, as well as gauntlets, chains, embroidered caps and, most strangely of all, what looks like a white baby doll on a cushion. Whole essays could and have been written on the colonial gaze, the imperial frame. Here there is just the space to pause a while and wonder what it must have been like for now 8-year-old Alamayu to be back as a detail in someone else's piece of Abyssinian roleplay, just a matter of months after the real-life bloodshed. He looks bereft and forlorn, once more utterly alone, which is no doubt exactly what Julia Cameron was trying to evoke for her artistic effect.

◎ ◎ ◎

Just room for one more Victorian giant: Charles Darwin was also around on the Isle of Wight, largely pleading poor health so he could get on with his studies, including work on his upcoming book *The Expression of the Emotions in Man and Animals*. He met Alamayu and quizzed Speedy about the boy's and other Ethiopians' expressions and behaviour during his research.

From the book, we learn that Ethiopians shrug their shoulders, jerk their head to the right with a slight cluck to say 'no', throw their heads backwards and raise their eyebrows for a 'yes', place their right hand to the forehead with the palm facing out to show surprise and sometimes

laugh so much that tears fill their eyes. A close-up, gesture-by-gesture portrait of our prince, courtesy of the father of evolutionary theory.

◎ ◎ ◎

Just as Alamayu was settling in and getting used to his new home on his holiday island, the ever-restless Speedy applied for a job more than 4,000 miles away from Freshwater. In the early months of 1869, newly married, with a new future ahead of him, he was formally appointed district superintendent of police in Sitapur, northern India.

There were quick consultations with London, and the powers that be decided that the current arrangements should continue for now. The boy was to stay with his guardian for at least another two years and travel with him to India on the same financial arrangements – a £300 salary for Speedy plus £400 a year in expenses, paid out of the Imperial Exchequer.

Things sped up again as the extended Speedy–Cotton family went into full planning mode. Provisions were bought, crates were packed and new clothes were ordered for Alamayu. He himself was emotionally torn. He wanted to go with Speedy, but he didn't want to go without his other new standby, Benjamin Cotton.

'In answer to our frequent questions on the subject, he would very sweetly say, "Me glad to go, – me *varry* sorry to leave you;" and then flinging his arms round "Grandpapa's" neck, he would coaxingly add, "*You* go with me to India, Grandpapa, then me *varry* glad to go,"' wrote Mrs Speedy in her account, which includes a lot more in the same vein on the boy she called 'the little stranger', 'the tiny little black child' and 'the little forlorn Abyssinian'. Like many chroniclers of her age, she liked to take several spoonfuls of sugar to help the narrative go down. In between the sentiment she also produced a detailed account of a grave, conscientious and deeply vulnerable child bursting with affection, who loved Bible stories as much as outdoor adventures and was constantly reaching out to passing father figures.

The night before they set off, Alamayu was busy writing out autographs for friends and other people who had requested a memento and

a piece of his writing – perhaps including the one that opened this book. As the night wore on and a servant came in at last to take him to bed, he threw down his pen, burst into tears and rushed over to Mr Cotton again for a hug. 'Words of soothing seemed powerless to reach or check this long pent-up grief, the child refused to be comforted, and actually sobbed himself to sleep on "Grandpapa's" knee – the spot of all others which he deeply loved to occupy.'

The next morning, a year after Alamayu's steam-powered dash to Britain, it was time to dash back again, following pretty much the same route in reverse. Speedy, the new Mrs Speedy and their young charge packed up their island life and set out from Southampton on Saturday 26 June, on the P&O paddle steamer *Ripon*. (There is no mention of the servant Kasa. Like the little 'Abyssinian slave girl' he arrived with, he abruptly disappears from the main storyline, Alamayu's last Ethiopian link to his past gone.) Details of Alamayu's departure had been printed in the press, so another crowd gathered to see him off, many of them asking to shake his hand. Mrs Cotton caught her last sight of them on deck, Alamayu in Speedy's arms, waving a white handkerchief.

Back on the Isle of Wight, the Speedys' friends came to the waterfront to watch the *Ripon* go by. Tennyson's son Hallam and a school friend borrowed the cover from a lady's carriage and waved it in the air like a flag. Old Benjamin Cotton kept apart from the little gathering and stood out on the pier alone until the boat disappeared over the horizon.

The first leg of the journey was a familiar one – the English Channel, skirting the Bay of Biscay, back past France, Spain and Portugal, squeezing past Tangiers to stop at Gibraltar, then Malta and Alexandria. The direct Suez Canal route through to the Red Sea wouldn't be open for another few months. So, from Alexandria the party took the same rail route across Egypt, and then back out onto the Red Sea on another boat, down past the coastline of Africa. We will never know if Alamayu realised that his old mountain homeland was drifting past him to starboard, just out of reach. He fell ill on the approach to Aden – though he begged the Speedys and fellow passengers not to mention it in their letters back home, in case the news got back to Mr Cotton. The boat kept going, heading south and then east towards India.

Chapter Seven

Interludes

'They approached the city which filled the strangers with astonish-
ment. "This, said Imlac to the prince, is the place where travellers
and merchants assemble from all the corners of the earth. You will
here find men of every character, and every occupation ... You will
see all the conditions of humanity."'
The History of Rasselas, Prince of Abissinia

Turning back the calendar a few months and shifting the focus away
from the shores of the Isle of Wight, Abyssinia fever burned bright
across Britain, from the great chambers of Parliament to the nation's
public houses and music halls, as soon as news of the victory came puls-
ing over the telegraph wires.

Prime Minister Benjamin Disraeli stood up in the House of Commons
in early July to praise 'one of the most remarkable military enterprises
of this century'. He gave a colourful account of the campaign, right
up to its climax where 'the standard of St. George was hoisted on the
mountains of Rasselas' – a slightly confusing mash-up of references as
St George is as venerated in Ethiopia as he is in England, if not more
so. The expedition, Disraeli said, would 'add lustre to the name of this
nation, and ... beneficially influence the future history of the world'.

At the Theatre Royal, Holborn, *The Abyssinian Duet* sung by Miss
Fanny Josephs and Mr G. Honey was 'rapturously encored' night after
night. A whole musical extravaganza, *The Fall of Magdala*, performed
at London's Agricultural Hall, promised a grand descriptive quadrille
complete with military effects, imposing martial marches and four

military bands. A great orchestra performed pieces evoking scenes from the 'warriors of Britain and the martial sons of India encamped on the plains of Hindostan' through to 'the revels of the African savages in the wild fastness of their native land'. Another piece, *The Abyssinian Expedition*, had musical passages representing mortars and Snider rifle fire. You can still pick up the sheet music, arranged for piano or violin and cello, for about a tenner.

Elsewhere, the briefest of references to the victory was guaranteed to raise a cheer at rallies for the upcoming general election, whatever your political persuasion. There was a gala day at Crystal Palace's exhibition halls and pleasure gardens. Napier and his wife stood out in the royal box, accepting the cheers of 10,000 people packed outside. Fountains shot out 200ft jets of water that drifted in the breeze, turning the spray into rainbows. As night fell, the skies filled with fireworks.

On 27 July, the newly ennobled Lieutenant-General Lord Napier of Maqdala took up his seat in the House of Lords, then went out to celebrate with a dinner in his honour at the Oriental Club. The night after that was a much more intimate affair. All the boys from the great expedition were back in town – everyone from the chroniclers Holland and Hozier to Lieutenant Prideaux representing the prisoners and, once again, Richard Rivington Holmes of the British Museum – and they all got together for a dinner of their own at Willis's Rooms, King Street, St James's.

Over the weeks and months that followed, honours for almost all of them rained from the skies. By mid-August 1868 Britain had created, by *The Times*'s own reckoning, two new Knights Commander of the Order of the Bath (KCB), twenty-six Companions of the Order of the Bath (CB), one major-general, six aides-de-camp to the queen (three of them conferring colonelcies), nine other colonels, seventeen lieutenant-colonels and thirty majors. And the public wanted more. Letters and articles filled newspaper columns listing the officers and officials who had been unjustly excluded. Crowds, desperate to celebrate a clear victory abroad after the struggles in Crimea and India, flocked to see anything even remotely connected with the Abyssinian exploit.

For sixpence, you could head into the Crystal Palace and see Hammel, 'the favourite charger of the late King Theodore', brought back to Britain by the enterprising men of the 33rd Regiment. The horse was put on show daily alongside a small exhibition of relics including 'Theodore's shield', a drinking horn and a set of Dr Blanc's fetters.

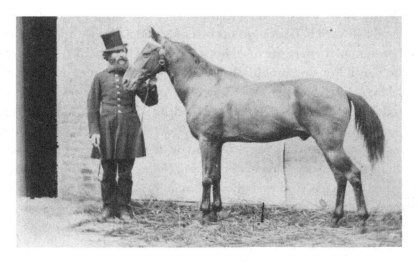

Tewodros's 'favourite charger', Hammel, was put on show in Britain after the campaign.

Similar exhibits popped up wherever soldiers came home and started showing off their souvenirs. 'King Theodore's shield' was also among the star attractions at the Welsh Fine Art Exhibition in Ruthin, Denbighshire, alongside his gauntlets, through August and September. Leeds hosted a National Exhibition of Works of Art to raise funds for its new general infirmary, including exhibits loaned by five returning soldiers. This was how the bulk of the plunder came to Britain – small pieces stuffed into pockets and packs. In Leeds, J. Hannan of the 3rd Dragoons lent a string of coloured beads; H.D. Birchall contributed two manuscripts, a shell projectile made of antimony and pewter, a brass cannon ball and a fragment of chain worn by an Ethiopian captive;

W. Martin of the 33rd Regiment, another portion of chain and a piece of brocade from the queen's robe; Private T. Goodwin, an anklet, a silver ornament, a pistol, a drinking horn, a comb, a fragment of chain armour and four strips of manuscript; Mr E. Smart, two illuminated scrolls and fragments of a third.

The British public's first chance to see substantial objects from the Maqdala treasury came back in the capital. Grumpy Lieutenant-Colonel Milward had brought his box of Maqdala treasures to Britain and presented them to the royal household who had, in turn, lent them to the South Kensington Museum, today better known as the Victoria and Albert Museum, the V&A. The front-page newspaper ads blared: 'KING THEODORE'S CROWN AND ROBES, by command of Her Majesty, with other Abyssinian spoils now EXHIBITED'. Mondays, Tuesdays and Saturdays were free and on Wednesdays to Fridays you could guarantee yourself a better class of fellow spectators by paying a sixpence entry fee. And no bones about it: the exhibition was an exhibition of *spoils*. The cultural institution set up to be a 'schoolroom for everyone', bringing together the best of art and design, had turned, for a period in 1868, into a display case for plunder.

The poet and journalist Edwin Arnold, who reviewed the show for *The Gentleman's Magazine*, had a fuller phrase for the exhibits – *spolia opima*, the term used to describe the rarest and highest level of classical plunder that a victorious Roman general stripped from an enemy commander whom he had himself defeated in combat. Arnold meant it sarcastically – there had been no such romantic climax to Maqdala. His main reaction to the actual exhibits was condescension, expressed in overblown prose.

'I am sorry for Theodore as I stand gazing at this case full of tinsel and royal rubbish ... these be but paltry belongings for a "king of kings" however hard-up,' wrote the author of a now-largely-forgotten eight-volume collection of pseudo-Buddhist blank verse.

'Here is a blue robe hung with what look like fire-extinguishers, and warlike effigies punched rudely out of silver at which a Wallachian peasant dressed for a holiday would turn up his nose,' Arnold wrote of

the royal cloak seen here on the right of the illustration taken from his article. Arnold scoffed that he had heard that Tewodros had originally meant to give the robe to Queen Victoria as a love token – based on the false report circulating at the time that the king's spurned letter to her had been a marriage proposal. The robe on the left was yellow, woven out of gilt and silk thread, embroidered with silver-silk flowers.

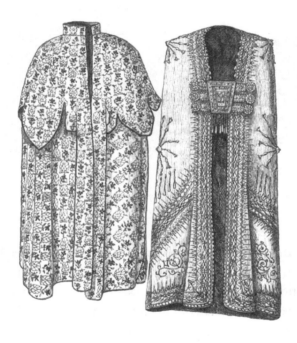

Maqdala robes on display in the South Kensington Museum, 1868.

Arnold saw it all as slim pickings for such a grand venture as the Abyssinian Expedition, and a disappointing legacy for the grand Emperor of Abyssinia – though of course this was just a small sample and other boxes of Ethiopian treasures had only just started landing with a series of thumps across the capital. 'Here a grubby "tarboosh", with silver bars, sorely the worse for wear,' Arnold wrote, continuing his

description of the Kensington show, 'also a melodramatic crown of the stage pattern' – the crown to the left and the 'tarboosh', or royal cap, to the right of the illustration below. He didn't deign to mention the silver filigree slippers with the curled-up toes.

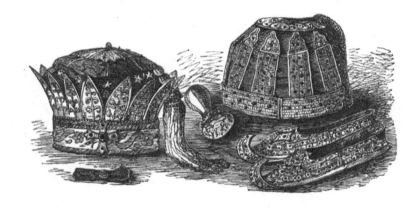

'Abyssinian trophies' on display.

Instead, the poet saved his deepest scorn for the imperial seal in the centre of the illustration, engraved with a picture of a lion encircled by the motto 'Tewodros, King of Abyssinia and Ethiopia: The King of Kings, Tewodros'. It turned out that the stamp used to sign many of the letters mentioned in this story had been made years earlier by a London craftsman and sent over to Tewodros as a gift, maybe from Plowden. 'This big seal, with the Abyssinian lion and the tremendously arrogant inscription,' wrote Arnold. 'It is only eighteen-pence in a cab to the shop where they cut it to his order, with a view to stamp the edicts of Magdala and seal the mandates of the "king of kings". Better for Theodore to have stuck to native manufacture ...'

The same tone of weary scorn flows through much of the story of the people and objects brought back from Ethiopia. Holmes sneered at the paintings in the churches he passed along the way; Arnold derided the

'souvenirs of Theodore' in their glass case in Kensington. A decade later a catalogue of the gold and silver exhibits in the museum dismissed the Ethiopian workmanship as 'rude in the extreme' and had another dig at the royal headgear as having 'the look of such a crown as may be seen in representations in the circus'. The crown looked Byzantine, it said, though the 'rude workmanship' could suggest 'it is African of much more recent times'. Deeds speak louder than catalogue descriptions, and these days that scorn, or at best indifference, is most often expressed in the decision by most museums to keep the bulk of their Maqdala treasures packed away in storage boxes, far away from public view.

◎ ◎ ◎

In the build-up to the expedition, *Punch* magazine had fantasised about the possibility of bringing back Tewodros himself and putting him on display for the paying public. That was beyond the powers of the British Museum or the V&A. But one British institution with its own royal endorsement had a good go at the next best thing.

Towards the end of December 1868 – around the time when Alamayu was getting ready for his first European Christmas in Afton Manor – newspaper advertisements appeared across Britain touting the latest attractions at the great travelling zoo, the Queen's Menagerie, Wombwell's Royal No. 1. Mr Alex Fairgrieve, proprietor and director, begged to draw the public's attention to the *tout ensemble* of his whole collection, made up of 600 living specimens of natural history arranged according to their different *genera*, including musical elephants, grand groups of Bengal tigers, magnificent performing lions, petite marmosets, giant monkeys and, at the bottom of the bill, one last-minute addition and special intimation – the 'THIRD SON OF THE LATE KING THEODORE'.

'PRINCE BOUTA WORKEY' would be appearing in his Grand State Saloon – his own enclosure next to the other exhibits – alongside a display of 'ABYSSINIAN RELICS', a royal robe, a saddle and bridle, a letter from one of the European captives and his original iron fetters, the authenticity of all of which could 'be proved by sworn affidavit'.

133

Stories of this new prince – presumably third in line after Meshesha and Alamayu – spread as the zoo-circus trekked around the provincial cities of Britain. The boy bore a striking resemblance to his late father, the *Norfolk Chronicle* wrote, and accepted 'his new and novel position with the most perfect *sang froid*'. In between his performances, Bouta Workey played with the other children in the troupe and hung out in the animal enclosures. According to the *Nottinghamshire Guardian*, he got on particularly well with the show's star attraction, the great elephant Maharajah.

One time in Woburn, north of London, the newspaper said, Bouta had finished his own act and was riding Maharajah around the menagerie when a man in the crowd reached out and prodded the great animal with a stick. On the second time round, the man did it again, then again, until the elephant decided he had had enough, curled his trunk around his attacker, lifted him high up into the air and dropped him down into a cage full of monkeys. The crowd cheered as the man clambered out, muttering what witnesses described as 'curses not loud but deep'.

Half an hour later the elephant was back in his own enclosure, accepting cakes and apples from the admiring audience. The man approached, pulled out his pocketknife and plunged the blade deep into Maharajah's trunk. The animal bellowed in pain, his eyes blazed with fury and the crowd cried out again, this time in horror, as he reached out to seize the man a second time to dash him against the iron bars. Prince Bouta Workey, who had been standing nearby, rushed over, reached up and started saying soothing words.

'To the surprise of everybody the animal at once released the fellow, and caressed the Prince with his trunk in the most affectionate manner,' wrote the paper's reporter in March 1869 – around the time that, miles away on the Isle of Wight, Alamayu was getting ready for his departure to India. 'The Prince received quite an ovation from the spectators, while the elephant was the circle of attraction during the remainder of the stay of the menagerie at Woburn.'

The crowd urged Mr Fairgrieve to hand the man over to the police. 'But that gentleman, thinking that the fellow had already received sufficient fright and punishment, declined to do so.'

News of the heroic boy prince spread and he rose up the bill, just below the daily feeding of the 'BIRDS, BEASTS and REPTILES' and the star turn from the 'PAIR OF TIGER CUBS!' His fame spread so far that people started asking questions. Was a travelling zoo really displaying a scion of African royalty in an enclosure next to its animal exhibits?

A reporter tracked the third prince down when the show came to Dundee in November that same year and questioned him directly. It's a fair cop, the boy said, or the Victorian equivalent. His name was not Bouta Workey. That was a lie, just a piece of cod-African showtime flim-flam, something pleasingly exotic that the crowds could pronounce. That was made up, but the rest was true. His real name was Wolde Selassie. And he really was, he said, a prince of Abyssinia, son of the King of Kings, Emperor Theodore, a direct descendant of none other than the Bible's King Solomon ... and the Queen of Sheba.

Fairgrieve also insisted his star exhibit was genuine and he had an ace up his sleeve. In another part of the city, another institution, the Dundee Young Men's Christian Association, was hosting another event, a lecture by the famed missionary and freed Abyssinian captive the Rev. Henry Aaron Stern. Fairgrieve sent the boy to the venue and made him sit through the lecture, which was a long recitation of his purported father's atrocities. Afterwards Stern met the boy and had a long conversation with him in Amharic. According to the *Dundee Courier*, Stern did not go as far as confirming Bouta's royal blood, but said he recognised the boy from Maqdala and 'had not the slightest doubt that the lad was connected with King Theodore'. Another of the captives, a Frenchman called Mr Bardel, also wrote to the press, saying he believed the boy had been 'brought up in the King's harem'. More of his story came out, including that he had been apprenticed to one of the European craftsmen on Maqdala who had brought him back to Europe. And here is where at least part of Bouta Workey's story starts to add up. In the immediate aftermath of the campaign the newspaper *Memorial de la Loire* reported that a Frenchman, Mr F. Bourgand, who had worked as Tewodros's armourer, had arrived back home in Saint-Etienne 'with his wife and their five children, and a young Abyssinian negro, all in

excellent health'. Fairgrieve had heard of the boy, travelled to France and signed a deal with Bourgand to let him take the boy and some of the Frenchman's souvenirs back to England to join his show.

The name was fake, the elephant story definitely fishy. Bouta Workey, aka Wolde Selassie, may not have been a legitimate son of Tewodros with a claim to any title. But without a doubt he was another lost Ethiopian boy caught up in the turmoil of war, taken out of his home and brought to Britain. A brother of Alamayu's, at least in experience.

Like the other Ethiopian children, he disappeared from the story after a while – the travelling zoo eventually folded and auctioned off its animals. But he had one more notable appearance in the records after Dundee. The 1871 census that had recorded the Black pageboy Woolda Somsale in Ardwick, Manchester, also said that a 14-year-old Abyssinian boy called Bouta Workey was staying in a guesthouse run by Marly and Ellen Schmitt at 23 Duke Street, just off Oxford Street, London, on the night of 2 April that year. The menagerie must have been in town at the time. In the census column headed 'Rank, Profession, or Occupation', there was a single handwritten word: 'Prince'.

◎ ◎ ◎

The simplest way for Fairgrieve to prove Bouta Workey's identity would have been to engineer a meeting with Alamayu. But, perhaps conveniently for the showman, by the time people started asking awkward questions, Alamayu was thousands of miles away in his new home in India.

Through July and August 1869, he had steamed down the Red Sea, headed east and sailed round India, stopping off at Bombay (now known as Mumbai), Ceylon (Sri Lanka), Madras (Chennai) and finally Calcutta (Kolkata). From there the lost prince of Maqdala was brought inland to the site of another imperial conquest, the river-crossed plains of what was then called Oudh, a princely state the British had annexed just short of fifteen years earlier. The whole area had erupted again during the 1857 revolt, but by the time the Speedys arrived British forces had taken back control and were keen to demonstrate that fact.

Interludes

Captain Speedy took up his post as district superintendent of police covering the town and surrounding area of Sitapur, in the north of the modern-day Indian state of Uttar Pradesh, close to the border with Nepal. Ten years earlier, Deputy Commissioner Captain Thomson had stamped British authority on the town by redrawing large parts of its street plan and giving his name to its market. It was a cantonment – a permanent British military post in India – and sat on a hub of the road and rail lines, projecting British authority across the region. Such an ordered, regulated centre might not appear to be the natural home for the freewheeling Speedy. But he appeared to prosper, with reports of steady if unspectacular promotions – from fifth grade soon after his arrival all the way up to third by the end of the following year – and a commendation from his commissioner for his 'zeal and intelligence'. Speedy sent back reports on his charge to the India Office and to Queen Victoria via members of her household, telling them that he had hired an Indian tutor called Baboo Ramchandra Bhose, 'a most intelligent well educated man and a Christian'.

They re-established more direct royal connections a few months after arriving, when Queen Victoria's second son, Prince Alfred, barrelled in on a blood-soaked state visit, shooting any wild animal that strayed onto his path. Speedy joined the 25-year-old British prince, the Duke of Edinburgh, for a few days in February 1870, as his party crossed in and out of Nepal cornering tigers and deer.*

Speedy left early so he could collect Alamayu and bring him to meet Alfred on his way out of the state in Lakhimpur. 'We all reassembled at Major Shaw's house, where the Duke and his suite were entertained at breakfast, and where Prince Alamayon was presented by Captain Speedy,' wrote the anonymous author of a memoir of the trip, printed for private circulation. 'The little fellow spent the morning there, and when he was asked by the Duke on his departure whether he had any message to send to any one in England, he said, "No." Pressed again, he said, after some consideration, "Yes, there is one." "What is it?" said

* Alfred and his entourage ended up bagging 303 'head of game', including 5 tigers, 70 deer, 109 partridges, 2 pythons and 2 poor porcupines, during just eight days in the state.

the Duke. "Give my love to the Queen," was his answer, and I have no doubt the message went home in all its simple integrity.' The message did, and Prince Alfred reported to his mother that Prince Alamayu looked well and happy and had almost got over his shyness and fear.

The most remarkable thing about the reports on Alamayu from this time is how unremarkable he comes across, for all his regal background and fractured upbringing. Here we have the classic monosyllabic young boy left tongue-tied in the face of a grown-up's inane questions. There are other glimpses in Speedy's reports back to Britain. Alamayu was 'passionately fond of all outdoor sports and riding, but with regard to any mental occupation, most lethargic. I have but one fault to notice, that is an occasional tendency to untruthfulness, but by appealing to his bravery and better feelings, I have never failed to obtain the truth from him.'

Twenty-first-century ears may pick up hints of something like dyslexia from the number of times people mentioned his struggles with book learning. But for the most part, you could be reading the report card of thousands of other rough-and-tumble boys, any other *Just William* or, more appropriately for his time, Rugby School's fictional pupil Tom Brown. He would have stood out a bit less in multicultural British India, where his guardians and their immediate circle were as foreign as he was. It must have been a blessed relief.

◎ ◎ ◎

In general, reports of Alamayu from this part of his life are thin on the ground. From Britain's point of view he was a loose end from their Abyssinian adventure, out of sight thousands of miles away in India's interior, and tidied away out of mind.

Abyssinian fever may have burned bright in London's music halls and pleasure gardens, but there was one corner of British society where enthusiasm had dimmed considerably since Plowden's initial engagement. The ministers and civil servants were exhausted after the long battle to extract their representatives from Ethiopia. As far back as 1865,

Interludes

when it looked like Rassam's mission had secured the release of the hostages, Lord Russell had wrapped up his time as Foreign Secretary with a memorandum on Britain's Abyssinian policy.

In essence, he said its policy had been to stop having an Abyssinian policy. 'Considering the short tenure of power in the Abyssinian Kings, whatever be their title, the difficulty of reaching with a regular British force their seats of empire, the little value of a victory gained at Gondar and Shoa, the risk of failure, and the certainty of expense, it has seemed to the British Government a preferable course to withdraw, as much as possible, from Abyssinian engagements, Abyssinian alliances, and British interference in Abyssinia.'

By the end of 1868, *The Times* reported on Christmas Eve that the government had 'suppressed' the consulship in Massawa. Britain, it turned out, no longer needed to send anyone to that stretch of Red Sea coast to watch over the waters and feel the pull of the Ethiopian highlands behind them. Plowden and Bell's dream of an enduring bond with the land of Rasselas was officially over. Cameron was compensated for the loss of his job with a pension of £350 a year. Rassam, Prideaux and Dr Blanc received generous one-off payments for their service.

'Our Abyssinian money account is, in fact, closed, so far as our Consuls and Envoys are concerned, and let us trust that it may never be re-opened within the lifetime of this, or, indeed, any future generation, unless some country more favourably situated than England for the experiment, or with more money to throw away, should take our quondam most Christian allies in hand, and impart to Abyssinia very different associations from those which the name now conjures up,' *The Times* wrote in a sentence whose ponderous construction and winding subordinate clauses, on top of its overriding weary tone, embodied the official enervation over anything related to that particular subject.

◎ ◎ ◎

What all this lack of British engagement amounted to from Alamayu's point of view was a glorious period of benign neglect, a time where he was left to ride and play away from the eyes of mainstream British society. When the papers back home remembered to write anything, their assumption was that he would be staying in India. 'It would scarcely surprise us to see Alamayou flourishing a few years hence as an assistant-commissioner or settlement officer in Oudh, or some other part of the East,' wrote the *Hampshire Telegraph*. Another widely syndicated article saw him progressing to a post in the 'Native Civil Service' or perhaps becoming 'an Indian judge, who dispenses impartial justice to black British subjects'. Note the very specific limits set on his prospects.

And that is where he may well have stayed, neglecting his books and galloping out on the plains in 'some part of the East' towards an obscure paper-shuffling career, if he hadn't come to the attention of one of the great bulldozers of the British Victorian era, the then Chancellor of the Exchequer, Robert Lowe.

◎ ◎ ◎

Lowe was jolted into action by a looming deadline. The British government had agreed that the Speedys should look after Alamayu for an initial period of two years. And that time was up on 1 August 1871. Someone had to decide what happened next.

Then came a development that really shook the bean-counters at the Treasury. The ever-restless Speedy suddenly announced that he had applied for and secured yet another job, thousands of miles beyond India, as commissioner of police in Penang, then in Britain's Straits Settlements, now in Malaysia.

This geographic shift brought up a concrete question: which part of Britain's world-spanning administration should now have the burden of paying for the boy? And now that hard cash and hard budgets were involved, Alamayu's future became something of a turf war for the great offices and officers of state. As the boy was moving even further south

and further east, away from India, wrote Mr Merivale of the India Office to the Secretary to the Treasury in March 1871, 'it would scarcely appear that the India Department of Her Majesty's Government would be required to concern themselves any further in the arrangements for the maintenance of Prince Alamayou'.

Mr Law of the Treasury replied to Mr Merivale of the India Office, telling him that he was 'desired by the Lords Commissioners of Her Majesty's Treasury to request you to inform the Secretary of State for India in Council, that they think it inadmissible to allow the young Prince's fate to depend on the accidents of Captain Speedy's professional career ... They cannot justify an expenditure of [£700] a year for an education at Penang.'

Alamayu could not go to Penang with Speedy. That much was clear as a point of hard principle. Either the India Office should pay for Alamayu and keep him in India, Mr Law's letter continued, or they should all go back to the drawing board and bring him back to Britain.

There was only one problem, which neither Mr Merivale nor Mr Law were aware of as they wrote. Speedy, living up to his name, had already left India and taken Alamayu with him.

The Speedys must have known something like this was coming. From early 1871, aware that the two-year deadline was approaching and, perhaps, uncomfortably conscious that Alamayu's education arrangements had not been all they might have been, they decided to try to take the initiative by embarking on a programme of lobbying and manic travel in a campaign to keep hold of the boy. Their reason was simple, as they told anyone who would listen, particularly anyone in high office or anyone connected with the royal family: they now considered Alamayu to be their son.

'Alamayu is growing up a fine lad but I cannot get him to care for his books. It is something ludicrous – his utter dislike for anything in that line. But he is otherwise the best boy in the Universe,' Speedy wrote to Sir John Clayton Cowell, master of the household to Queen Victoria. 'The child has somehow entwined himself round our hearts, and as we have no family it seems as if Providence has given himself to us.'

Mrs Speedy headed back to Britain to try and find a full-time personal tutor who would agree to come out to the East and teach Alamayu one on one. Speedy went to Penang and then to Singapore. From different points of the compass the Speedys pressed on with their campaign.

For a short while, Alamayu went to study at Singapore's Raffles Institution and was escorted to and from lessons by two Sikh policemen. Alamayu, now halfway around the globe from both Maqdala and London, really was seeing the world. Speedy took Alamayu with him when he went to Singapore's Government House to meet Major-General Archibald Edward Harbord Anson, the acting governor. Anson was persuaded and wrote to the Colonial Office to say that he had seen the man and boy together. 'Were Captain Speedy his father he could not have done more for him in every way, and I consider, under the circumstances, Captain Speedy is deserving of every consideration and Captain Speedy, being a married man without children, should be allowed Alamayu to take the place of a son.' Speedy got another note of support from Arthur W. Birch, acting lieutenant-governor of Penang. Even the Duke of Argyll, the Secretary of State for India, told the prime minister, William Ewart Gladstone, that he would support the Speedys keeping the boy.

But it all came to nothing. It was the Treasury that controlled the purse strings. And the Treasury had spoken. Speedy, just a few months into his new job dispensing justice and chasing pirates in Penang, was ordered to get back on a boat, bring Alamayu back to Britain, hand him over and, with that, terminate his guardianship. Speedy had one more go, sending a letter in October begging for the Lords Commissioners of the Treasury to change their mind. 'He has lived with me as my own child ... I have a very strong attachment for the boy, who returns it most warmly, and I cannot but feel that to take him away from the only person who has known or cared for him in life, at his present tender years, would be a harsh measure.' Speedy said he would be happy to give up his guardian's salary or find a tutor or stay with Alamayu in Britain. He regretted his decision to move to Penang which, he said, he had only made to protect Alamayu's health

by 'taking him to a healthy seaport town, rather than continuing in the enervating climate of the interior of India'. But it was still no use. The Treasury's orders were repeated and stood.

On 22 November 1871, Speedy and Alamayu got back on a P&O steamer and left Penang for a near forty-day trip back to Britain. Around the same time, Chancellor Robert Lowe came out from behind the cover of his Treasury underlings and set out his own reasons for his decision on Alamayu in a memo. He wrote in a flinty prose a world away from the officialese of the Merivale-Law letters or the high emotions of the Speedys' correspondence:

The case had to be decided on general principle. We are *in loco parentis* and ought to look after his welfare as if he were our own child. What parents would voluntarily bring up a child in Indian Cantonments where he is sure to become an accomplished liar, and would probably be contaminated with those vices which arrest the physical and mental development of boys? ... I attach no importance to what Captain and Mrs Speedy say for they have a large pecuniary interest in keeping him.

Lowe was, it is almost universally agreed, one of the most bull-headed, most curmudgeonly, least flexible men ever to hold senior office in Britain. And that is a competitive field. 'When I take up a principle,' he said, 'I like to carry it out to its utmost extent.' Fine, if you inflexibly fix on the right side of the argument. But he was more often wrong than right. He had opposed the democratic reforms of the day and saw little point in sugar-coating policies and decisions to placate the ignorant masses. Around the time he was wrenching Alamayu out of Penang, he decided to part-fund an increase in defence spending by imposing a halfpenny tax on boxes of matches, enraging every smoker and firelighter – pretty much everyone – in the land. He only backed down when the match-makers and match sellers of London gathered in their thousands in the East End and marched on Westminster, hurling insults and stones and forcing him to enter Parliament through a tunnel.

There were no little matchmakers to come out and argue for Alamayu. Lowe, a staunch believer in meritocratic education, had already set out Alamayu's future. 'I have arranged with Mr Jex-Blake, the head of Cheltenham College, to take him into his own house. He has a large family, so the boy will not be solitary.'* Speedy's salary would cease the moment he handed the boy over. The £700-a-year payment would transfer to the Jex-Blakes.

A few weeks after his first memo, while the prince was still en route and Mrs Speedy was still pressing her case with the royal family, pleading to keep him and searching for a tutor, Lowe blasted out another broadside:

I am tired of all this cant, one would think that education consisted in coddling and petting instead of making men. Special tutors mean general ignorance ... if he [Alamayu] is truthful there is no time to be lost for he will not be so for long. These people think that a boy's character is formed by those in whose house he lives, not by other boys and the general moral tone of the community.

As always, as always, we do not get to hear from the boy himself. By then he was 10½, and went where the grown-ups sent him. On this occasion, they sent him back out to sea, back around India and back up the Red Sea, giving him one more chance to watch the mountains climbing up to the tablelands of his Ethiopian home, drifting by him on the port side.

* Jex-Blake did have a large family – at that stage nine children, all of them girls.

Chapter Eight

Retreat

'There was nothing to be hoped from longer stay. They returned ...
repenting of their curiosity, censuring the negligence of the govern-
ment, lamenting their own rashness.'
The History of Rasselas, Prince of Abissinia

What was happening in those Ethiopian hills and mountains at the
time? Was anyone missing Alamayu? Was anyone thinking of him?
Standing on the deck of the P&O steamer *Australia* on the Red Sea in
December 1871, Alamayu could have been forgiven for thinking that
no one was thinking of him. He had had no news, no messages from
his home country or from anyone left in his fractured family since his
forced exit three years earlier.

That, it turns out, was not the fault of Ethiopia, nor of his relatives.
Tewodros's successor, Emperor Yohannes IV, had tried to send envoys
to Britain in 1870 to build on the good relations he had established by
helping Napier's force. But they were turned back by the British authori-
ties in Egypt. Westminster had been serious when it said its future
Abyssinian policy would be to have no Abyssinian policy. Any future
communications, the British said, should be sent east not west, via Her
Majesty's representative in Aden, who would decide what action to take.
And as we have seen, British officials did not have a great record when it
came to processing Ethiopian correspondence.

The Prince and the Plunder

A matter of weeks after Alamayu was steaming back up the Red Sea, his grandmother Woizero Laqaya was sitting down to write two letters in a church compound near his mother's old home in the Simien Mountains.

One was to Victoria, one matriarch to another, Woizero Laqaya asking the British queen to look after her grandson:

In the name of the Father and the Son and the Holy Ghost. One God. Sent by Woizero Laqaya, mother of Itege Tiruwarq, grandmother of Dejazmatch Alemayehu. May this reach the English queen ... May the Saviour of the World give you health on my account. May He extend your kingdom. May He destroy your enemies ... May you protect your charge for me; when God took his father and his mother, He gave him [Alamayu] to you ... He calls you 'mother' but he does not call me 'mother' because I did not bring him up. You bring him up, for God's sake.

One was straight to Alamayu:

My child, my darling, how are you? Why haven't you sent me a letter since we parted? While I die in grief and mourning, I have no other son, no other child apart from you. Send me a letter quickly, with a picture of you so I can always look at it. May Christ bring us together. Amen.

Be friendly to the English queen, the Russian king, the French king, to all kings. Send letters. All the people of Abyssinia are waiting for you. They want you. Be wise, open the eyes of the people of Abyssinia, for they have become blind. Open up science for them. Don't let them stay like this, blind as they are.

Woizero Laqaya, the mother of Queen Tirunesh/Tiruwarq, was holding fast to Tewodros's plan that his son would go to Europe and come back again, armed with new skills, new technologies and new ideas to help Ethiopia. If Alamayu had received the letter, it is a thought that might have helped him feel that his exile had some sort of purpose. (If he had received the letter, he might have also needed some help to read it.

146

His command of his native language was slipping – no one had honoured his mother's last wish for him to continue his Amharic studies.)

Possibly the greatest charge we can lay against the British authorities and Alamayu's guardians, from the safe distance of 150 years, is that these letters did eventually make it to Aden and then to London, and then on to the royal household in Windsor Castle. One report suggests one of them may have even got as far as the Rev. Jex-Blake's study in Cheltenham College. These Amharic letters, along with a handful of others from Laqaya and a foreign-educated Ethiopian man called Samuel Giorgis, were translated and passed from office to office, studied idly as exotic curiosities and filed. At no stage, as far as we can tell, did anyone think to write a reply or pass them on to Alamayu.

◎ ◎ ◎

The tone of Alamayu's story so far has shifted from imperial romance to military history to island adventure to sugar-sweet family memoir. It is time to move it once again, this time into the realm of overblown, supercharged soap opera.

Speedy and Alamayu steamed back into Southampton on the P&O steamship *Nyanza* on Saturday 30 December 1871. There was a letter waiting for them, ordering them to travel straight down the coast to meet the Jex-Blakes in Brighton, where they had been staying for Christmas. But Speedy either missed or ignored the instruction, and headed straight over the Solent to the Isle of Wight for a family reunion and a conflab. The very next morning, on New Year's Eve, another message arrived, repeating the clear orders. Speedy was to say his goodbyes and hand the boy over to the new guardians.

Instead, Speedy and Alamayu jumped on a train, shot up to London and booked into the Langham Hotel. The Treasury sent another agent to intercept them there, but found the pair had already flown. Speedy had jumped onto another train and headed to Windsor, to seek the protection of his greatest champion, Queen Victoria, the one who had promoted his guardianship from the start. She met them and agreed,

Speedy wrote, that it would be cruel to separate them and she would do anything she could to stop it. There followed a period of frantic activity as Speedy kept on the move between London, the Isle of Wight and Windsor, firing off letters, seeking alliances, trying to frustrate Lowe's plans, trying to do anything to keep hold of the boy.

'I cannot refrain from expressing my regret and surprise that I, who since the close of the Abyssinian Campaign have stood in *loco parentis* to the boy, should not have been consulted regarding the future of one in whom I am deeply interested; with whose particular temperament both physical and mental, no one can be so immediately acquainted as myself,' Speedy wrote to the Treasury from the Langham. 'I think it is my duty to state that in my opinion the boy is totally unfitted for a large public school ... I earnestly solicit the favour of a personal interview before anything [is] definitely settled.' The Treasury replied that everything had already been definitely settled and it would not communicate with him again until he obeyed its orders. Crestfallen, he headed down to Brighton to see the Jex-Blakes, but got a last-minute telegram from Sir John Clayton Cowell, Master of the Queen's Household, ordering him *not* to hand over Alamayu.

The family drama had moved onto the national stage and turned into a full-blown national power struggle – one waged between Windsor Castle, represented by an indignant and emotional Queen Victoria, and the government, represented by an indignant and iron-willed Robert Lowe.

Victoria expressed herself through letters and telegrams sent by members of her household to ministers and officials and in the pages of her journal. She was 'perfectly furious at Mr Lowe's conduct and she would be quite ready to pay ... herself to have the boy brought [up] and would be happy to do so rather than see such treatment.' She was outraged that no one had even told her that Alamayu was coming back, or consulted her about the plans. 'While there can be but one opinion with respect to the boy's education and that is that it should be the best that circumstances can permit,' she was steadfast 'against separating him from Captain Speedy who is his only friend in the world'.

In the early days of 1872, Speedy received a telegram ordering him to go to the Isle of Wight, to Osborne House. There he was expecting to see the queen, but he found himself sitting down for an interview with Prime Minister William Ewart Gladstone. The tussle over a 10-year-old had now drawn in all the main players on the political stage. Gladstone – taking a break from the great affairs of state to act as some sort of diplomatic go-between – asked Speedy to state his case. Speedy told him that he was sorry to part with the boy and the boy was sorry to part with him. If someone could find him a job, paying £500–600 a year, he would happily stay in Britain and everything would be settled.

Nothing was settled. Neither side budged. We can get a taste of Alamayu's bewilderment at the high-level custody battle boiling around him in a letter from Speedy in the family archives. 'Alamayu wants to know what is the good of having a queen if she can't make people obey,' Speedy wrote to his brother Alfred. Alamayu's bemusement was understandable, but he wasn't to know that this was just one of a string of political battles and skirmishes between Crown and state that marked Victoria's reign, battles that she did not invariably win.

In the weeks that followed, the confrontation turned into a war of attrition, with small bits of ground grudgingly taken and given. The queen acknowledged that Alamayu should stay in Britain, but she demanded that he get a medical check-up to make sure he was strong enough to stand the climate and the rigours of school. Her physician, Sir William Jenner, examined the boy and gave him a guarded all-clear. Mr Lowe agreed that Alamayu could stay with Speedy until his future was fully decided. In the weeks that followed, the sides slowly, painfully edged towards a sullen armistice, a kind of compromise. The boy would go to Cheltenham with the Jex-Blakes, where he would initially study with a tutor. Speedy, in the meantime, would stay in Britain for at least another year and get to see the boy whenever he wanted and exchange private letters.

Speedy, expensively ensconced at the Langham Hotel, kept up his search for a job in Britain. But mysteriously there were no vacancies wherever he looked. For Lowe – determined to stick to his principle for the sake of sticking to his principle – had never really accepted defeat and

had one more shot to fire in his battle. On 8 February 1872, the Treasury announced it had received a very conveniently timed letter from the Colonial Office stating that Speedy was urgently needed back in Penang, and that it could no longer give him a year's leave to stay on as Alamayu's guardian. Speedy, facing another government directive and the prospect of unemployment in Britain, finally accepted defeat. Perhaps after all, he wrote in one letter, in an effort to convince himself as much as the recipient, Alamayu would be all right in his new surroundings. After all, the little boy had appeared 'much more manly and self-reliant lately'.

Queen Victoria had also been outmanoeuvred. With one more twist of the knife, Lowe sent a letter asking if she would like to meet Jex-Blake to discuss her concerns about Alamayu's education. The queen's private secretary, Henry Ponsonby, confided to another senior member of the household that he was reluctant to pass on the message to her. 'She will be in a terrible state. She hates the name of Jex-Blake and it is merely her anxiety to give in somewhere that makes her consent to Alamayou going there,' Ponsonby wrote. 'She insists he ought to have another home – someone he can appeal to when he wants to get away from Mrs. Jex-Blake and the nine Miss Jex-Blakes and the governesses.' There was no more said about the suggested meeting.

Speedy finally conceded and handed over Alamayu to the Rev. Thomas William Jex-Blake, principal of Cheltenham College, on 4 March 1872, the month before the boy's eleventh birthday.* Alamayu asked to spend one last evening with Speedy at his hotel, but Jex-Blake said that would not be possible. When Speedy asked if his wife could visit, as she was staying in Britain for a few more months, Jex-Blake said he could not respond to a hypothetical question. Speedy reported this all to the royal household, and there was a little flurry of letters, with everyone assuring everyone that there had been a misunderstanding, that of course Mrs Speedy's visits would be allowed. Ten days later, Speedy got on yet another P&O steamer at Southampton bound for Penang, and another father figure left Alamayu's life.

* Alamayu's birthday is widely recorded as 23 April 1861, though I have not been able to track down the source of that information. His mother could have told Rassam or, perhaps, Speedy.

Retreat

◙ ◙ ◙

Alamayu's immediate future may have been settled, but the contest over who was going to have the last say in the political battle surrounding it was still churning. On 8 March, Sir Stafford Northcote – who had been the Secretary of State for India at the time of the Abyssinian Expedition and was now in opposition – stood up in Parliament and asked the Chancellor of the Exchequer why Prince Alamayu had been withdrawn from the care of Captain Speedy.

Lowe answered at length, his words taken down verbatim by the scribes of the official Hansard record and by the members of the press.

The government, he said, had come 'to the conclusion that India was a bad locality for educating him [Alamayu], and that it was not creditable to the Government that his movements and residence should depend upon those of a gentleman in the service of the Indian Government who is ordered about as suits their purpose ... It was therefore determined that he should come to England.'

The government, Lowe continued, had consulted doctors who had 'advised that it would be inexpedient to send him [Alamayu] to an English school, as he might meet with rough usage, and his health might be injured ... He has no elementary knowledge; so that he would not be fit even for the humblest school, such as gentlemen's children attend. He is of promising ability, but I believe he cannot really read or write ... Under these embarrassing circumstances we resolved to send him to the headmaster of one of the best schools in the kingdom, Cheltenham School, which contains two departments, one scientific and the other classical; not, however, to the school, but to live with this gentleman's family, and to receive the instruction he so much needs.'

If the situation was embarrassing for the government, imagine how it must have felt for the near 11-year-old child at the centre of it all to have his private life, his delicate condition and his struggles with reading, writing and the basics of schooling broadcast so loudly to the whole nation. Accounts of the debate were wired to all the main newspapers

and landed on the breakfast tables of the parents of his future school-mates the next morning. (The plan was he would enter the main school proper as soon as his tutor thought he was ready.) Any of those boys who might have been inclined to treat him with 'rough usage' had plenty of ammunition to use against him now.

◎ ◎ ◎

So the prince took up residence in the headmaster's house in the spa town of Cheltenham in Gloucestershire, quite far north for Alamayu, who had so far hugged the south coast. Today the town is well known as the headquarters of British intelligence's GCHQ. Through the mid-nineteenth century it was associated with Bath chairs, invalids and faded Regency architecture. If Lowe had set out to find the exact opposite of Captain Speedy in Penang, he could have done little better than the Rev. Thomas William Jex-Blake in Cheltenham. Speedy, in his mid-thirties at the time of the handover, was a man of grand gestures and grander eccentricities. He had first impressed Tewodros, the stories went, by his ability to chop a sheep in half with one swing of his sword. He walked around in polite European society in his idea of Ethiopian military dress. When he went back east, he took up the bagpipes and played them everywhere, loudly and badly. Jex-Blake was five years older than Speedy and an entirely different kind of animal – an ordained man of words, broad-church ideals and establishment musings. He was a disciple of the art and social critic John Ruskin and had already written one book, *A Long Vacation in Continental Picture Galleries*, his notes on paintings he had seen on his holidays. In five years' time, he would publish another – *Life in Faith*, a collection of his sermons. His portrait in the school shows a serious, good-looking man with mutton chop whiskers and immaculate academic robes. He is quoted in the official history of Cheltenham College singing the praises of team activities and warning the boys against a range of evils from 'lounging about town' to 'dawdling dandyism' to the 'haunting of billiard rooms and places of still worse repute'.

Our *Boy's Own* boy who loved riding and hunting and struggled with books was about to enter a family where words, art and ideas reigned supreme. The implication behind Queen Victoria's sneering line about the 'nine Miss Jex-Blakes and the governesses' was that he was also about to enter a world of ribbons, fripperies and idle chatter. That, in fact, was very far from the truth. It was the women and girls of the Jex-Blake family who gave it its edge. Thomas William's youngest sister was Sophia Louisa Jex-Blake, a leading campaigner for women's medical education. She had braved the insults and missiles of an angry mob to sit her exams at Edinburgh University, and went on to become Scotland's first qualified female doctor. Two of Thomas William's daughters – Henrietta and Katharine Jex-Blake, the closest of his children in age to Alamayu – also grew up to be champions of women's rights and went on to become, respectively, the principal of Lady Margaret Hall, Oxford, and the mistress of Girton College, Cambridge.

It turned out that the girls were actually pretty good playfellows. Many years later, when someone published a letter saying Alamayu had been violent during games at Cheltenham, scurrilously implying it was a sign of an inherently savage nature, it was one of the younger Jex-Blake sisters, Evangeline, who wrote to *The Times* to defend him. She said that she still remembered the day when Captain Speedy brought Alamayu to live with them:

> During the first winter, an elder sister and I, both of us younger than Alamayahu, spent many hours amusing him with games such as dominoes or draughts, for he was laid up in bed with bad chilblains for several weeks. He in turn sometimes talked about Abyssinia; and always, both then and later, he was as gentle with us as any boy could possibly be. By nature he was shy, reticent and dignified; intelligent, but European book learning was not for him.
>
> He and some cousins of ours then at the college used to come to tea with us on Saturdays and we spent the evenings at hide-and-seek in a very large dry and quite empty basement. There would be great excitement but never any rough usage in our games; if anyone got a

bruise or a knock the dim light would be the reason for it. I do remember an older cousin saying Alamayahu was very wild the first time he played football. But the game was, of course, quite unknown to him.

The football here was rugby union football. It took a while, the boys said, for Alamayu to learn to tone down the ferocity of his tackles.

◎ ◎ ◎

After what must have been an upsetting separation between Alamayu and Speedy – an event that no one felt the need to record for posterity – Jex-Blake quickly started sending positive reports to the Treasury about how well his new charge was settling in. He noted in particular the boy's 'considerable social tact, and instinctive good breeding'. Alamayu, he wrote, was 'in excellent health and spirits, and enjoying life thoroughly. Progress is slow in lessons from dilatory nature and late commencement, but in temper and good-feeling ... there is nothing to be desired.'

For now, Alamayu was staying in the family home and getting private tuition. He worked through a very exact programme of 31½ hours a week of arithmetic, English, geography, history, Latin, poetry, reading, spelling and writing. In April he got a tantalising taste of what was to come once he graduated from this regime and moved into the school, when he got to sit in the stands and watch the boys' sports day. He was already making regular visits to the school gymnasium. Sometimes a couple of boys would come over from the school at the weekend and play with him.

In one of the monthly updates demanded by Lowe, Jex-Blake observed that 'the Prince possesses nothing whatever that belonged to his father or mother'. (Speedy must have kept Tirunesh's Book of Psalms as his own souvenir.) Was there any way, Jex-Blake asked, the government could let Alamayu have some of the treasures that had been taken from Maqdala, something that would help remind him of his first home? 'It is much to be hoped that a nation that does not make

war for "loot" will let him have something of his father's or mother's property for keepsake.' Mr Lingen of the Treasury wrote a note on the letter: 'souvenirs, speak to Lord Ripon'. But there is no mention of whether this went any further. As you can see from the end of this book, there were lots of things lying around on the storage shelves of Britain's museums that they could have sent.

The headteacher had said he was willing to take Alamayu in and treat him as one of his own, on the understanding that he would be 'quite free in the discharge of my duty'. This hinted at continuing tensions with Alamayu's previous guardians, particularly Mrs Speedy, who was still in Britain and regularly reporting to Victoria via the queen's staff. In a sign of how deep the bad blood was still flowing, archives in Windsor Castle show that Victoria was in fact paying Mrs Speedy from the royal purse, to give her an income while she kept an eye on the boy.

That set up an inevitable confrontation between Alamayu's two stand-in mothers, the old and the new, Mrs Speedy and Mrs Jex-Blake. At times it approached a genteel slanging match, conducted at a remove via waspish correspondence. Mrs Speedy pushed the Jex-Blakes for a letter from the boy. Mrs Jex-Blake replied that Alamayu had 'every facility for writing, but there appears to be no one he cares to write to'. Ouch! Mrs Speedy passed a report of the exchange on to the queen.

In response, Thomas Biddulph, the Keeper of the Queen's Privy Purse, wrote to Lowe saying that Victoria wanted him to *order* the Jex-Blakes to let Alamayu spend a day with Mrs Speedy in Cheltenham. It wasn't until May that Mrs Speedy got her first meeting since the separation. She booked into the town's Queen's Hotel. After her outing with Alamayu she reported back that he looked paler and thinner, that he seemed to have lost his appetite and seemed to be left too much to his own devices. Above all, she kept stressing, he was missing the company of boys. 'He constantly said "I want boys – and I want more exercise." ... I do not think Alamayou seems quite happy and satisfied,' wrote the far-from-neutral witness. The queen ate up every word.

We are back in the world of conflicting reports on Alamayu from conflicting sources, with no direct testimony from the boy himself.

He did get to spend one more summer holiday with Mrs Speedy over July and August, at least part of it back in Afton on the Isle of Wight. One of Mrs Speedy's nephews was there as a companion. Old Benjamin Cotton was also around, but getting older by the day. He would only see two more summers. Mrs Speedy wrote again to the queen via Biddulph to say Alamayu was pressing on with his reading and writing, driven on by the hope that he would soon be able to ditch his tutor and join the rest of the boys in the school. 'His manly character and keenness of observation renders him very apt at learning from *life*, more than from books and emulation in his lessons would probably be the greatest assistance he could have.'

Alamayu returned to Cheltenham after his summer break and in a few months had all the male company he needed. On 10 October he finally ended his period of purdah and moved out of the Jex-Blakes' house and into the junior school during term time. On that very same day, down on the coast, yet another of his parental stand-ins was leaving the stage. Mrs Speedy, dispirited after months of failing to undermine Lowe's Jex-Blake schemes, got back on a boat in Southampton and sailed off to join her husband in Penang.

Chapter Nine

Lessons

'Rasselas rose next day, and resolved to begin his experiments upon life. "Youth, cried he, is the time of gladness: I will join myself to these young men, whose only business is to gratify their desires, and whose time is all spent in a succession of enjoyments." To such societies he was readily admitted, but a few days brought him back weary.'
The History of Rasselas, Prince of Abissinia

The boys of Cheltenham called him Ali. He was down on the register with his one name, Alamayu – no surname or initials or mention of his princely ranking, presumably in an effort to help him blend in. But even that was too much of a mouthful for his new companions.

'Ali, as we used to call him ... was just a royal savage when he came to Cheltenham; if he was hot, he took his coat off and threw it on the ground, and left it,' wrote Douglas Sladen, one of Alamayu's contemporaries who grew up to become a writer of humorous tomes, among them *Queer Things About Japan* and *More Queer Things About Japan*.

'He had no tutor to go about with him; he just mixed with the boys in the ordinary way. And at first he had the cruelties of his bringing up; he once, for instance, pushed a small boy into the water to see the splash he would make. But he soon got cured of this, for Jex-Blake wisely left him to fight his own battles, and though a sense of chivalry made the boys very indulgent to the poor little orphaned black, they soon let him know that bullying was not to be one of his privileges, though almost anything else was treated as a joke ...

'I knew him very well, because I was in the head form when he came to the school, and was often at Jex-Blake's house, and was asked by "Jex" to keep an eye on him. He was a nice little boy, with a very affectionate disposition, and not at all stupid.'

It is an odd and unsettling mixture of scorn and condescension mixed in with some affection that was repeated again and again in old Cheltonians' memoirs, letters and journals.

Any sign of a shortcoming, any outburst of normal boyish boisterous behaviour, was held up as a tell-tale sign of Alamayu's African roots and 'cruel' upbringing – witness the savagery of the young boy taking his jacket off … and leaving it on the floor! Any sign of good behaviour and intelligence was seen as notable because it is not what they might have expected from someone with such a background and such an upbringing.

Alamayu had secured a bed in the imposing patterned-brick bulk of Teighmore boarding house, a short walk down away from the chapel and the rest of the imposing main buildings on the Bath Road facade.

'He took very kindly to civilisation, and the greatest offence against its laws and customs which, as far as I know, the poor boy ever committed consisted in roasting chestnuts at the dining-room fire, and wiping his hands on the painted walls,' wrote Alamayu's schoolmate, the future colonial administrator and Liberal MP Sir John David Rees.

Rees, who was a whole six years older than Alamayu and went on to write a series of books celebrating the British Raj, remembered the prince as 'a slim boy with bright black eyes, and an intelligent and attractive face, of the less pronounced African type'.

He learned to speak English well, and was a very good runner. His victory in a race at the annual school sports was a very popular one, and he was much liked by Dr Jex-Blake, and by all his schoolfellows. During the holidays he was sent to see the Queen, and when he came back to school he was naturally a great authority on Her Majesty and the Court. He said the Queen was very kind to him.

It is another strong theme in all the reminiscences – Alamayu's winning nature kept winning through. The boys, brought up in the deep prejudices of their time, dismissed and underrated him, sometimes derided him. But, without an exception, they couldn't help liking him.

There was a rush of reminiscences about Alamayu in *The Times*'s letters page in 1935, including one contribution from the Rev. A. Westcott, who had shared a study with the prince. It is worth reading almost in full:

> He was my junior and not my special chum, but I helped him in his 'prep,' as he was not a brilliant scholar. In gratitude for this service he was anxious to bestow on me any or all of the books which, suitably inscribed, he had received as gifts from Queen Victoria. I prudently declined these offers, but I made him tell me stories of his travels with Captain Speedy, and all that he could remember of his past life. His earliest recollection was of hearing his father shouting for him, as King Theodore proposed to shoot his son also at the time he shot himself. But the servants, Alamayahu told me, hid him. He was a very plucky boy and fought a boy who was the acknowledged 'cock of the house'.

The fight was interrupted by the dinner bell, Westcott wrote. 'When the fight was resumed he continued to receive such punishment as few boys could have endured until he finally yielded. He was a zealous footballer, and as captain I gave him his house colours. I should like to bear witness that he was a brave and generous lad.'

The boys never let Alamayu forget his foreign background, his unbridgeable otherness. But when they came to remember their actual encounters with him, they all sketched the outlines of a classic schoolboy hero. A boy who was sporty, brave, with glamorous connections, someone who was always ready to take on a bully and take a beating, with a break for dinner, without complaint. He may have been no scholar, but that didn't matter inside the bubble of classroom approval. He earned a little more contempt from the boys with his efforts to make friends by trading the few riches he had – the presents from Queen Victoria. But after lights out, they turned to him again as a reliable fount

The Prince and the Plunder

of adventure stories. There is no other source suggesting that Tewodros had meant to kill his son at the climax of the battle. It is probably safe to dismiss that detail and allow him some licence for self-dramatisation, or implanted memory. Most of the accounts of the campaign that he might have read had depicted his father as a monster.

By April 1873, around his twelfth birthday, Alamayu was allowed to take part in the sports day events. The *Cheltenham Examiner*, in a highly detailed account of the festivities, reported that he received third prize in the Consolation Handicap Race – a modest start to a run of athletic victories. One silver cup he won is still at the school. Jex-Blake was able to report that year that Alamayu had started reading for his own enjoyment. The boy showed 'considerable social tact and instinctive good breeding; excellent courage, and as yet a perfect temper. We have never seen him cry, never seen him cross.' Alamayu, in other words, had mastered the chief virtue of public-school life – the suppression and repression of troubling emotion.

◎ ◎ ◎

For once, we are able to turn to Alamayu himself for a direct report on his schoolday adventures. He had been spending some of his holidays with the Biddulphs and wrote in July of 1874 to the lady of the house:

I hope you are quite well. I am sorry to say that Mr. Jex-Blake will not let me come to see the match. I have had a letter from Captain Speedy he says he went to India to some of the brave men from here and before he went to fight the Chinese he asked the Raga of Caroot to ask them if they could have peace but they would not listen and so the Raga told Captain Speedy to go and take their forts and Captain Speedy and a hundred men went and took six of their forts and mud stockades and Captain Speedy said that the Chinese put sharp bamboo spikes and poisoned them and so the Malays were afraid to go near the forts but the Indians did not care because they wore boots. What does Sir Stafford Northcote say about my going into the

modern? I am going in for a junior race and I am getting on very well in my class. I may get the prize I am working very hard. If I stay at Cheltenham I shall get my promotion but I would like to know what Sir Stafford Northcote says about it. Yours Alamayu.

It is glorious to hear his own voice again after so many years of silence and stilted reported statements from other people's accounts. Anyone with any acquaintance of a 13-year-old, or at least a good enough memory of their own early teenage years, will recognise the free flow of grammar and punctuation, the enthusiasms and images. In this case Alamayu was also caught up in a free flow of father figures. He was obviously still enamoured with his old life out East, repeating the name of Captain Speedy like a mantra, a distant and glamorous totem of endless adventure. If you want to join some of the dots of that account of stockades and bamboo spikes and brave Indians – which did bear some relation to real events unfolding far away across the seas – try and get hold of Speedy's biography *The Rise and Fall of Basha Felika* (Basha Felika roughly meaning Captain Speedy in Amharic), lovingly researched by his great-great-niece Jean Southon. The Rev. Jex-Blake makes one brief appearance in the letter, the stern Victorian *pater familias* popping up to say 'no' – Alamayu could not go to the match. And then there is the solid Victorian eminence of Sir Stafford Northcote, the Secretary of State for India at the time of the Abyssinian Expedition who had taken an increasingly close interest in Alamayu in the years that followed. Most recently, along with the Biddulphs, he had also regularly offered up his home for Alamayu's school holidays. As far as the boy was concerned, the heavily bearded Conservative statesman – who around that time took over as Chancellor of the Exchequer, giving him control of Alamayu's purse strings – was the natural person to turn to for advice on the minutiae of navigating the rites of passage of public-school life.

The promotion Alamayu was talking about was his looming move from Cheltenham's junior to senior school. The Junior Department, which took boys from 7 to 13, was supposed to prepare them for the full range of respectable careers and futures, with particular attention

given to grammar, spelling and writing, arithmetic, history, geography and, according to the School Class Lists handbook, a bit of French and 'the rudiments of Latin and Greek' – or as an alternative to the classical options, elementary mathematics. The ordained teachers bridged the worlds of church and academia. Manly outdoor pursuits and Anglican worship were equally important parts of the curriculum in an age inspired by the philosophy of 'muscular Christianity' that mixed sport with the spiritual. Holidays were an opportunity for rest, more manly outdoor pursuits and more study. Alamayu spent the summer of 1873 ploughing through Professor Archibald Geikie's actually relatively compelling scientific primer *Physical Geography* – a study of the globe from its crust to its core. The prince who had seen the world was now studying the world. According to the school handbook, he was also preparing for examinations 'in Latin and Greek Accidence, or in place of latter, Euclid ... Arithmetic and Algebra to Simple Equations' at the start of the next term.

As he approached the end of his time with the juniors, Alamayu had two main options to consider: an entry into the senior Classical Department, which was meant to prepare boys for yet more study at university or careers in the civil service and the 'learned professions'; or into the senior Military and Civil Department, known as the Modern, largely a launching pad for boys heading into the military and other more hands-on work, preparing them for 'Competitive Examinations for admission at Woolwich and Sandhurst, for the Indian Civil Engineer College, for the Direct Commissions in the Army, for Government Offices, and for Mercantile life'. Alamayu, in his letter to Lady Biddulph, was considering the Modern. Even a cursory survey of his record shows why his first thought wasn't a more academic route. Cheltenham College's registers listed the boys by their results in class work and examinations. You can still see his progress from Class IVA in the December of 1872 all the way to Class IIB two years later. With the exception of the first term, when his results were incomplete, he was invariably bottom or second bottom in each class. In July 1873 only

Jones, E. was below him in the rankings and by the end of 1874, he had edged ahead of the languishing Lamb, F.A. Jex-Blake had blamed a 'dilatory nature' for Alamayu's slow progress, echoing Speedy's complaints from India and Penang. But there were no signs of slowness or idleness in any other parts of Alamayu's active life. Such lazy and blanket condemnations will be familiar to anyone who has struggled to get a school to recognise their child's difficulties with learning. It is a risky business diagnosing anyone from the distance of 160 years, especially with no medical or other relevant expertise. Suffice to say the understanding of conditions such as dyslexia when Alamayu was at school was effectively nil. The earliest English use of the word listed in the online version of the Oxford English Dictionary is from years later, in 1885, and even there it is used in a different context.

Alamayu was busy considering his options when, suddenly, the whole issue of his academic future in Cheltenham became ... academic. Two years into the boy's stay at the school, the Rev. Thomas William Jex-Blake announced that he had applied for and secured a new appointment about 80 miles further northeast as the headmaster of the even more prestigious English public school of Rugby – where he had previously been both a pupil and a housemaster. Jex-Blake, it turned out, had one big thing in common with Captain Speedy. He too was an ambitious man in his chosen field, on the lookout for advancement and new opportunities. And when his career took a new path, everyone connected to him, including Alamayu, had to go with him.

After Alamayu left, he slowly faded into a Cheltenham myth. Boys told each other stories for years to come about a ghostly African man-servant who had hid in the basement of the boarding house and come up after dark to give the prince treats.

◎ ◎ ◎

It is tempting to see Alamayu as a real-life embodiment of the fictional hero of the bestselling book *Tom Brown's School Days* as he headed off

The Prince and the Plunder

to Rugby in the autumn of 1874. Alamayu too would have drawn up in a loaded coach, perhaps in plenty of time for dinner, and passed by the school field with its noble elms and the boys playing football, and tried to take in at once the long line of grey buildings, beginning with the chapel and ending with the School House, where the headmaster lived and the great flag waved lazily from the highest tower. Did he, like Tom, also begin 'to feel proud of being a Rugby boy as he passed the school gates, with the oriel-windows above, and saw the boys standing there, looking as if the town belonged to them'? He must have been hugely excited to start his new life as a boarder with a measure of independence from the Jex-Blakes – who moved en masse into School House, which eventually had to be extended to accommodate a growing family that now included two young sons alongside the nine girls.

In Thomas Hughes's book, Tom Brown meets his first friend within minutes of arriving and is racing out across the 'great playground' with him nine pages later. Alamayu moved into the Rev. Charles Elsee's boarding house on the edge of the school grounds in September and by the 24th of that month had his first appearance in the school newspaper *The Meteor* by coming fourth in the regular Harborough Magna race. On 4 October, he wrote another short letter to a friend called Victor (maybe Mrs Speedy's nephew?) saying he had already started football and music and been placed in the lowest form, though things might improve 'if I work very hard'.*

◎ ◎ ◎

Whatever you think of Britain's treatment of Alamayu, you can't accuse it of stinting on his education, at least in terms of the prestige of the institutions that he attended. Cheltenham College was impressive enough, but was a relative new-build at the time, founded only thirty years before Alamayu joined, the first of a rush of major public schools launched

* In another tangle of fiction and fact, Tom Brown's great enemy at Rugby, the bully Flashman, is the antihero of George MacDonald Fraser's fictional account of the Maqdala campaign, *Flashman on the March*, mentioned earlier.

during Victoria's reign. Rugby was and still is one of the cornerstones of the English establishment, founded in 1567 when Shakespeare was still a boy and Elizabeth I was on the throne. Old Rugbeians lined up behind Alamayu included Charles Lutwidge Dodgson, aka Lewis Carroll, the author of *Alice's Adventures in Wonderland*, and William Webb Ellis, the boy who according to a now widely dismissed myth, first 'took the ball in his arms and ran with it' during a game of football, inventing the game of rugby in the process. Old Rugbeians who followed after him include the First World War poet Rupert Brooke, the British Prime Minister Neville Chamberlain and, right up to the present day, the author Salman Rushdie.

Rugby's reputation had hit a peak a generation before Alamayu with the headmastership of Thomas Arnold, an earnest and devout giant of the era who had shaken up England's moribund public school system with a new set of priorities to sit alongside academic results and social standing. 'What we must look for here,' Arnold had famously said, 'is, first, religious and moral principles; secondly gentlemanly conduct; thirdly, intellectual ability'. Arnold's Rugby – the one attended by Tom Brown – was in the business of forming and reforming young men, infusing them with the right kind of Christian moral and political philosophy and sending them out to build Britain, and beyond that the British Empire, along the same lines. 'Perhaps ours is the only little corner of the British Empire which is thoroughly, wisely, and strongly ruled just now,' one young idealistic master tells Tom towards the end of the book as his schooldays are coming to a close.

Those educational priorities – with faith and conduct set above academics – might have been the perfect grounding for the young, open-hearted, active prince when he entered the lower school, listed in the register as 'Alamayu, Simyen, only legitimate son of the late Theodore, King of Abyssinia, and Teruwark, Princess of Simyen, Queen of Abyssinia'.

But after a strong start, he only made sporadic and unspectacular appearances in *The Meteor*, among them a catch in a cricket match in the July 1876 issue; two rugby defeats in October that year at which, nevertheless, Alamayu had been among those who 'did the most' and

'played best' for his side; and a run out for 12 in a match against the Rev. P. Bowden Smith's team in the 8 May 1877 edition. A painting still at the school shows a mass of boys in a rugby scrum with Alamayu watching several steps behind them in something like the fly-half position, part of the team and out on his own all at the same time.

Alamayu only made sporadic appearances in *The Meteor* largely because he only made sporadic appearances in school. For all the Arnoldian principles and priorities of the importance of achievements outside the classroom, he had hit a brick wall when it came to his lessons. In 1875, he was taken out of classes altogether for an extended period of tuition at the hands of Henry Montagu Draper, who had just set up a new educational establishment northwest of London in Boxmoor, Hertfordshire. Lockers Park school survives to this day, with Alamayu mentioned on lists of its prominent former pupils, alongside the Cold War Soviet agent Guy Burgess. Alamayu returned to Rugby after the Easter holidays the following year. By May 1876, when he was about to turn 15, Jex-Blake had all but given up when it came to the boy's academic prospects, and had decided there was now only one way forward for the young prince.

'Progress in study he will never make as I would wish,' Jex-Blake wrote to Biddulph. 'But he is active, manly and pleasant and fitter for the army than for any life I can think of. Wherever he goes he is well liked, I think, and the Army should give him an excellent training. He is very good at games, especially football, and I have never seen him out of temper.'

'Never out of temper' does not necessarily mean happy. You can get brief glimpses of Alamayu at Rugby in a couple of class photos in the collection of the late Sandy Holt-Wilson, one of Draper's descendants and a Rugby School old boy who grew up to become a campaigning eye surgeon and an expert on the prince. You have to look very closely to spot Alamayu in the first shot. There are more than forty boys, dressed in dark jackets and starched white collars, holding still for the long exposure in a classic school line-up. Foliage hangs off diamond-shaped windows and patterned brick walls in the background in one of the school's closes or quadrangles. A severe Victorian teacher with a severe Victorian beard sits in the middle of the ranks of teenagers.

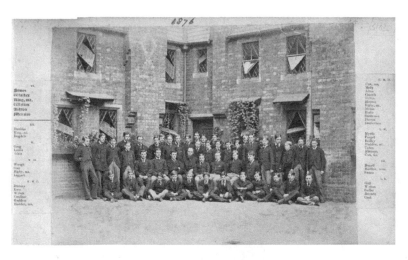

Class photo, Rugby School, 1876.

In the top right, three boys stand out. One of them, with short blond hair and dark shadows under his staring eyes, looks menacing, a bit like Lurch in the original *Addams Family* TV show. The one next to him is even taller, a bit more rough-cut, perhaps the sportsman of the group. And next to him is a public-school boy from central casting – centre parting, cool stare and an easy, assured stance. Just behind him, peeking out so only part of his face makes it into the picture, is Alamayu, shorter and slighter than the rest. He is the only Black boy in the class, which makes his disappearing act in the picture frame all the more striking. It is dangerous to over-interpret one moment caught in one photograph taken some time in 1876. But he seems timid, cowed and desperate to melt unnoticed into the background.

The second photo comes from the following year. There is a list of who's who, row by row, left to right, all surnames, no first names: Greg, Swann, Sadler, Salomons, Hadden, Wolton, Sparrow and Alamayu. Again, it is just one captured moment. But something has changed. A year after Jex-Blake effectively wrote him off academically, Alamayu, surrounded by perfectly turned-out schoolboys, has let his hair grow long, with his collar pulled up and his tie left askew. Has Alamayu

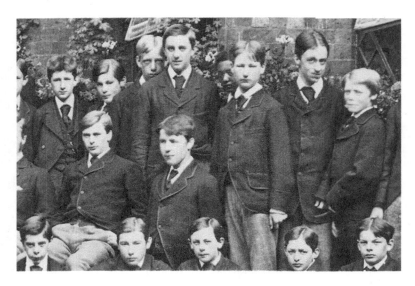

Detail of class photo, Rugby School, 1876.

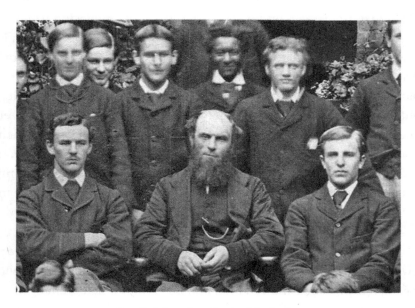

Detail of class photo, Rugby School, 1877.

resorted to playing the class clown? Has someone just leaned over and yanked his tie before the exposure? There is something about his expression that reminds me of my own children and their friends, when a crazed teenage thought has just flashed across their brain. Or maybe it is just a trick of the light and the murky nineteenth-century exposure.

◎ ◎ ◎

Whatever was happening, the truth is that behind the brave grinning front, all was not well beneath the surface. If Jex-Blake had never seen Alamayu out of temper, he clearly hadn't been paying enough attention.

In 1876, Speedy was back in Britain for a while and Alamayu was allowed to spend some time with him back in his old seaside home on the Isle of Wight. This is when Dorothy Tennant, the artist and future wife of Henry Morton Stanley, got a chance to meet them and record it all in her diary. 'The boy', she wrote, 'is depressed and unhappy.'

The lessons were too difficult for Alamayu, she said, and he was bottom in all his classes – in fact, bottom in the whole school. Speedy had argued that the boy should get coaching, should have gone to a preparatory school instead of Rugby. Alamayu was floundering, out of his depth.

Adolescence is a tough and isolating experience for anyone in the best of circumstances. Imagine how it must have been for Alamayu as he battled along through year after year of academic frustration. At a time when he most needed a home and a solid foundation, he was back shifting between a series of different holiday homes and guardians. And back on the Isle of Wight, back out in the open in the public thoroughfare of Victorian Britain, he was facing old problems. Everywhere he went everyone kept looking at him, everyone kept staring. Everyone including Dorothy Tennant. 'Alamayou, a slight boy of about sixteen, quite the n****r type,' she wrote. 'He is slight, in perfect proportion but small. His hands are lifeless and cold, and he was very silent and very shy ... He has a fine head, fine eyes, but thick nose and lips.' We are back in the stifling waiting room in Exeter St Davids railway station, back under someone else's dissecting gaze.

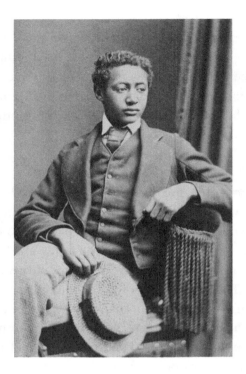

Alamayu at Rugby.

For Alamayu, wherever he was, it never let up. Britain's attitudes to the darker-skinned peoples of the world, particularly its imperial subjects, would have been reflected back at him in the conversations he overheard, the news in the newspapers and the few books he read. Queen Victoria gave him a copy of the newly published book *Wolfe's Wild Animals*, packed with exciting engravings of African wildlife and passages about the risks of 'attacks of savage beasts, or still more savage man'. It seems Alamayu had a taste for adventure stories. Even his personal copy of Jules Verne's *The Fur Country*, set far away from Africa in Canada's northwest territories, still had its characters celebrating the fact that out there they would not have to face the 'fierce black races'. They are equally rude about the Canadian locals with their

reddish-black complexions 'always ascribed in Europe to the evil spirits of fairyland'.*

Alamayu told Speedy about the time he had been watching some of the boys at school blacking up their faces with coal for a theatrical performance. Forgetting himself, and keen to join in, he had asked if he could have a piece of the burnt coke too. Other reminiscences about Alamayu in Old Rugbeians' memoirs are very thin on the ground, maybe because of the amount of time he spent away from the school with a tutor. There are no reports of best friends or a special gang of companions. The most significant relationship that crops up is by anyone's definition problematic.

Rugby, along with other major public schools, operated the 'fagging' system, under which junior boys did chores for the older pupils and could get payments or punishments in return. Alamayu ended up 'fagging' for one William Hawtrey, the son of an aristocratic family who went on, with his more famous brother Charles, to become a star of the music hall stage. In 1911, Hawtrey was on tour in the United States, where he gave publicity interviews to media, livened up with some of his own anecdotes of Alamayu:

'Once upon a time a King offered to make me his prime minister,' announced William Hawtrey, who came to English's today, at a little dinner given him during his run in Chicago in 'Dear Old Billy,' by the Press Club of that city. 'The King was Alamayu of Abyssinia, a son of Theodore, who was defeated by Lord Napier at Magdala.

'I was a school lad in the sixth form at Rugby, and Alamayu was sent there by the British government. He shared my room, and, as was customary, in English schools at the time, being a younger boy and a new scholar, he was my "fag". That is he had to run my errands, smuggle in tarts, birch beer and other forbidden schoolboy delights, and

* His copy is still listed in Rugby's school library collection. Other books of Alamayu's that we know about from other sources include Charles Dickens's *The Pickwick Papers* and Mrs Markham's *A History of England*, famed for its author's stated intent to tell the story of the country for children with most of the 'scenes of cruelty and fraud' left out.

black my boots. Rugby was a true democracy, for many a member of the highest nobility has had to "fag" for a commoner, and woe to him if his services were not satisfactory. He got what is known as a "jolly good hiding" from his master. So, in addition to nearly being a prime minister I've also had the pleasure of whacking a king and having him black my shoes.

'Alamayu was a melancholy youth, black as the ace of spades ... but he was very fond of me, and we boys used to plan how we would go back to Abyssinia when our school days were over and sweep Menelik from the throne. Then I was to be prime minister and teach the Abyssinians the white man's ways.'

Jex-Blake (like Speedy) was against corporal punishment, and got some flak from more conservative elements for refusing to beat his boys. But, lower down the hierarchy, his school could still be a punishing place.

◎ ◎ ◎

Back at school after his break, there was still no progress in Alamayu's lessons, so it was time to find another private tutor. Jex-Blake fixed on a man in his own mould, a driven Oxford graduate called Cyril Ransome. You would be right to think that surname sounds familiar. Cyril Ransome would go on, around seven years later, to have a son called Arthur, a boy who would write and illustrate the beloved *Swallows and Amazons* series of children's novels, books packed with Lake District adventures of camping, sailing and childhood exploration. If you are thinking that Alamayu may have at last found the role model he had been waiting for, someone who could whisk him out of the classroom and out onto the lakes of Windermere and Coniston Water, then prepare to be a little disappointed. The chapter about Arthur Ransome's early boyhood in Roland Chambers's excellent biography of the author, *The Last Englishman*, is titled 'The Judgemental Professor'.

Cyril Ransome, M.A. Oxon., had studied mathematics then modern history at Merton College, then gone on to teach at the Oxford Military

College in Cowley – a private school for boys preparing to get their military commissions. He seemed the perfect man to usher Alamayu along what was now universally seen as the next stage in his career. Ransome was still in his twenties and active, a lover of hiking, fishing and other self-improving, manly pursuits – and that in itself must have been refreshing. But he was above all, like Arnold and Jex-Blake before him, a champion of more cerebral exertions. A few years later, the day after one Edith Boulton accepted his proposal of marriage, he presented her with volumes of Walter Bagehot's essays and Wordsworth's poems marked with his own annotations, and said he would be testing her on them a week later. He started out as a Liberal but was a more natural Conservative, a champion of empire. His own works included his takes on British history for students and a collection of lectures to working men's societies, with the self-explanatory title *Our colonies and India: How we got them and why we keep them.*

In 1877, as he wrote in the draft of his unpublished autobiography, now in Leeds University's Brotherton Library, he was appointed tutor to Prince Alamayu of Abyssinia, who had shown 'an ineptitude for regular study'. There is little of Alamayu in this stage of his hand-written memoirs, more about the connections he made and his kind reception from the Jex-Blakes. He lodged at 22 Warwick Street in Rugby, took the boy and some of the older Jex-Blake girls through their lessons and, in his spare time, took walks and bicycle rides in the surrounding Warwickshire countryside. He 'consumed much tobacco and discussed all things in heaven and earth' with his new acquaintances among the masters.

A year on, he heard of a new job opening as professor of history and modern literature at the Yorkshire College and made a successful application. Before leaving, he agreed to spend a few more weeks over the summer with his young charge and take him to Europe. Ransome picked up Alamayu at Osborne House on the Isle of Wight, where he had been staying for the holidays, this time with Lord Biddulph. The pair headed over to the French capital, which was then in the throes of hosting the third of its great world fairs, the Exposition Universelle of 1878 – a vast display of fine arts and industrial marvels

spread over both banks of the Seine. The giant head of the Statue of Liberty, complete with spiked crown, was out on display, seven years before her journey across the Atlantic to New York. Alexander Graham Bell showed off his telephone, alongside other electric marvels. There were demonstrations of Henri Giffard's huge balloon. True to his name, Alamayu got to see the world, spread out in front of him in miniature, with the great powers of the time and their colonies competing against each other with displays along La Rue des Nations. In a reminder to Alamayu of how people like him fitted into this polished schema, several countries constructed pavilions and dioramas alongside ethnographic exhibits and a display of turbaned 'Indian workers' at their loom in the Galerie du travail.

From there, Ransome and Alamayu visited Rouen, Loreux and Caen before taking the boat back from Cherbourg to Southampton. Then they headed to Rugby, where Alamayu packed up a few possessions, for his time at the great school of Tom Brown, Thomas Arnold and Thomas Jex-Blake was over. Ransome accompanied him on this next great journey, back south to what was then called the Royal Military College, Sandhurst. The adults governing Alamayu's life had decided that from now on in, he must follow the military route.

A number of accounts of this time have suggested that Alamayu bonded with his tutor during their year together in Rugby and France. If he did, the relationship was a little one-sided. During the trip, the twenty-something tutor found the teenager's presence 'a great nuisance', Ransome later wrote in his unpublished autobiography. Alamayu had particularly annoyed him towards the end of the trip by complaining about the Jex-Blakes. 'When we parted, I told him plainly what I thought of his ingratitude.'

There is no record of any other parting words, perhaps of support or encouragement, as Alamayu took in his new surroundings at the officer training centre in the Home Counties town of Camberley. Arthur Ransome – who went on to have his own rather miserable schooldays at Rugby – always said he felt he had been a huge disappointment to his

exacting father, who died in 1897 when his son was just 13. It is another of the great what-ifs in Alamayu's story: what if things had turned out differently and Alamayu had been able to stay in touch with the Ransomes over the years? He would have been a compelling elder brotherly, avuncular figure for the future writer of *Swallows and Amazons* and *We Didn't Mean To Go To Sea*. All in all, they would have had a lot of common ground to go over.

◎ ◎ ◎

And so, finally, Britain's plan for its young Ethiopian charge had ground its way to its conclusion. From the moment Alamayu set foot in Britain, the talk had been that he was destined for a remote outpost in the British Empire, probably a remote military outpost given his love of outdoor life and hatred of books.

'I should think that the kindest thing for him would be to let his education take a military turn,' Britain's bulldozer Robert Lowe wrote back in 1870. Six years on, his successor Sir Stafford Northcote stopped for a moment to wonder if 'it would do to put Alamayu to command white men'. But that thought didn't hold him back for long. There were, of course, lots of non-white men for the boy to command and administer beyond Britain's borders, out in India. 'At all events if he is ultimately to join the Indian service,' Northcote continued, 'it must be through the regular army.' That was the end of it. Alamayu *must* join the British Army – the force that had invaded his country, killed his father and blown his first home to pieces.

On 1 September 1878, at the age of 17, Alamayu signed on for a year's tuition at the institution that had sent and would continue to send thousands upon thousands of young officers to the frontlines to fight for kings and queens and country. The statesmen directing Alamayu's future must have thought they had the whole thing sewn up. Normally recruits crammed like mad to get through an entrance exam, but Alamayu's academic record was such that they had got him

an exemption. In a matter of months, he would be on his way. In those days, once a young gentleman got into Sandhurst, he very, very rarely failed to progress on to the infantry or cavalry. The pressure was on to keep the supply of young officers flowing to guard the empire and fight the endless succession of 'little wars' that punctuated the increasingly inaccurately named era of *Pax Britannica*. A cadet could fail a few exams, misbehave, even go off the rails, but there were always retakes and other ways to get over the finishing line to his commission.

The pass marks were 'ludicrously low', former instructor Lieutenant-Colonel G.F.R. Henderson told a parliamentary committee investigating standards at Sandhurst at the turn of the century. 'No cadet has the slightest difficulty getting out of Sandhurst,' he added, meaning 'get out' the other end, fully qualified, as a serving officer.

Alamayu found another kind of exit route. Three months after starting, he sat down with the other 140 cadets in his intake to take his proficiency examinations and crashed out of the course in spectacular fashion.

The boy who had grown up on Maqdala, one of the world's greatest natural strongholds, got 29 for fortifications, 10 for military law and zero for military surveying. The double row of figures in the college's Cadet Register (1864–81) – all that's left of Alamayu in the college's digitised records – does not show the total marks he could have been aiming for. But as an indication, after scraping a pass in military administration and in tactics, he was still way down at the bottom of the class with an overall total of 226 marks, a fail. The next worst on the list, an 18-year-old called Francis Henry Smalpage, also failed with almost twice that amount. That day's star performer, a 19-year-old who went on to become Lieutenant-General Sir Frederick McCracken, and serve in Egypt, Sudan, the Boer War and the Battle of the Somme, came top with 1,055.

No problem, there were re-sits. Alamayu sat down again with three other cadets in July the next year and did better, marginally better – a few more marks in fortification and military law, a rise from nought to 50 in military surveying (still a fail), but a collapse in his military administration grade and his only pass, a much slimmer pass, in tactics.

Lessons

The total figure, 245, is crossed out with a single line in the ledger, the sign of another overall fail. The three other young men passed on their second go and, eventually, headed on to their commissions and their regimental barracks. Alamayu never went on to his finals, perhaps a shame as they included extra examinations where he may have shone – gymnastics, drill and riding.

It would be wonderful to find some positive spin at this point, to present Alamayu's grades not as signs of failure, but as acts of defiance, a conscious effort on his part to bring the statesmen's plans for his future to a juddering halt. The full force of the British establishment had been pushing him on, forcing him down one career path. That state-powered progress had now crashed into a line of crossed-out copperplate figures in a military logbook. Now everyone would have to stop and think again. This time, perhaps, they would think to consult the prince.

It would be wonderful to think that. It is much more likely however, that Alamayu tried his best but simply found himself facing insurmountable obstacles, obstacles that stood in his path through no fault of his own and left him at a point of real crisis. If he was mounting a protest, it was a very quiet, internalised one. A few of the other cadets were marked down in the records as 'unsatisfactory' or 'troublesome'. Alamayu's conduct was always 'good' with reservations – 'good but hopelessly unpunctual', 'good but never on time for anything'.

The first obstacle was an education that had simply failed to prepare him for the challenges he faced. Cheltenham and Rugby may look impressive on paper but the reality, as we have seen, was a mishmash of tutors and constant movement from establishment to establishment, guardian to guardian, even continent to continent. We will never be able to gauge the impact of his childhood traumas and whatever ill treatment he received out of sight, out of mind in the years that followed. The statesmen may have thought they were doing him a favour by sparing him the Sandhurst entrance exam. But that exemption deprived him of essential groundwork. Compare the career of one of his classmates, Charles Carmichael Monro – another future First World War general – who arrived at Sandhurst aged 18 equipped with a full, unbroken stint at

England's elite Sherborne School followed by an extra year in a military 'crammer' college in Wimbledon, where he got extra tuition in, among other subjects, maths, drawing and geometry to prepare him for his studies. He got through his Sandhurst exams the first time around, albeit without distinction. Alamayu's entry, by comparison, was a rush job: straight out of school, one of only a handful of 17-year-olds in his intake.

You might think he would have found subjects like fortification more appealing than book study. But Sandhurst's curriculum leaned to the theoretical over the practical. If he did have something like dyslexia, the knowledge wasn't there to recognise or deal with it.

From a distance of 160 years, through all the walls of establishment silence and missing records, it is almost impossible to reconstruct exactly what was going on for Alamayu at Sandhurst. Whatever it was, it was bad. All the trauma, the separation and abuse, were working away at him from inside. The only clues, again, come from other people's letters, other people's accounts.

Evangeline Jex-Blake's letter to *The Times* more than fifty years later went on to describe his later career. 'At Sandhurst he was much ragged, as a man in the Army told me years afterwards. But he himself uttered no word of it to anyone at the time, at least to none of our family.' For 'much ragged', read bullied. Reticent Alamayu, bound by the cast-iron honour code of public-school life, never told on his classmates and held everything in.

That code of silence no doubt contributed to the fact that very few reminiscences of Alamayu at Sandhurst survive. But the hints are there and we can connect the dots. Sandhurst had a long and ignominious history of bullying. 'None but the tough fellows could live through it, Sir, at Sandhurst,' Major Bagstock tells Mr Dombey in Charles Dickens's *Dombey and Son*, first published in serialised form in the late 1840s. 'We put each other to the torture there, Sir. We roasted the new fellows at a slow fire, and hung 'em out of a three pair of stairs window, with their heads downwards. Joseph Bagstock, Sir, was held out of the window by the heels of his boots, for thirteen minutes by the college clock ... It made us what we were, Sir ... We were iron, Sir, and it forged us.'

Outside the covers of Dickens, stories still circulate in Sandhurst from the 1830s of one Horace Cockrane, who branded the king's initials onto his dormitory mates after a royal visit. Both of those earlier nineteenth-century accounts come from a different era, when the college took in boys from their early teens onwards. By Alamayu's time, the course was down to one year, taken after a boy had already survived secondary school. But he was still one of the youngest in an intake that had cadets into their early twenties, and among the shortest, according to the entrance logs. He was also, by far, the Blackest.

It can't have helped that at least one of the textbooks used at the college – *Minor Tactics* by Cornelius Francis Clery – included a reference to lessons learned in the 1868 Abyssinian campaign. Some editions of another – the *Manual of Field Fortification, Military Sketching and Reconnaissance* – ended with an all-bold advertisement for Holland and Hozier's two-volume *Record of the Expedition to Abyssinia*.

Another letter to *The Times* came in a week after Evangeline Jex-Blake's. 'My brother was at the R.M.C. at Sandhurst at the same time Prince Alamayahu was there,' wrote Captain W. Tower Townshend of Bodiam Manor, Suffolk. 'He told me it was a pitiable sight to see this poor young man shivering with cold at morning parade, and he used to say to the cadets, "I know I am only a poor n****r and all you fellows are laughing at me," which they certainly were not, as they were very sorry for the way he seemed to feel the English climate.' Sorrow and pity, but no suggestion that anyone did anything about it or offered to help. Alamayu's frustration and the obstacles he faced had backed up into a cesspool of self-hate.

On 13 August 1879, the vast majority of Alamayu's class lined up, took up their commissions and headed out to regiments dotted across the British Empire. The last column in the Sandhurst logbook marks Alamayu down as 'withdrawn'.

Chapter Ten

The Funeral Psalm

'I know not, said Rasselas, what pleasure the sight of the catacombs
can afford; but, since nothing else is offered, I am resolved to view
them, and shall place this with many other things which I have
done, because I would do something.'
The History of Rasselas, Prince of Abissinia

Alamayu, now 18, headed back to his adults. He had no money or place
of his own – the £700 annual payments had always gone straight to his
guardians. He spent some time touring Scotland with Speedy, who hap-
pened to be back in the country. By early September, he was holed up
in Pynes, the sprawling manor house outside Exeter that was then the
home of Sir Stafford Northcote, the Chancellor of the Exchequer.

Northcote, by then the leader of the Conservative Party in the House
of Commons, knew how to corral the whips and manage the intricacies
of public debt, but he had no idea of how to handle a traumatised, direc-
tionless teenager. After consulting with Jex-Blake, Lord Napier (recently
elevated to the governorship of Gibraltar) and Alamayu himself, it was
clear that the young man could not go back to Sandhurst.

Alamayu did have one clear idea for his future. The prince 'had a
hankering after his own country where he said he had two aunts and a
half-brother living', Northcote wrote to the queen via Lady Biddulph.
The Chancellor moved quickly to nip that plan in the bud. 'I told him
that his going to Abyssinia was out of the question, and he then said
there was no one in England who had ever done him so much good as

181

Mr. Ransome and that he would like to go to him.' In the absence of any better schemes, Northcote wrote to Ransome and asked him if he could resume his tuition for at least the next six months, while they tried to work out what to do next.

Ransome agreed. The financial arrangements – £250 for him and, for the first time, £50 'to be put at Alamayu's own disposal' – were satisfactory, though he suggested he would not give the young man all of his allowance at once. And Alamayu was back on the road once again as winter drew in, heading north to his tutor's new home at 1 Hollin Lane, Headingley, a bracing half-hour's walk out of Leeds city centre. It is still there, though the street numbers have changed, in a row of handsome Victorian houses on a ridge looking out over what would have then been open land. When I visited, sun streamed through the windows and the prince's portrait still hung in the hall – the present owners are big Alamayu fans and have done their research. Back then, without central heating, modern insulation and indoor lavatories, it would have been a much, much chillier place. Alamayu moved into his room – possibly the one at the back with big windows and a view of the garden – and prepared for his studies. His main weaknesses, Ransome had decided, were English composition, particularly letter writing, and French.

Then, on 11 October, came what the tutor later described in his autobiography as the 'foolish act'. Alamayu, Ransome wrote, got up to go to the bathroom and fell asleep in the outhouse in the middle of a particularly cold night. There, Ransome said, the boy caught a violent cold that developed into full-blown pneumonia. Alamayu was confined to his bed.

Pneumonia was bad enough, a regular killer. But something just as serious had been building up inside his mind. After Alamayu fell ill, Ransome wrote to Northcote, who spread the news through Alamayu's disparate network of guardians. Northcote wrote to the queen, via Lady Biddulph, that the boy's condition had 'been aggravated and his strength sadly reduced by an extraordinary fancy that he had been poisoned which led him for some time to refuse all food and medicines'. Echoes of Tewodros's mounting paranoia in his scarlet tent at the top of Maqdala, as his enemies gathered around him and his avenues for

The Funeral Psalm

escape, even movement, narrowed. 'I wish I could be of any use to you, but I cannot think of any suggestions that would be worth offering,' Northcote wrote back to Ransome on 21 October. 'There is no doubt an amount of suspiciousness in Alamayu's nature which makes him very difficult to deal with. It verges on insanity, and makes one fear for the future. I am afraid from your account that he is in very considerable danger: but you could do no more than you are doing.' He had clearly experienced some of Alamayu's darker moods before.

For the most part, the adults limited themselves to expressing their concern by telegram and letter. They were busy and nineteenth-century Britain kept rushing on around them. Northcote was staying at another of the nation's great properties, Galloway House on the east coast of Scotland, but was due back in London and then had an appointment with the queen back up at Balmoral. He advised Ransome to channel his letters via 10 Downing Street.

In their absence, Alamayu had finally found a reserve of iron will to defy all their wishes, by refusing his food and refusing all treatment, at least for a while. Northcote said he eventually gave way. Addled by fever, Alamayu lay in his bed, largely oblivious to anything else.

Every day there was another rush of letters and telegrams arriving at Headingley – you can still find them all, bundled neatly together in boxes in the archives in Leeds University's Brotherton Library – leaving a frantic Ransome to deal with his patient, all the correspondence and, presumably, his day job, all at the same time. Some correspondents asked whether Alamayu should go back to Speedy to recuperate on the south coast of England, some suggested Napier, in the healthier climate of Gibraltar. In one heartrending note, Northcote wrote, 'When I last heard from Capt. Speedy he did not wish to have him; but perhaps the illness may have made a difference.' We will never know what made Speedy, at the last moment, reject his former charge. Perhaps after seeing the full extent of Alamayu's decline after Sandhurst, he felt he would now be too much to handle.

None of these discussions came to anything. Ransome wrote that, for now, the doctors had ruled out all movement. Alamayu had grown

weaker and weaker through lack of food. 'So far I have not been able to find out what the patient wishes.' The doctors had diagnosed the onset of pleurisy and 'tapped' Alamayu twice in the chest – though Ransome did not go into any more detail on the procedure.

Reports of his illness, a brief recuperation and then a deeper decline, got blow-by-blow coverage in the national press. Prayers were said in Rugby's school chapel. The queen sent telegram after telegram down from Balmoral asking Ransome to send more updates that very morning, that afternoon, that evening. She sent expensive doctors, representatives from her household, prayers and good wishes. Even old Cornelia Cotton, Alamayu's quasi-grandmother, now widowed and staying with relatives in St Andrews, got in touch, anxious to know whether there was a minister on hand to look after his spiritual welfare alongside his health. She had been concerned about Alamayu's apparent lack of interest in scriptural matters the last time he had come to visit:

> He seemed to know nothing of his own state as a sinner or of the only way to salvation through faith in Christ and now that he appears hovering on the borders of Eternity it would rejoice me to know that there are those about him who will endeavour to lead his soul to the only true source of ... safety. Poor boy!

An Edward C. Robbins, from St John's Wood in London, wrote to say he had known Alamayu and Speedy since they had first arrived in Britain. Could he pass on his prayers and best wishes? Could he have even a brief update on the boy's health? 'Dear fellow, as he grew in years, the peculiarity of his position seemed to exercise his mind detrimentally to his health – and his "heart-solitariness" to grievously oppress him.'

At one point Alamayu rallied and asked to see Speedy, who did come to stay for two days. There are no details of what they said.

Alamayu's most constant companion at that time did not come from his rollcall of eminent guardians. A young woman called Sarah Nainby, who had been working at a care home in Hyde Terrace, Leeds, was taken

on as Alamayu's personal nurse. While the telegrams buzzed in over the wires and the doctors' coaches crunched up to the door, Nurse Nainby spent five weeks treating, washing and caring for her patient. She also tried feeding him the oranges and other fruit sent in by well-wishers. 'He was not very talkative but he seemed to take to me as a nurse,' the by then elderly Mrs Sarah Fearnside told a reporter from the *Yorkshire Evening Post* half a century later.

Week after week of sickness and decline, dark diagnoses and darker forebodings. But it still came as a shock when it finally happened. Alamayu died on the morning of 14 November 1879, a few months short of his nineteenth birthday.

Ransome and Mrs Jex-Blake were with him at the end. More telegrams went out, and more and more telegrams flooded back in. Among the first of them, one from the queen, expressing her deep sorrow and asking for 'all details you can send of his last moments' and a lock of hair from Alamayu's head. In another echo of his father's fate, Alamayu ended up losing several locks of hair that day. One went to Nurse Nainby, who around fifty years later displayed the rest of her relics of the boy to the Yorkshire reporter, among them the chart she had used to record Alamayu's temperature, and the prince's copy of *The Pickwick Papers*. All of Alamayu's personal effects were divided among those who had been closest to him, including the servants, by order of the Treasury.

Victoria, still 300 miles north, up at Balmoral castle, kept up the flow of telegrams over the next few days. She wanted his funeral to be at St George's Chapel, Windsor Castle. She wanted to thank Ransome for all his care and attention. She wanted the letter she had sent Alamayu, and any other of the personal trinkets she had given him, to be buried with him in his coffin.

There was no let-up for the tutor at Hollin Lane. A plaster cast was taken of the prince's face for any future memorial statues. A photographer came to take two posthumous photographs. I can still remember the moment they came out of the box at the Brotherton Library. Alamayu could still be sleeping.

185

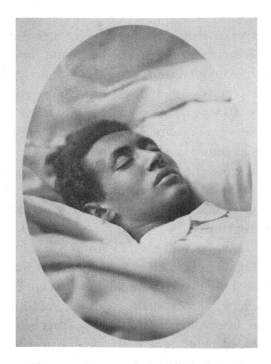

Alamayu photographed after death, 1879.

And then there was the post-mortem to handle. The final diagnosis varies depending on what record you are reading. It was pneumonia, pleurisy, pleuro-pneumonia, bronchitis, broncho-pleuro-pneumonia, consumption, a lingering case of tuberculosis – echoes of Alamayu's young mother.

On the day of his death, Queen Victoria summed up her feelings in her journal:

> Was very grieved and shocked to hear by telegram that good Alamayou had passed away this morning. It is too sad. All alone in a strange country, without seeing a person or relative belonging to him, so young and so good, but for him one cannot repine. His was no happy life, full of difficulties of every kind, and he was so sensitive, thinking that people stared at him because of his colour, that I fear he would have never been happy. Everyone is very sorry.

The Funeral Psalm

◎ ◎ ◎

It was a Reuters reporter who had watched the prince's arrival in Britain eleven years earlier. It was another Reuters reporter who watched his departure on Friday 21 November, 1879. The news agency's correspondent in Windsor sent in his report: 'At noon the remains of the late Prince Alamayou were interred in the presence of a number of spectators at the west end of St. George's Chapel.'

From all the protestations of concern and friendship, you might have expected Queen Victoria herself to have been one of those spectators. But her loyalties were divided. John Grant, her head keeper at Balmoral and a family favourite over the past twenty-five years, had died around the same time. She decided to spend another three or four days in Scotland as a mark of respect to him.

It was a select group that arrived to remember Alamayu in Windsor, partly due to the weather. Heavy snow had fallen since dawn and lay an inch thick on the ground. After the choristers and lay clerks assembled, Lady Biddulph, the Hon. Lady Ponsonby and Mrs Jex-Blake walked down the nave and placed wreaths on the coffin. They were followed by Sir John Cowell, representing the queen, Sir Stafford Northcote and Napier's son – Napier himself was detained in Gibraltar, entertaining two of Victoria's grandsons. Then the mourners reassembled and formed a procession, accompanying the polished oak coffin down the aisle of the chapel, which was decorated in black and white festoons. The Rev. Jex-Blake, Captain Speedy, a representative of the Cottons and Mr Richard Rivington Holmes, formerly of the British Museum, now swelled the congregation. The bulldozer Robert Lowe arrived late. By the time he entered by the south door, the procession had already started. 'Being recognized by some bystanders he was conducted to the west end of the Chapel, where he joined Sir Stafford Northcote,' a widely syndicated newspaper report stated, without further comment.

The choir sang 'I Know that My Redeemer Lives' and then, after the body was placed on the bier and the congregation took their seats, the 39th Psalm, sung to a chant by Beethoven in C minor.

The 39th Psalm is known as the Funeral Psalm, a standard text wheeled out again and again for burial after burial. But it could have been written for Alamayu and the small group of failed father figures who turned out to mourn him. So much had gone unsaid through his life; so few had spoken out for him. And his death when it came was abrupt and absurd.

> I was dumb with silence, I held my peace, even from good; and my sorrow was stirred. My heart was hot within me, while I was musing the fire burned: then spake I with my tongue, 'Lord, make me to know mine end, and the measure of my days, what it is: that I may know how frail I am. Behold, thou hast made my days as an handbreadth; and mine age is as nothing before thee: verily every man at his best state is altogether vanity.

They are the words his mother would have read countless times as she looked through her own Book of Psalms, the manuscript covered in wooden boards that he brought with him to England.

> Hear my prayer, O Lord, and give ear unto my cry; hold not thy peace at my tears: for I am a stranger with thee, and a sojourner, as all my fathers were. O spare me, that I may recover strength, before I go hence, and be no more.

It could have just been the Psalm of the day, slotted into the service by one of Windsor's duty clergy. It could have also been a request from someone who knew the prince well and wanted to have some real words of grief and anger spoken over his coffin. If it was, my money is on Speedy.

After the lesson and the anthem, there was a performance of the 'Dead March' from Handel's *Saul*, almost certainly unbeknownst to them the same music that the British military band played, briefly, as Alamayu's mother was taken to her grave in Ethiopia.

The prince was laid to rest outside the church, in a brick vault built for him in the underground burial chamber, the catacombs, at the north-west end of the chapel. The weather was bitterly cold, so the mourners did not stay long. The Hon. Lady Ponsonby and the Hon. Lady Biddulph walked over to the grave and covered the coffin with flowers.

◎ ◎ ◎

More than a year later, Victoria herself was back in Windsor, inspecting some new memorial plaques in the chapel. One of them on the west wall of the north nave aisle was a handsome brass tablet, engraved in English and Amharic, dedicated to the memory of 'Alamayu, Prince of Abyssinia ... placed here to his memory by Queen Victoria'. It had been designed for her by her chief librarian in Windsor Castle ... one Mr Richard Rivington Holmes, previously curator at the British Museum and briefly 'archaeologist' on the Abyssinian Expedition.

More than forty years later, in 1924, Ras Tafari Makonnen – then Ethiopia's Prince Regent, soon to be its Emperor Haile Selassie – visited the chapel on a state trip to Britain. After the officials showed him the plaque to Alamayu, he had a close look at the wording and declared that there was a mistake in the engraving. Holmes had clearly not triple-checked his Amharic formulations; to the end the British never quite managed to get the prince's name right. Ras Tafari ordered a simple silver gilt plate to cover up the error. You can still see it today – 'Alamayu Tewodros' in Ethiopian letters, hammered out on top of the British memorial.

Chapter Eleven

Return

'They deliberated a while what was to be done, and resolved, when
the inundation should cease, to return to Abissinia.'
The History of Rasselas, Prince of Abissinia

And that was where I had meant to end Alamayu's story. Until two
folders of confidential British government papers that I had missed
in The National Archives turned up online. One contained the text
of a letter from none other than the great British imperial figurehead
Gordon Pasha – aka Chinese Gordon, later General Gordon, Gordon
of Khartoum – starting: 'In answer to your letter dated the 19th October
[1879], received yesterday, respecting the return of Prince Alamayou to
Abyssinia ...' It turned the story on its head. All the way through the
prince's time in Britain, the authorities had been clear there was no way
they would let him go back to Ethiopia. But here was proof that in the
weeks leading up to his death, someone, somewhere had been making
enquiries, wondering after all if it would be possible to give Alamayu
what he wanted: a ticket home.

The original request is not in the folder. But those twenty or so words
at the start of the reply open up an alternative universe of what might
have happened if Alamayu had held on for just another few months.

Alamayu's name keeps cropping up in the Foreign Office papers.
Gordon, then coming to the end of a two-and-a-half-year stint as governor
general of Sudan under its Ottoman–Egyptian rulers, was travelling in
neighbouring Ethiopia, sometimes passing through territories around

Lake Tana – the old stomping ground of Bell, Plowden and Cameron before him. He was testing the political temperature wherever he went and keeping in touch with the authorities in Britain which, as the full Scramble for Africa approached, was getting ever more deeply involved in Egypt and Sudan, so had a good reason to renew its interest in Ethiopia.

It turned out the Ethiopians had not forgotten their lost prince while he was gone. Alamayu's 'name was known throughout the land, and the people thought our government would send him here', Gordon wrote in a diary that was transcribed and sent on to London, where it was included in the confidential Foreign Office files.

Gordon described in another dispatch how Ethiopia's warring princes had tussled for power after Tewodros's defeat at Maqdala back in 1868, until Kasa of Tigray eventually came out on top in the north of the country, helped by the guns the British forces had left him as they withdrew to the coast. He claimed the Solomonic title, named himself King of Kings Yohannes IV and made plans for his own imperial dynasty. But he was always on the lookout for challengers and the thought of his predecessor's son growing older and stronger out of his reach in Britain was a constant nag.

At one point, Yohannes's translator took Gordon aside for an off-the-record briefing. 'The King has a son 13 years of age,' the translator said pointedly. 'The King is quite sure England is his friend and will never let Alamayou come back.'

Yohannes wanted Alamayu to stay in Britain to stave off any threat to his own rule or his own son's succession. Unsurprisingly, the rebels fighting against Yohannes had other ideas. They were very keen for Alamayu to return as the figurehead of a revolt. One in particular, called Walad el Michael aka Wadenkal, had begged Gordon to bring Alamayu home.

(Gordon had earlier heard reports that Captain Speedy was also active, sending out messages, reaching out to the Rases, trying to drum up support for Alamayu's return. Remember those question marks over his motives. If Speedy had managed to bring back Alamayu and place him on the throne with himself alongside as the new emperor's old guardian, he would have out John-Belled John Bell.)

Adding to the mix, two young men calling themselves Tewodros's sons and Alamayu's half-brothers had also cropped up on the Ethiopian political scene. One was Meshesha – presumably Tewodros's afore-mentioned first son from his days in Kwara. The other was younger, according to Gordon's letters.

We know that Meshesha at least survived and went on years later to become a key ally and senior office holder under Ethiopia's next emperor, Menelik II – Meshesha's old boyhood friend from their days up on Maqdala. Who knows what might have happened if Alamayu had returned to join his half-brothers, what geographical or hereditary alliance he might have been able to forge? He could have been a warrior king, or a failed militia leader, a debauched tyrant or a Christian champion – Bob Dylan's noble hymn-singing king from his Ethiopia-tinged track *I and I*. He could have also wasted away his years as a political prisoner in a 'happy valley' or a mountain fortress somewhere in Amhara. Whatever his fate, there is a good chance he would have kept living and breathing for at least a few years longer.

We'll never know. The letter to Gordon asking about the chances of Alamayu's return may have been dated 19 October 1879, a month before the boy's death, but it got to Gordon late and he replied in December, the month after Alamayu's funeral. Gordon already knew Alamayu was dead when he sat down to write; the news had spread far and wide by telegraph, newspaper and official dispatch. In Gordon's opinion, if Alamayu had survived and come back, Yohannes would have publicly, warmly welcomed him. But then, like Rasselas and Tewodros's political prisoners before him, the boy would have been placed in some sort of gilded cage, safely out of the way. 'The King would have rejoiced at Prince Alamayou's arrival, but he would have been a state prisoner,' Gordon wrote. That is what Gordon thought would have happened *if* Alamayu had come back. But one stark fact wiped out all alternate histories and speculative endings, happy or otherwise.

'In answer to your letter dated the 19th October, received yesterday, respecting the return of Prince Alamayou to Abyssinia,' Gordon wrote in his three-line response, 'as the Prince is dead, the matter is finished.'

Part Two

The Plunder

The Plunder

'The palace stood on an eminence raised about thirty paces above
the surface of the lake ... Many of the columns had unsuspected
cavities, in which a long race of monarchs had reposited their
treasures. They then closed up the opening with marble, which was
never to be removed but in the utmost exigencies of the kingdom;
and recorded their accumulations in a book which was itself con-
cealed in a tower not entered but by the emperour, attended by the
prince who stood next in succession.'

The History of Rasselas, Prince of Abissinia

Here's how to find some buried treasure in the centre of London.

Forget the explorer's gear, the hat, the whip. You don't need to look
like Indiana Jones for this. Dress like a tourist and head to Westminster
Abbey, across the road from the Houses of Parliament. Hand over the
exorbitant entrance fee and follow the crowds past the tombs of empire
grandees, prime ministers, princes and poets.

Towards the end of the trail, you will come to a chapel that holds the
remains of King Henry VII and his wife, Elizabeth of York. Wait for the
red-robed guards to move away, edge past the velvet ropes at the altar
and poke your head around the back. And there you will see ... well, at
first glance, not very much.

Push your luck and edge a bit further round, getting your body into
the gap between the altar and the tomb. You should be able to make out
two windows, a few inches wide, set into the altar's rear wall.

If the guards still haven't spotted you, peer into the first one on the
left and you are going to be disappointed. The window is a sheet of
something like Perspex over a small rectangular chamber cut into the
back of the altar. Someone has smeared paint over the inside of the
pane, blocking the view. Below it, on the wall, there's a carved message
describing what's hidden inside – a fragment of the wreckage left when
fire ripped through Canterbury Cathedral in 1174. A dig through the
archives will tell you it is a piece of stone, removed from Canterbury,
taken to Westminster and placed inside Henry's altar like some kind

of ecclesiastical transplant or lucky charm. You will have to take the archives' word for it. You can't see anything in the murk.

Next to that there's a smaller window, just as badly besmirched. The carved label and the archives tell you there's another 'fragment' lying in the alcove behind, taken from a Greek church in Damascus that was destroyed during a massacre in 1860. Another wrecked relic sealed inside the altar, forced to share some of its aura with Henry's monument. You can't see it through the paint and it's not what you're looking for anyway.

Beyond that, can you see empty space past the two windows, the space where a third window could be? Get the light right and you should indeed see the faint square outline of a slightly larger, squarer opening. Someone has blocked it off completely with a sheet of hardboard, and then painted it over the same colour as the surrounding surface – almost as if someone in the abbey was trying to hide something.

The only clue to what is buried behind that barrier is the remains of another inscription just below it. The carved words have been filled in with plaster or paint. Get close up and you can still see the shape of the letters.

They spell out the message: 'brought from Magdala in 1868'.

◎ ◎ ◎

Treasures from Maqdala spread far and wide after they landed in London and a handful of other capitals in 1868. A few artefacts had their moment in the spotlight in exhibitions. Most crept into quieter places – museum storage boxes, library rolling stack archive shelves, hidden crevices in royal tombs.

What follows is a list of relics and wonders – all the Maqdala plunder and other treasures from the expedition that I could find. It builds on the research of others, particularly, time and time again, Richard Pankhurst, son of the suffragette Sylvia Pankhurst. He grew up to become one of the world's leading experts on Ethiopian affairs. His wife Rita Pankhurst, through her own studies, almost single-handedly

tracked down the locations of the Maqdala manuscripts. This section is dedicated to them. Other items were traced through contemporary accounts, museum databases and online ledgers. The fuller directory can be seen on this book's website: www.theprinceandtheplunder.com.

The last time most of these objects were all together in one place was at the top of Maqdala more than 150 years ago, on the afternoon of Monday 13 April 1868, before the soldiers swooped and the torn manuscript pages started flying in the wind.

It is more than a random collection of riches. There are clear signs that Tewodros was trying to marshal some sort of central national collection of artefacts and books as he used the strength of his army and his own character to force Ethiopia to unify after its decades of chaos.

Some of the manuscripts were commissioned by Tewodros himself. He took others during his raids on Gondar and the other centres of the old, fragmented regimes. You can often follow the books' journeys in the notes that priests and other custodians wrote in the margins of their pages. Alaka Wolde Maryam, the author of another chronicle of Tewodros's reign, said that he collected 981 volumes, the nucleus of a national library.

At the top of Maqdala, one courtier was appointed 'Keeper of the Royal Archives', according to Hormuzd Rassam. Documents and manuscripts were kept in a number of huts, walled off in a compound next to the main church with their roofs protected from the rain by watertight coverings of woven black wool.

Below the main keeper there were more levels of accountability. Other officials got parts of the collection to watch over and were responsible if anything went missing. Once or twice a week, Henry Blanc wrote, they would meet 'to assure themselves that the "treasures" entrusted to their care were in perfect order and in safe keeping'.

They failed, through no fault of their own. One of the keepers of another set of archives – the British Museum's Richard Rivington Holmes – got in with the full force of the British military at his back. The Maqdala collection was piled up on the Dalanta plateau, sold off and dispersed.

This, as far as I know, is the first attempt to bring it all back together again. It is just a start. There is probably just as much again, if not more, hanging on walls and mouldering away in homes, stately and not so stately, across Britain, parts of Europe, India and beyond. If any of it looks familiar, a bit like that thing you've got in your attic, feel free to get in touch via the website.

One day it would be wonderful to get it all off those shelves and out of those archives. I know for a fact there is a lot of exhibition space available in Ethiopia. One day there may even be a place for it all back on the top of Maqdala.

People often say that places like the British Museum would be empty if they responded to every repatriation request. But the vast majority of the Ethiopian artefacts listed here are not on show. They are out of sight, in storage, in boxes. If they all went home today, visitors to the British Museum would not even notice they had gone.

Alamayu

That necklace

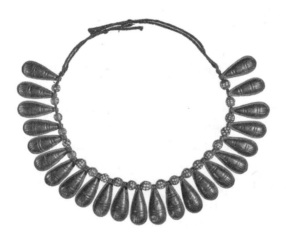

There it is on the British Museum website, that necklace, the one Alamayu wore in the first photograph the Royal Engineers took of him when he was still reeling from the shock of war. You can see him wearing it again and again in the black-and-white engravings and the staged studio photographs on his rush out of Ethiopia and his first years in Britain. It is still a jolt to see it today, in three dimensions, in colour, like the jolt when the colour floods into the old First World War footage in Peter Jackson's documentary film *They Shall Not Grow Old*, something out of distant history shifting into present reality.

Twenty-three teardrop or shell-shaped silver pendants, separated by bright red and white glass beads and threaded onto a blue silk cord. What had once been an emblem of rank for Dejazmatch Alamayu must

have become something much more personal, something of home to hold on to as the world kept shifting from Ethiopia, to Britain, to India, back to Britain. He may have got a bit more tired of it as photographers kept insisting on him wearing it, even over his Western clothes. It became a prop, a shorthand for the exotic, and disappeared from his portraits as he got older. The necklace ended up with Speedy – something of Alamayu for him to hold on to.

- *The British Museum (Af1912,0410.7)*

His mother's Book of Psalms

This time a fable comes to life on a museum shelf. There was one story that everyone knew about Alamayu's mother: the story about the time Tewodros interrupted her as she was reading the Bible's Book of Psalms. The queen turned to him coldly and told him to go away, saying she was conversing with a greater king than him. The story was repeated so often, and made its point so clearly, that it must have been a parable. But again, there it is, her actual copy of King David's hymns and laments, in the British Museum. Someone who visited Speedy and Alamayu on the Isle of Wight described how the queen's wood-covered Psalter was one of the boy's most prized possessions.

The British Museum doesn't make a lot of it. There's no picture on its website and, like Alamayu's necklace, it is not on display. That is hardly surprising. Ethiopian Books of Psalms are relatively common, one of the best-represented classes of sacred literature in collections of Ethiopic manuscripts. Most of them aren't meant to be rarefied treasures. They are books for regular readings, daily devotions and prayers. Many, like this one, come with a leather carrying case and shoulder strap so people can lug them around with their baggage.

This one's real value is in the story and in the details that must have reminded Alamayu of his mother – the small motifs next to the black and red text, the 'square of red damask silk with floral designs in yellow

and green' set into the back. A small square mirror set in the inside cover would have caught the reflections of his mother's face. It was not there for cosmetic reasons. Mirrors, which appear on a number of Ethiopian manuscripts, can be symbols of transcendence, of looking through something to something else or somewhere else. 'It shows the importance of a prayer book,' the Rev. Belete Assefa, a London-based priest from the Ethiopian Orthodox Tewahedo Church, told me. 'It's a reflection of the Kingdom of God, a reflection of heaven.'

- *The British Museum (Af1912,0410.37.a, Af1912,0410.37.b)*

Tirunesh

Alamayu may have got his mother's Book of Psalms after she died, but the bulk of her clothes and 'things' were wrapped up and packed up with the rest of the expedition's baggage and claimed as the property of Britain. It is highly unlikely that he knew it, but as he mourned her loss and hankered after home, keepsakes and mementoes were actually close at hand. They were boxed up, sent to Aden and then on to London, to the South Kensington Museum, today known as the V&A.

The queen's dresses and shawl

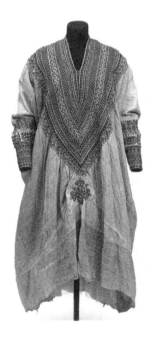

On one hand, it's tragic how little we know about Queen Tirunesh, beyond her family line and the fragments of myth. On the other, there are few great figures from history that we can get to know so intimately, if we take the time to look through her possessions. Take this dress. All the accounts agree she was young when she married Tewodros, very young indeed, maybe 12. She would have grown into her role from young girl to young woman and you can see her do it in real time through the adjustments and tweaks in her gown as she got bigger and taller. The dress is 49in long, including a whole extra panel extension sewn in at the bottom. I can hardly imagine it fitting an average 12-year-old now, so Tirunesh must have been tiny when she first put it on. The V&A, which suggests the dress was part of the queen's dowry, was kind enough to let me have a closer look a few years back when it was in storage. The first thing that stood out were the cuffs, so narrow that no one but a child could have got their hands through the holes.

There are lots of details to admire, particularly the beautiful silk embroidery on the cotton that loops down the torso like a giant necklace. (Silk wasn't produced in Ethiopia so there is a good chance the thread came from an imported piece of cloth that was painstakingly unravelled, according to academic Nicola Stylianou in her paper 'The Empress's Old Clothes'.) But it is the overall form that lingers. Even when the dress is laid out on a table, you can get a very real idea of the young woman who wore it and the life that she lived. It may have been a luxurious garment when she got it. Over the years though, as Tirunesh waited neglected at the top of her mountain fortress, it got more than its fair share of regular use, down to the stains and marks of wear and earth and the ragged hem. A second beautifully embroidered cotton dress and a woven shawl have also both seen better days. Tirunesh was very much an empress who had to walk on the ground. The V&A had a bit of a clear-out of its collections in the 1920s and 1930s. Some of the queen's things disappeared, some passed as part of a job lot to the Museum of Archaeology and Anthropology in Cambridge.

The Prince and the Plunder

- Cotton and silk-embroidered *kamis* (dress) – *V&A (399-1869)*
- Second cotton and silk-embroidered dress – *V&A (400-1869)*
- White cotton *shamma* (shawl) with coloured border – *V&A (401-1869)*
- One pair of silk pyjamas – *Missing, last seen in the V&A, possibly destroyed*
- Queen's blue cotton cloak with blue floral lining and metal decorations – *The Museum of Archaeology and Anthropology, Cambridge (Z 19184)*
- Queen's blue silk cloak with gold lining and silver gilt filigree – *The Museum of Archaeology and Anthropology, Cambridge (Z 19185)*
- Queen's embroidered blue silk cloak with hood and scarlet lining – *The Museum of Archaeology and Anthropology, Cambridge (Z 19188)*
- A fragment of silk brocade, 'part of a robe ... worn by the queen' – *Missing, last seen at the National Exhibition of Works of Art in Leeds, 1868. Loaned to the exhibition by T.P. Martin of the 33rd Regiment*

The queen's jewellery

Many people who have lost a parent will know that strange, intimate moment when you go back to the empty house after the funeral and start sorting through their possessions – the old books, the faded clothes and the odd pieces of broken jewellery. Tirunesh brought her last few things with her on the road out of Maqdala. Her attendants held some of them up as they mourned her before her burial. The bulk of her jewellery, including a broken silver-bead bracelet, was then boxed up with her dresses. Other pieces, more or less accurately described as hers, were picked up by soldiers and brought back in their baggage.

- Silver anklets with cone-shaped pendants – *V&A (403/403A-1869)*
- A pair of silver-bead bracelets, one broken – *V&A (404/404A-1869)*

Tirunesh

- Silver neck ornament with chains and plaques – *V&A (405-1869)*
- Silver triple-chain necklace – *V&A (406-1869)*
- Bunch of twelve silver and gilt rings – *V&A (407-1869)*
- Silver, leather and amber necklace with crescent-shaped ornaments – *V&A (408-1869)*
- Pair of silver bracelets – *V&A (409-1869)*
- Silver bracelets with fifty-two pendants – *V&A (410-1869)*
- Silver amulet with two copper rings – *V&A (411-1869)*
- Silver and gilt bells – *V&A (412-1869)*
- Twenty-eight silver rings – *V&A (413-1869)*
- Ten horn rings – *V&A (414-1869)*
- Silver hairpin – *V&A (415-1869)*
- Silver, leather and amber necklace – *V&A (416-1869)*

Napier presented one of Tirunesh's necklaces to Benjamin Disraeli, who had helped push through the funding of the whole Abyssinian Expedition when he was Chancellor of the Exchequer. By the time the troops got home, he was prime minister. Today, the necklace is still in Disraeli's old Buckinghamshire country house, Hughenden Manor, now a National Trust property. Professor Richard Pankhurst described its design as 'unique'.

- Necklace with silver cylinders, yellow, blue and millefiori glass beads – *Hughenden Manor, Buckinghamshire (NT 428872)*
- Silver-gilt bracelet 'worn by the queen' – *The National Museums of Scotland (A.1901.395)*

Tewodros

His remains

Images showing Tewodros just before and after his death.

When Captain Speedy first met Tewodros, he was struck by his muscular build, his brilliant eyes and his 'massive black curly hair ... plaited in fine high ridges from the forehead to the nape of the neck while the ends to the length of eight inches hung down his back in curls'. The distinctive style became one of Tewodros's trademarks and featured prominently in engravings and other portraits alongside his lions, spears and guns.

When we first get to see Tewodros after his death, in sketches made at the scene, his hair looks dishevelled, cropped, torn. A clue to what happened in between came barely a month after the last battle at Maqdala, when some of his missing curls turned up in a shop window in England.

The *Western Daily Press* reported that the hair had arrived in Plymouth on Tuesday 19 May 1868 on a mail ship, along with a note. 'I send you a real lock of Theodore's hair. I cut it off myself as soon as we found his body in the gateway, and I assure you it is genuine. I little thought when I promised you this in fun that it would be fulfilled in reality.'

The note – which got back to Britain weeks before the returning troops – came from Captain Cornelius 'Frank' James, a member of Napier's staff who was an artist. Like Holmes, he had been with the troops after the final charge on Maqdala and had paused to grab a quick sketch of Tewodros's body. As James sat drawing, he remembered that he had joked to the folks back home that he would bring them a lock of the emperor's hair. So in between the pencil strokes he reached out to cut off a few souvenirs.

He wasn't the only one. Remember the crowd of 'vultures dressed like Englishmen' who descended on the dead or dying Tewodros when they burst through the gates of Maqdala, ripping at his clothes, seeking the most basic, most primal of battlefield trophies: a piece of the enemy.

Traces of Tewodros – from his body and the things he was wearing when he died – have been turning up in the most incongruous places ever since. My most recent sighting was in a cafe in Bloomsbury, London, during one of the brief breaks in the COVID-19 lockdown, in August 2020. I was there meeting a collector who was showing me one of their albums of Maqdala artefacts including a piece of fabric which, according to the label, had been cut off Tewodros's clothing 'five minutes after his death'. There were marks on it that could have been blood.

In Lancaster, the King's Own Royal Regiment Museum holds a cloth 'stained with the emperor's blood' and an envelope containing bits of what are 'said to be the hair of Emperor Theodore', alongside two other pieces of his tent. Further north still, in Hamilton, Scotland, is the museum for The Cameronians (Scottish Rifles) – a force that arrived in

Ethiopia too late for any of the battles but still managed to get hold of an 11.5cm-long sliver of embroidered cloth from Tewodros's coat for its archives. A French officer on Maqdala passed the scrap on to the regiment, perhaps as a kind of compensation for missing the action.

Captain James's gruesome souvenir ended up in the window of James & James booksellers and stationers in George Street, Plymouth (perhaps a family business). Someone thought the public might be interested, so they put the hair on display. That might appear to be a nineteenth-century aberration. But locks of Tewodros's hair taken by James – or at least a picture of them – were on show in London well into the twenty-first century.

James's family donated a pile of his paintings and other belongings to a precursor of the National Army Museum in 1959, including one of Tewodros's letters (a handwritten message to a senior aide ordering Rassam's release from his chains). In one corner of the parchment, someone in the family had attached a small transparent envelope holding a mass of black and grey hairs. And that's where they stayed, hair and letter locked together in a frame in the museum's brutalist building close to the chi-chi shops of Chelsea, central London, until they were spotted by staff at the Ethiopian Embassy, just half an hour's walk away on the edge of Hyde Park.

The embassy and a clutch of campaigners got in touch and started a campaign to get the hair returned so Tewodros's family could bury it with the rest of his remains. And in March 2019, the museum finally acquiesced. Its director, Brigadier Justin Maciejewski DSO MBE, handed over the hair in a box draped in the Ethiopian flag to Ethiopia's Minister for Culture, Tourism and Sport, Dr Hirut Kassaw, as a crowd ululated in celebration. She received it with thanks and used the occasion to appeal for the rest of the Maqdala plunder to come home. 'For Ethiopians, these are not simply artefacts or treasures but constitute a fundamental part of the existential fabric of Ethiopia and its people.' She asked museums 'to consider the intrinsic value of the items in their collections which are of far greater significance to Ethiopians than to those who removed them'.

The National Army Museum, which has a clutch of other Maqdala items on its shelves, tried to keep the focus firmly on the hair at the repatriation event. 'Having spent considerable time researching the provenance and cultural sensitivities around this matter, we believe the Ethiopian government claim to repatriate is reasonable and we are pleased to be able to assist,' the museum's Head of Collections Standards and Care, Terri Dendy, said. At some point during its lengthy research into whether it was OK to display human remains, the museum also decided that assistance could only go so far. It kept the looted letter.

At the time of writing, the hair is with the Ethiopian government in Addis Ababa, awaiting reburial in Tewodros's birthplace of Kwara. where his remains now lie. A number of years after the British invasion, his son Meshesha (Alamayu's older half-brother) went to Maqdala and brought the emperor's bones back home.

- Tewodros's hair – *Previously National Army Museum (NAM 1959-10-71). Now in Ethiopia*
- An envelope said to contain Tewodros's hair – *King's Own Royal Regiment Museum, Lancaster*
- Piece of handkerchief stained with Tewodros's blood – *King's Own Royal Regiment Museum, Lancaster (KO0229/15)*
- A piece of Tewodros's coat – *The Cameronians Regimental Museum, Hamilton (CAM.G308)*
- Cloth cut from Tewodros's clothing 'five minutes after death' – *Private collection, UK*

The amulet

Richard Pankhurst holding Tewodros's amulet in Addis Ababa, 2002.

You might have thought it would be impossible to find a more intimate relic of Tewodros than his hair or his blood. One artefact that is at least a contender for that title is now encased in a frame in the Institute of Ethiopian Studies at Addis Ababa University.

Behind the glass, a dark cotton cord encircles an unrolled oblong of parchment marked with two columns of largely Ethiopic characters. Just above, on the mount, someone has written in fine, English copperplate: 'I hereby certify that this charm was taken off the neck of King Theodore on the 12th of April 1868 as he lay dead inside the gates of Magdala by me. Henry Bailey, Sapper, 10th. Compy. R.E.' The date is a day out, but the rest of the details could not be more precise.

Bailey, from the 10th Regiment, the Royal Engineers, was one of the first to break into Maqdala at the end of the battle and planted the British flag in the fortress. That would have made him among the first to discover the body and he got the plum prize, the amulet. Bailey wouldn't have known it, but the amulet contained a charm, written out on the parchment that would have been rolled up in the little leather pouch at the top of the frame. A translation of the text suggests it was meant to grant its owner majesty, charisma and riches. That charm was made all the more effective because it included its holder's name – not Kasa or Tewodros but another special one given to him at his baptism. These baptismal names, still given to Ethiopian Christians today, are known by the priest and by the baby's family and by God. According to an analysis by the Ethiopian academic Professor Hailu Habtu, the writer of the charm appears to have made an effort to conceal the name by mixing up the letters, presumably to prevent such a powerful piece of information falling into the wrong hands. It feels wrong, then, to publish it here. These days, I am told, these names are less of a secret.

Sapper Bailey presented the amulet to his uncle, a fireman, when he got back to his home in Notting Hill, London. Over the years, it passed into the hands of someone who agreed to return it anonymously in 2002 to the Institute in Addis where it remains to this day, one of a small but gradually growing collection of returned plunder.

- The amulet – *The Institute of Ethiopian Studies, Addis Ababa. Returned in 2002*

The Prince and the Plunder

The gun

Remember the pistol that Queen Victoria presented to Tewodros after the death of Plowden? Journalists and other writers later insisted that this was the very gun that Tewodros used to take his own life at the Battle of Maqdala. But that feels too neat, too ironic to be true and that isn't mentioned in the official accounts. The only thing that is certain is that the pistol was at Maqdala when the British troops arrived. We know that because they found it there, brought it home and presented it back to Queen Victoria. Today it is still in the Royal Collection – an octagonal-barrelled, blued-steel, silver-inlaid percussion revolver, with a presentation inscription: given by Victoria 'in acknowledgement of the kindness shown by [Tewodros] to her servant Plowden'. It is a relic of the grand British–Ethiopian alliance that blossomed briefly in the days of Plowden and Bell, before Consul Cameron blundered his way into the frame. All too tellingly, it is a relic in the form of a weapon.

- Revolver made by the British gunsmith Charles Lancaster of New Bond Street, presented to Tewodros then brought back to Britain – *The Royal Collection (RCIN 61616)*

Swords, spears and shields were some of the most popular mementoes from the Maqdala battlefield. Many of them came over to Britain confidently labelled as Tewodros's personal property. Here are some that might have actually been his:

- Shield with lion's mane. Taken by Richard Rivington Holmes – *The British Museum (Af1868,1001.1)*
- A leather shield decorated in metal. 'Collected' by Captain Speedy – *The British Museum (Af1939,09.1)*
- Sword and scabbard engraved in English: 'The sword of King Theodore of Abyssinia Presented to Major-General Sinclair R.A.M.C. by Her Majesty Queen Victoria' – *The Royal Armouries Collection, Britain (IX.1291)*
- A silver and gilded silver gauntlet in the V&A – *V&A (M.140-1922)*

214

Tewodros the icon

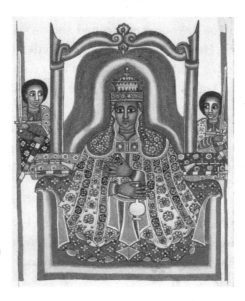

'A portrait of the emperor' in selections of the Gospels of Matthew and Mark.

We have heard a lot about how other people saw Tewodros. How did he see himself? There is a clue in one of the books from Maqdala's library that came back with the British troops – a collection of passages from the Gospels of Matthew and Mark produced for Tewodros during his reign. Britain makes its claim on the plundered volume on the opening pages – officials have stamped the British Museum's coat of arms straight onto the parchment and printed out the message 'Presented By the Secretary of State for India Aug. 1868'. But it remains Tewodros's book and you can feel his presence everywhere else. He was a leader who tried to pull a fractured Ethiopia together through the force of his own will, his military prowess and his faith. The book mixes the same elements of the sacred and the state and of Tewodros himself. An Ethiopian scribe has used the fly leaves to write out a number of official lists and inventories – a not uncommon intrusion into church books. Throughout, the sacred text is broken up with other notes and

lists including, towards the back, references to copper cannons, iron cannons and bombs. And then comes the book's only full-page illustration, a depiction of Tewodros enthroned and crowned in an aura of red, gold and green. He wears a gorgeous, embroidered robe – perhaps the same one that *The Gentleman's Magazine* later derided at the V&A's *'spolia opima'* show. And either side of him lie the details of his own iconography – two swords and two guns.

- Selections of the Gospels of Matthew and Mark written for Tewodros with notes and 'a portrait of the emperor' – *The British Library (Or 733)*

The worlds of politics, military power and divine revelation all came together in the person of Tewodros – as can be seen in some of the sacred artefacts that found their way back to Britain:

- A silver communion cup that looks like it is filled to the brim with gleaming gold, thanks to the gilt lining inside. An engraving around the crenelated rim describes it as a eucharist chalice 'given by Emperor Tewodros for the salvation of his body and soul'. 'Collected' by Richard Rivington Holmes – *The British Museum (Af1868,1001.8)*
- A matching paten – the plate used to hold the host during communion. It is engraved with images including Christ as the sacrificial lamb and has a similar dedication mentioning Tewodros. From Richard Rivington Holmes's haul – *The British Museum (Af1868,1001.11)*
- A silver and gilt cup, decorated with filigree and engraved 'King of Kings Tewodros' that ended up in the South Kensington Museum, later the V&A, in 1870. There are no other details in the online ledger on how it got there – *V&A (63-1870)*

'The Abuna's Crown and Chalice'

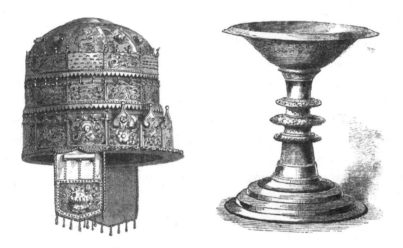

Britain on the whole presented a united front after the conclusion of its Abyssinian Expedition. As far as it was concerned, its mission had been righteous, its march had been a logistical triumph and the few things it brought back from the battlefield had been barely adequate compensation for the huge expenses involved. The first cracks in that facade only appeared when the troops and officials started falling out over the loot, particularly one of the real treasures of Maqdala: a stunning three-tiered, cylindrical, solid gold crown wrongly described by the British at the time as belonging to the Abuna, the head of the Ethiopian Orthodox Church.

What follows is a curious study in the economics and politics of plunder. A British soldier found the crown and a golden chalice in the first heady moments of the British victory. Looking for a quick profit, he quickly sold both of them for £4 to the British Museum's man on the ground. Richard Rivington Holmes couldn't quite see the crown in the dim light but said in a letter back to the museum he felt he had snapped up one of 'the most valuable relics' on Maqdala for a bargain price.

Soon after that, the senior officers ordered that all unregulated plundering should stop. Soldiers were forced to hand over their treasures. Everything was auctioned off to officers who paid out tens, if not hundreds of pounds for artefacts to raise money for the troops.

The crown and the chalice were recognised as a different class of plunder, way beyond the budgets of anyone at the scene. So Holmes was allowed to keep them, on the condition that the British Museum pay the proper price for them on his return. The money would be added to the pot to be split among the soldiers. The kind of sum being mentioned now was not £4, not hundreds of pounds. In days the estimated price had inflated to £2,000 (£125,220 today according to the National Archives calculator).

The job of taking the crown and chalice to the British Museum fell to the artillery officer appointed as prize agent – grumpy old Lieutenant-Colonel Milward. He duly dropped them off and waited, and waited, for the payment. Months on, exasperated by the lack of news, he started peppering the museum with angry letters. The flustered museum trustees said they did not have that kind of money lying around, asked the Treasury for a special grant and stalled. The Treasury, now headed by the bulldozer Lowe, eventually said it was under no obligation to pay out such a large sum. At the end of June 1871, three years after the mission, the dispute exploded onto the public stage with a full debate in the House of Commons. MPs with military connections demanded justice and payment for the British soldiers. Napier, making his views known via a minute, suggested the crown and chalice should be bought, kept, then returned to Abyssinia when a suitable stable power emerged. The Chancellor, Lowe, dismissed the artefacts as 'large masses of gold'

without artistic merit and said they should be sold on the open market. Then the prime minister, William Ewart Gladstone, stood up and finally said the unsayable. The question in front of them, he said, was unsatisfactory 'from first to last':

> He [Gladstone] deeply regretted that those articles were brought over from Abyssinia, and could not conceive why they were so brought. They were never at war with the people or the churches of Abyssinia. They were at war with Theodore, who personally had inflicted on them an outrage and a wrong; and he deeply lamented, for the sake of the country, and for the sake of all concerned, that those articles, to us insignificant, though probably to the Abyssinians, or at least hallowed by association, were thought fit to be brought away by a British army.

That was a lot to drop onto a parliamentary session on a summer day in 1871. In the space of a few minutes, Gladstone had undermined the whole case for Britain holding on to the Ethiopian plunder – and given the lie to the modern-day argument that people thought differently about loot back then. The debate ended soon after the prime minister spoke, with a lot of harrumphing but no actual decision. In the weeks that followed a quiet deal was done. A sum was paid to Milward and the crown and chalice were handed over – not to the British Museum, not to a stable Abyssinian power but, officially on loan from the Treasury, to the South Kensington Museum, now the V&A.

- The 'Abuna's Crown', later identified more broadly by the scholar Jacques Mercier as almost certainly a 'sacerdotal crown', worn by priests during processions and ceremonies, possibly taken by Tewodros from Gondar. Two side panels, described as earpieces, seem to have disappeared – *V&A (M.27-2005)*
- Golden chalice – *V&A (M.26-2005)*

The Dig

The dig at Adulis.

In the 1990s British television series *Time Team*, a group of charismatic archaeologists raced against the clock to explore a small corner of a Saxon burial ground, a forgotten dockyard or a Roman fort. In each episode, they had three days to study the 'geophys' scans of the site, dig some trenches, crack some jokes and unearth something to show the viewing public.

Way ahead of them was Captain William West Goodfellow of the Royal Engineers in 1868. His challenge was to uncover a corner of a largely unknown civilisation in the time it took his comrades to pack their bags at the end of the Abyssinian Expedition. He got back to Zula on 24 May and asked if anyone could spare some men. He and the other amateur archaeologists on the trip had been denied the chance to divert

from the route and dig up the ancient city of Axum. But the ancient port of Adulis – one of the centres of a trading empire that reached its height in the third to sixth centuries – was right next to them on the coast. While the rest of the British and Indian soldiers were folding up tents and packing up crates, Goodfellow got permission to borrow twenty-five Madras miners and sappers and started digging narrow trenches across some mounds on the site in present-day Eritrea.

Days in, they found some stone columns and, after removing some more debris, uncovered the outlines of a building, possibly a church. Along the way they found a few fragments of marble, including one with a cross, but it was impossible to say how it fitted in with everything else, as they hadn't had time to dig deep enough. By 5 June, the sappers and miners were withdrawn and put on a boat back to India. Two days later, Goodfellow got the services of a whole company of Bombay sappers and miners (eighty men). But his time was up. By 9 June, he was writing his final report and preparing to leave the part-dug site behind him. 'It is much to be regretted that there is not time, now that the campaign is over and all the arrangements for excavating the country complete, to continue this work, so as to throw light on the history of some of the hidden things of the past,' the report read. One of Europe's first archaeological digs in sub-Saharan Africa was over.

A few months later, two crates of marble fragments and shards of pottery arrived at the British Museum. Augustus Franks, first Keeper of the Department of British and Medieval Antiquities, had a quick look at what was inside. 'These objects are not of great archaeological value,' read the official report. They ended up in storage.

Artefact from Adulis.

The Prince and the Plunder

- A fragment of a sixth-century relief sculpture carved with a cross – *The British Museum (OA.11008)*
- Part of a sixth-century octagonal marble column – *The British Museum (1868,1005.10)*
- A sixth-century column capital, carved with acanthus leaves – *The British Museum (1868,1005.12)*
- Part of a sixth-century relief sculpture of a cross inside a wreath – *The British Museum (1868,1005.15)*
- Corner of a sixth-century relief sculpture, with a leaf design – *The British Museum (1868,1005.16)*
- A coin associated with the Axumite kingdom – *The British Museum (1868,1219.1)*
- Goodfellow's report in Holland and Hozier's official account also mentions 'various fragments of marble and alabaster vessels' and 'the fragments of an earthen vessel'. They don't appear to have made it into the British Museum's records online

6,450 Animals
and a Human Skull

As we saw, William Jesse of the Zoological Society of London struggled at the start of his mission. He made it halfway to Maqdala then only did a little better for himself on the way back to the shore. Among the desiccated, de-boned corpses that he sent home from that stage of the trip were six live animals, two of which – a pair of wild cat kittens – actually survived the voyage. The two rats and the two guinea-fowl did not.

Things started to look up when he joined forces with the expedition's official geologist, William Thomas Blanford, who was there to study highland rocks but was also an expert marksman and collector.

As the military mission wound down, Jesse and Blanford waved off the troops at Zula then sailed north up the coast to Massawa. From there, on 22 June 1868, they headed back up into the highlands of modern-day Eritrea – just them, thirty-eight camels, eight horses and about thirty other men to carry all the gear. One night, a week into the trip, a leopard got into the camp and killed one of Jesse's servants. They buried him the next morning, left a pile of stones on the grave, then headed off the same day to keep on hunting. Things were slow at the start. 'I fired at two panthers without effect,' wrote Jesse. 'We passed through ostrich country, but we did not see any.' Their fortunes soon changed and the animal death count started to mount.

Jesse and Blanford's biggest prize was a joint effort. An excerpt from Blandford's account gives a taste of the life of a tooled-up nineteenth-century naturalist.

The Prince and the Plunder

Mid-July, 'having provided my men with as many birds as they could possibly skin, we all started together the next afternoon to look for rhinoceroses'. Some of the servants spotted a mother and her calf hiding in a thick patch of undergrowth but the pair escaped across a river. The party switched its attention to a passing herd of antelope and shot a young doe:

As we came up to the body two rhinoceroses, one a huge beast, the other about three parts grown, ran across the open about 150 yards from us, and disappeared in a broad ravine. After peering about for some time, a sharp-eyed Somali caught sight of the larger one standing in the jungle, and by making a circuit we came within 100 yards ... Jesse and I took steady aim, and fired. With the most astonishing sound, a series of snorts like puffs from an enraged steam-engine, the brute, with its young one following dashed into the bushes in front and came on towards us.

The zoologists dodged behind a bush and the mother ran past. Soon one of the servants came up to say it:

was running round and round in a circle and falling over. We soon came up with it: the monster lay dying on the ground, the young one stood by prodding the mother with its horns, and evidently trying to induce her to move on ... Though very badly hit, the old one took several more bullets before it was dead; the smaller animal, after receiving one or two shots, rushed off at the most astonishing pace, and we saw it no more. An examination of the body next day showed that Jesse's bullet, a conical, had hit on the shoulder, turned forwards, and lodged in the neck. Mine, a round bullet, had hit behind the shoulder, made a clean hole through the centre of a rib, and entered the lungs close to the heart ...

For two or three days Jesse and I were busily occupied in collecting and skinning. We drew lots for the spoils of the rhinoceros. Jesse won them, and with much labour preserved the skeleton, which is now in the British Museum.

Jesse's final haul

Live animals

Young wild cats*	2
Jerboa-like land rats	2
Guinea-fowls	2

* In Holland and Hozier's official account, the asterisk leads to the footnote: 'These were the only specimens forwarded by Mr. Jesse that reached the society alive.'

Specimens

Skins of mammals, about	24
Skull of an aboriginal	1
Skull of African elephant	1
Skeleton of rhinoceros	1
Heads of antelope	3
Skeletons of other mammals, about	8
Skins of birds, about	750
Birds and mammals in spirit, about	20
Reptiles in spirit, about	6
Tortoises and lizards, about	6
Fish, about	30
Crustacea, about	50
Lepidoptera, about	150
Coleoptera, about	200
Total specimens, about	1,250

The 'skull of an aboriginal' comes in at number 2 on Jesse's list, in between the mammal skins and the African elephant. The most striking thing about it is the lack of detail. There is no mention in their accounts of them picking up human remains along the way or any public note of its arrival in London.

'Aboriginal', according to the Oxford English Dictionary, suggests 'First or earliest as recorded by history; present from the beginning;

primitive'. We can safely rule out the idea that Jesse was claiming to have found a fossil of one of humanity's early ancestors – the science wasn't quite there at that time and, if nothing else, he would have made a much bigger fuss about his discovery.

The most likely conclusion is that it is a reference to one of the racist branches of pseudoscience active at the time that saw Africans as a whole as an earlier, more basic form of humanity. Neither Jesse nor Blanford had much good to say about the living African humans they met on their travels. If we strip the pseudoscience away, we are left with the skull of a person. Let's hope it wasn't their servant's.

Blanford's haul

Specimens

Vertebrate animals, about	1,700 (representing 350 species)
Mollusca and articulata, about	3,500 (representing 500 species)
Total specimens, about	5,200 (representing 850 species)

The detailed catalogue, of all his collections, with illustrations and notes, fills about half of his 500-page book *Observations on the Geology and Zoology of Abyssinia, made during the progress of the British expedition to that country in 1867–1868.*

The Kwer'ata Re'esu Icon

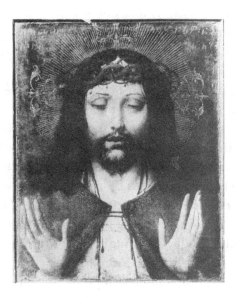

The Kwer'ata Re'esu icon in 1905.

In August 1872, when Alamayu was settling in with the Jex-Blakes, another Ethiopian monarch wrote another letter to Queen Victoria. This message got through. In it, Emperor Yohannes IV asked his former allies the British to return just two of the things they had taken. One of them was a copy of the book known as the *Kebra Nagast, The Glory of Kings* – Ethiopia's national epic including the foundational account of King Solomon, the Queen of Sheba and the Ark of the Covenant. In a stunning turn of events, the British authorities quickly tracked down two copies in the British Museum and agreed to send one of them back to Ethiopia. It made its way to Kiddus Raguel Church, in the hills above the modern-day capital Addis Ababa.

The second thing Yohannes wanted was a painting, an icon. It was 'a picture called Qurata Rezoo, which is a picture of Our Lord and Saviour, Jesus Christ ... it is surrounded with gold, and in the midst with colours,' read the English translation of the emperor's letter. The museum looked through its collection again, but this time came up with nothing. Queen Victoria wrote back promptly and politely to Emperor Yohannes. 'Of the picture we can discover no trace whatsoever, and we do not think it can have been brought to England. We regret that we are therefore unable to assist you in its restoration.'

Thirty-three years later, in August 1905, a short article appeared in the back pages of the *Burlington Magazine for Connoisseurs*. It was headlined 'A Flemish Picture from Abyssinia' and included a black-and-white reproduction of the image. It described the portrait of Christ wearing his crown of thorns, painted onto an oak panel, the background and robe a deep, cool blue surrounded by an ancient frame of gilded wood, the whole thing bound in frayed crimson silk. It had been found, the magazine wrote, hanging over the bed of Tewodros after the battle of Maqdala. And it had been brought back to Britain ... by Richard Rivington Holmes of the British Museum.

Holmes, it turned out, had done a bit of collecting of his own on Maqdala. He brought the painting back to Britain and kept it for himself in his home in Windsor. He showed it to a visiting Belgian scholar in the 1890s, but waited more than thirty years after the battle – when the Abyssinian Expedition had all but faded from memory – before giving in to the collector's urge to show off this treasure to the public. 'The picture itself is hardly less interesting than its history,' the *Burlington* article said in a classic understatement.

No definite details remain of who created the portrait, or where or when. Some experts suggest it is the work of a Renaissance master in Portugal or Flanders in the early 1500s, others that a Jesuit missionary painted it in Ethiopia as he tried and failed to convert its Orthodox Christian population. What there is of its story has been pieced together by historians and journalists, chief among them Richard Pankhurst and the *Art Newspaper*'s Martin Bailey. The first record of

its existence in Ethiopia appears in the sixteenth-century imperial chronicles. They call it the Kwer'ata Re'esu – 'the striking of His head', a reference to the scourging of Christ before his crucifixion. And it soon outstripped its original purpose. The icon became a spiritual, imperial, national standard, carried at the head of marching armies. Subjects swore imperial oaths on the painting. Tewodros picked it up in one of his raids, possibly on Gondar, and took it back to his fortress at Maqdala.

After Holmes's death in 1911, his widow sold it via Christie's to a certain M. Reid of Wimbledon for £420. By 1950, it was back for sale again and, this time, the Ethiopian Embassy in London raced to raise the funds to try and buy it, in a precursor of the restitution campaigns that would build into the twenty-first century. But the embassy was too late and the painting went to a mysterious buyer known only as 'Grey' for £315. Richard Pankhurst established that 'Grey' was acting for Portuguese art expert Luiz Reis Santos, who had a patriotic interest in the painting – he once wrote an article claiming it for the Portuguese tradition over the Flemish.

Reis Santos went to New York to work at the University of Columbia and the icon passed to his wife there after his death in 1967. Decades later, in 1998, Martin Bailey reported he had found it again in a Portuguese bank vault. The picture was still wrapped in a 20 April 1950 issue of the *London Evening News* and was the property of a private collector who had requested anonymity.

To bring the story right up to date, the Portuguese government, presumably at the owner's request, has since included the painting in its register of art 'in the public interest'. It remains in the private collection. But the government also said in a decree that it could no longer be moved out of the country without the specific authorisation of the Portuguese Ministry of Culture.

A lost renaissance masterpiece claimed by both the Flemish and the Portuguese schools of painting, used as a royal standard for centuries in Ethiopia, stolen by the British Museum's official representative on a punitive invasion then spirited away across US and European borders

through a series of international auctions. Now it has resurfaced one more time, this time under the protection of the Portuguese government, setting the scene for a cross-cultural restitution battle that could put the battle for the 'Elgin Marbles' to shame.

The Book Liberator

Seymour McLean in Edinburgh, 2002.

In 1983, staff at London University's School of Oriental and African Studies (SOAS) noticed that their library books were going missing. Not all the library books. Mostly just the ones with links to Ethiopian culture, history and language. Week after week, month after month, a person or persons unknown had been getting into the university, getting past the guards and the bag checks, getting past the library turnstiles and making off with books. These weren't priceless, antique manuscripts. They were mostly modern academic works, English translations and books of reference, worth on average a few pounds apiece. By August 1983, no fewer than 450 of them had disappeared from SOAS.

The chief librarian at SOAS said he suspected there was a political

And it wasn't SOAS alone. Other books were disappearing from other libraries. Lambeth and Wandsworth public libraries, the British Library, the Foreign Office Library, even the collection of the Bible Society. All in all, just short of 2,000 books, mostly on Ethiopian or African affairs, had disappeared into thin air.

The chief librarian at SOAS said he suspected there was a political motive behind the disappearances. His assistant told the *Sunday Times* that 'it might have been the Rastafarians'. The police sent in Detective Constable William Main-Ian to get to the bottom of the thefts.

In later years, Main-Ian would go on to join the royal protection squad and guard Princess Diana and her sons at Kensington Palace. Even later than that he would unsuccessfully stand as a candidate for the pro-Brexit UK Independence Party (UKIP) in the 2015 general election in Carshalton and Wallington. Back in the early 1980s he was working for Holborn CID. He pounded the streets, followed his leads and came up with the culprit.

The moment Main-Ian got his man is recorded forever in the 1989 Channel 4 TV docudrama *The Book Liberator*. In the early scenes an actor playing the culprit is seen wandering around an apartment, posters of Marcus Garvey and Haile Selassie behind him on the wall. There's a knock at the door and the man opens it to find the actor playing Detective Constable William Main-Ian standing in front of him.

'Are you Seymour McLean?' asks the policeman.

'I am ... come in,' replies the man. 'You took your time getting here. We were expecting you a year ago.'

In the scene, Main-Ian and another officer find some of the missing Ethiopian books on a shelf in the flat and arrest the man on the spot. The film then shifts into a police procedural and courtroom drama as Seymour McLean – Ras Seymour McLean – stands trial for theft and explains his motives. Part of it, he and his lawyer tell the police and the court, had been an act of education, of dissemination, to get the books out of the gated libraries and into his community. Many of the books, according to the evidence in the case, ended up in the Rastafarian centre in the famous mass squat in St Agnes Place, Kennington, south London.

The Book Liberator

Another part of McLean's plan, the lawyer explains, is that he had meant to get caught. 'He deliberately left a trail so he could be arrested and tell the world that the British have property which belongs to his people,' the barrister tells the judge. The trail of clues had included notes left in the empty spaces on the library shelves. McLean had wanted the police to find them so he could go through the whole legal process and stage his own show trial, then use the publicity to denounce a much more serious theft of books – the removal more than a hundred years earlier of hundreds of sacred illuminated manuscripts from the top of Maqdala. Crates carrying those manuscripts landed with a thump in the British Museum as the troops came home after the expedition in 1868. When the British Museum's library separated off to become part of the British Library in 1973, they moved to their new home. And there they stayed, to the growing anger of Ethiopian-minded campaigners like McLean.

In the TV drama (which, according to the credits, used transcripts from the actual trial), he and his lawyer repeatedly bring up Maqdala during the hearing. At one point they bring in a historian to give a detailed account of the build-up to the battle and the plundering, to the bemusement of the prosecution, who ask no questions.

'What [do] you understand by Theodorus and Maqdala? What [do] these things mean to you?' the barrister asks Main-Ian during cross-examination.

'Quite honestly my knowledge of history is sparse,' the detective replies.

McLean (portrayed in the film by Lovers rock star Victor Romero Evans) and the barrister try to present the book thefts almost as an act of forced reparation.

'The principle we apply to the movement of the books is that they were first looted by General Napier. Anyone who sees fit to recover library books, it is at their discretion,' McLean tells the detective.

The now very sadly late Seymour McLean almost definitely deserves the prize for the most direct bit of direct action to try to persuade Britain to part with its Maqdala plunder. His faith and veneration of

233

Ethiopia's last emperor, Haile Selassie, had led him back down the imperial line to the story of Tewodros II. For much of the rest of his life, the Jamaican-born financial consultant, who had changed track to become a Rastafarian campaigner and chaplain of the Ethiopian World Federation in London, gave speeches, led rallies and pressed for the loot to go home. In his hands, the story of Maqdala got tied into a broader narrative of empire, racism and reparation. 'What was colonialism if it wasn't racism and what are the manuscripts if they are not the spoils of colonialism?' he asked the *Guardian* in 1997. 'Black people are still not allowed to learn about their history. Do you think that Bob Marley or Peter Tosh ever got to see these scripts? They didn't even know they existed.'

Others who had taken their own routes to Maqdala tried different approaches to get the loot back over the years. Academics wrote papers. Activists wrote letters to *The Times*. An umbrella group of campaigners set up AFROMET – the Association for the Return of the Maqdala Ethiopian Treasures. In the most recent development, politicians, civil servants and historians formed a network of reparation committees under the aegis of the Ministry of Culture in Addis Ababa. So far, at least when it comes to the manuscripts in the British Library, very little of this campaigning activity has worked. The manuscripts are still there.

Back in the 1980s, at the trial of Ras Seymour McLean, his Maqdala-centred defence fared little better. The judge looked on bemused through most of the proceedings, listened to the lawyer's impassioned descriptions of the evils of the Abyssinian Expedition, took in the shorter prosecution arguments and promptly sentenced McLean to nine months in jail. 'I am not sure about your motives,' the judge told McLean during the sentencing, according to the TV script. 'I have heard a great deal of testimony about why you did these things and what your motivation was. The fact is that you stole a great quantity of books.'

◙ ◙ ◙

The Book Liberator

The great quantity of books that the British troops took during the Abyssinian Expedition spread further and wider than the British Library. Six of the best of them were presented to the British Royal Collection in Windsor Castle. Others made it as far afield as Austria, France, Ireland, Scotland and the United States.

The Tabots

The Ethiopian delegation at Waverley Station, Edinburgh, 2002.

The Rev. John McLuckie ushered the visiting party of Ethiopian priests into his church vestry on the West End of Princes Street, Edinburgh, and opened the safe. The priests had a quick look at what was inside and burst into song.

McLuckie's first reaction was relief. The object that he had been keeping safely locked away in St John's Episcopal church was what he thought it was. The tablet lying wrapped in an ecclesiastical cloth in a Scottish church on a cold January day in 2002 was one of the holiest artefacts known to Ethiopian Orthodox Christianity.

The young Scottish priest had found it a few months earlier when he was bored and started poking through a cupboard. At the back he saw a battered Victorian leather case, embossed with the message that it had

The Tabots

been taken at 'Magdala'. Inside was something that I cannot describe in any detail. Not because it defies description, but because doing so would risk offending a good proportion of the people reading this.

The object inside the case was broadly known as a Tabot, a sacred object that should typically spend most of the time wrapped away out of sight in the Holy of Holies in the centre of an Ethiopian Orthodox Church. It is closely associated with the Ark of the Covenant, and with the Tablets of the Ten Commandments that the ancient Israelites carried around in the Ark. It represents the presence of God, in a way embodies the presence of God, and sits at the heart of the Eucharist. You can read all the encyclopaedia articles you want, but to fully understand what a Tabot is, you really have to be an Ethiopian Orthodox Christian. Even then, you might struggle to put it into words. 'It's said that when a Tabot passes by you should bow down until it passes by,' Twitter user @madeinEthiopia4 told me. The one thing to bear in mind is that it is not just an artefact, a historical relic. It is meant to be the key living heart of a church. A church without a Tabot is just a building. A Tabot without a church has temporarily lost its purpose.

The Rev. John McLuckie – who by lucky chance had spent some time in Ethiopia as a student – had a good working knowledge of Orthodox Church culture and was pretty sure he knew what he had found. He did some basic research online about the battle and the plunder and decided that the only thing to do was return the Tabot to Ethiopia. His first thought was to contact the Ethiopian Embassy in London and send it back in the post. But after a few phone calls, it soon became clear that that would not do at all.

In late January 2002 an international delegation stepped onto the platform at Edinburgh's Waverley Station. There were staff from the Ethiopian Embassy, members of Ethiopian Orthodox congregations across Britain, campaigners including Ras Seymour McLean of the Ethiopian World Federation of London and a party of priests from London and Ethiopia led by His Grace Archbishop Bitsu Abune Isaias. This is where I first came across the Maqdala story. I was taking a break from journalism and working as the communications officer for the

broader Scottish Episcopal Church and was there to welcome them as they got off the train. The priests quickly headed to St John's to confirm that it was indeed a Tabot – a horrible doubt had remained in McLuckie's mind that he had brought them all up to Edinburgh on a wild goose chase.

When its identity was confirmed, preparations started for the handover ceremony – a marathon cross-cultural service at St John's that kicked off at 6 a.m. on Sunday 27 January and stretched on through the morning. The world's media looked on from an upper gallery as the chants of the ancient Ethiopian liturgy merged with the hymns of the Anglican tradition and incense filled the air.

There were civic receptions in Edinburgh and another big celebration and Orthodox church service attended by more than 2,000 people when the archbishop brought the Tabot down to London. Then he got on a plane and flew back to Addis. The government had declared a public holiday and hundreds of thousands of people packed the streets to welcome back the Tabot that the British had taken from Maqdala more than 130 years earlier.

◎ ◎ ◎

The thing was it wasn't the only Tabot that the British had brought back from Maqdala more than 130 years earlier. The 'Edinburgh Tabot' had been presented to St John's after the battle by Captain William Arbuthnot of the 14th Hussars, aide de camp and military secretary to Napier, commander of the Abyssinian Expedition. A nineteenth-century photograph of all the plunder Arbuthnot brought back with him shows at least two Tabots in with the swords, shields and robes. Other officers brought back other Tabots – the best guess is that Tewodros had collected them from the churches he raided in Gondar and other centres and brought them back to Maqdala, where they were snapped up again by the invading soldiers.

◎ ◎ ◎

The Tabots

Dr Ian MacLennan, an Irish convert to Ethiopian Orthodox Christianity, found one of them when he was looking through a catalogue published by Maggs Bros book dealers of Mayfair, London, in 2003. The description said it had been brought back to Britain by Hormuzd Rassam. 'I was absolutely shocked,' MacLennan told the BBC. He described how he started shaking when he saw it. He bought the Tabot for an undisclosed sum and flew to Addis himself just weeks later to hand it over.

◎ ◎ ◎

Somewhere deep in the bowels of the British Museum, there is a locked room that the staff have promised not to enter. Inside, covered in cloths, sit at least ten Maqdala Tabots that the staff have promised they will never handle, never even look at, never display. The only people who are allowed to interact with them in any way are Ethiopian Orthodox priests who have come in from time to time to conduct ceremonies in the secular space.

The extraordinary measures have been taken as a mark of respect for the Tabots' sacred status. 'The gesture is appreciated,' reads a statement from AFROMET, the Association for the Return of the Maqdala Ethiopian Treasures. 'But it raises the question of why the Museum is insisting on holding on to exhibits that it can never show.'

The answer to that question is in the small print of the British Museum Act, updated most recently in 1963, which bars the museum's trustees from exchanging, giving away or otherwise disposing of any object in the collection, apart from in a very limited set of circumstances. The act has been used as the final answer to campaigners calling for the return of everything from Greece's Parthenon ('Elgin') Marbles to Nigeria's 'Benin Bronzes' to the giant moai figures from Rapa Nui (Easter Island). The power of that legislation has also reached down into the heart of the British Museum and trapped at least ten Tabots in the weirdest of all legalistic limbos.

- Ten Tabots – *The British Museum, one linked in the records to Richard Rivington Holmes (Af1868,1001.21), seven to Sir Stafford Northcote (Af1868,1005.1-6; Af1868,1005.9), one to a Colonel Mackie (Af1968,0401.1) and one to Major-General Thomas William West Pierce (Af1990,22.1). One other Tabot in the collection (Af1979,01.3128) is marked 'Acquisition details unknown'*

◎ ◎ ◎

Less than half an hour's walk south across central London, yet another Maqdala Tabot sits in even greater isolation. Back in 1870, when Alamayu was exploring his new home in India, the authorities at Westminster Abbey set up a new altar for their Henry VII Lady Chapel. In 1935, they took it down during renovations and built it again, incorporating parts from its previous incarnations and – in three cavities in its back wall – fragments and relics from other great Christian sites. This is the altar described at the start of this section. The first cavity contains part of the burned wreckage of Canterbury Cathedral, the second, part of a Greek Orthodox Church in Damascus. And the third, according to the full inscription beneath it, contains a 'Fragment of an Abyssinian Altar brought from Magdala in 1868'. This was Arbuthnot's second Tabot, which he had donated to Westminster Abbey on his return from the campaign.

In the wake of the Edinburgh repatriation, calls started growing for the abbey to follow its fellow Anglican church St John's and return its sacred relic to Ethiopia. The abbey staff took a slightly different tack. They recognised that the Tabot could no longer be on public display so they placed a board over the cavity, trapping the Tabot inside, and did their best to fill in the inscription below it with paint. Among the loudest voices calling for Westminster Abbey to change its mind was the Rev. John McLuckie, who went as far as publicly calling the retention of the Tabot 'sacrilege'. Affronted, the abbey staff essentially went to ground. Off the record, there were suggestions of concerns the removal would damage the altar. On the record, they responded to inquiries with a

standardised message. 'The Dean and Chapter are very conscious of the sensitivity of the tabot,' they replied when I emailed them for this book. 'It was for this reason that steps were taken a number of years ago to ensure that the tabot, which is in a very sacred place, was properly covered and could not be seen by anyone. The Dean and Chapter keeps the status of all Abbey artefacts under review.'

Alamayu's Remains

Westminster Abbey is not governed by anything like the British Museum Act of 1963. It is a 'Royal Peculiar', a church that belongs directly to the monarch, suggesting that all decisions about its contents currently rest with Victoria's great-great-great-grandson King Charles III. Another prominent Royal Peculiar is St George's Chapel in Windsor Castle, where Prince Harry and Meghan were married in 2018, and where Prince Alamayu was buried in 1879.

In the years that followed his death, a succession of Ethiopian administrations and figures called for Britain to return Alamayu's bones so he could be re-buried in Ethiopian soil. Their campaigns have gone straight to the heart, appealing to the emotions. Alamayu was their orphaned lost boy, their missing prince, who needed to come home. To them, he was stolen, not rescued, taken by the troops along with the rest of the plunder. How would Britain's then Queen Elizabeth II feel, Ethiopian Ambassador Fesseha Shawel Gebre asked in 2019, if one of her own relatives was lying dead in a foreign land? 'Would she happily lie in bed every day, go to sleep, having one of her Royal Family members buried somewhere, taken as prisoner of war? I think she wouldn't,' he told the *Daily Mail*.

The tone of the responses from Windsor Castle has been remarkably similar to the one from Westminster Abbey about the Tabot – polite but unyielding. In 2006, according to the *Observer* newspaper, Britain's Lord Chamberlain wrote back to Ethiopia's president saying that 'while Her Majesty was in favour of repatriation ... identifying the remains of young Prince Alemayehu would not be possible'. Fifteen years after that, in 2021, the cultural campaign group the Scheherazade Foundation wrote to Britain's royal family repeating the request to exhume the prince. They got another sympathetic, carefully worded refusal, saying that the

queen 'has been advised that it is very unlikely that it would be possible to carry out such a task without disturbing the resting places of others in the vicinity'.

It's a tough one, and I must admit my position has shifted back and forth since I started writing this book, even since the last edition.

For the campaigners for Alamayu's return, there is an overwhelming feeling that, if there was a will to repatriate his remains, there would be a way. St George's Chapel, after all, has a history when it comes to re-burials. Queen Victoria's own mother, the Duchess of Kent, was interred there in March 1861, then moved five months later to a mausoleum in the nearby Frogmore estate. In 1928 alone, the chapel's website lists six royal figures who made the same journey from its increasingly crowded royal vault. Princess Alice of Battenberg – the late Queen Elizabeth II's own mother-in-law – was laid to rest in the vault at St George's in 1969, then moved to the Russian Orthodox Church of Mary Magdalene in Jerusalem in 1988.

Alamayu is buried in catacombs outside the chapel, not in the royal vault. Those catacombs are sealed off and entering them now would involve significant work on the site. But people know where they are. Contemporary accounts say he was laid to rest in his own sturdy coffin with his name written on the lid. In 2019, the Ethiopian–British poet Lemn Sissay wrote a blog post suggesting authorities could go one step further and verify Alamayu's remains by comparing them with DNA from the locks of Tewodros's hair recovered from the National Army Museum.

A few months ago, it seemed fairly clear to me that he should go back. And then other Ethiopians started getting in touch and posting messages online, speaking on condition of anonymity because the issue was so sensitive. 'Now is not the time to bring back his remains. Not now, not yet,' one wrote in a thread on Twitter. 'It's really not the right time,' someone else said quietly at an event to launch the hardback edition of this book. At the time of writing, regional rivalries and enmities are again tearing at the fabric of Ethiopian society. Battles have raged in some of the same places where Tewodros fought his enemies. It would

be a tragedy if the return of Alamayu's remains – and perhaps arguments over where he should rest – did anything to inflame an already smouldering political situation. At another event, a man gave a passionate address, saying how valuable it was for diaspora Ethiopians, for diaspora Africans and British-based followers of the Rastafarian faith, to be able to visit Alamayu where he was, buried in a place of honour.

And then you turn back to Alamayu's own wishes. In the months leading up to his death we know that he had a 'hankering after his own country'. At the time, Northcote ruled that any return was out of the question and sent him off to spend his last winter in a cold house outside Leeds. As happened so often during his short life, no one stopped to consider what he himself wanted, until it was too late. Perhaps all these years later, there is still room to dream that, when peace returns and when everyone can agree on where he should lie – alongside his mother or next to his father or alone on his promontory at the top of Maqdala – that then it will finally be time to listen to Alamayu and let him go home.

The Directory

Richard Pankhurst and Dr Hassen Said from the Institute of Ethiopian Studies, Addis Ababa, 2005.

Below you will find a directory, by current location, of the Maqdala plunder and the other treasures that the soldiers and captives and missionaries brought back. It is a history of the Abyssinian Expedition in at least 830 objects – 7,280 if you count the animal carcasses. You can find more details on each one on www.theprinceandtheplunder.com.

It focuses on things with substantial links in the records to the battle and expedition. Most were looted. There are asterisks next to a few where the links are less definitive (maybe just a date or a name) or where there is a chance the artefacts may have been given or sold along the route rather than plundered – though how free can a sale be when the buyer arrives carrying a gun with a world-conquering imperial power at his back?

I have also excluded scores of Ethiopian items from around the same time that may well have been taken from Maqdala but are now in museums with next to no details in the archives on how they got there.

Austria
Österreichische Nationalbibliothek, Vienna
1 manuscript
Canada
Royal Ontario Museum
1 sacred silk hanging
France
Bibliothèque Nationale de France, Paris
2 manuscripts*
Germany
Berlin State Library
2 manuscripts
The Ethnological Museum, Berlin
1 cloak*
1 drinking horn
Ireland
The Chester Beatty Library, Dublin
3 manuscripts (2/1*)
National Museum of Ireland, Dublin
'Scattered objects' from Maqdala and other colonial battles, uncatalogued [In all, about 37 artefacts linked to Abyssinia, including 'swords, belts, daggers and other items', some donated by military men]
Trinity College Library, Dublin
2 scrolls*
1 manuscript*

The Netherlands
The Afrika Museum, Berg en Dal
1 manuscript*
Norway
The Schøyen Collection, Oslo
1 manuscript
Portugal
Private collection
The Kwer'ata Re'esu icon
United Kingdom
The Bodleian Library, Oxford
11 manuscripts (5/6*)
The British Library, London
362 manuscripts (358/4*)
6 letters (additional MS 828, folios 27–32)
The British Museum, London
10 Tabots
2 sacred cloth hangings [One of them 'the largest tablet-woven textile in the world']
Alamayu's necklace
Tirunesh's Book of Psalms [The necklace and book aren't quite plunder: Speedy must have inherited them after Alamayu's death, and his wife gave them to the British Museum in 1912]
At least 6 fragments taken from the dig at Adulis
3 gold discs*

246

The Directory

10 crosses
9 items of sacred regalia – cen-
sers, sistrums, chalices (7/2*)
2 robes
1 diptych
2 umbrella ornaments (1/1*)
Slippers
7 pieces of adornment and jewel-
lery (6/1*)
1 silver gilt drinking cup
7 weapons (2/5*)
2 tents
2 pieces of horse tack*
1 pair of scissors
3 shields
*Cambridge Museum of Archaeology
and Anthropology*
4 cloaks/robes (2/2*)
Cambridge University Library
13 manuscripts (3/10*)
*The Cameronians Regimental
Museum, Hamilton*
1 prayer book*
1 cross
1 piece of the emperor's coat
The Cuming Museum, London
1 scroll*
*The Duke of Wellington's
Regimental Museum, Halifax*
Throne cloth
'Theodore's shirt'
1 sword*
1 ammunition belt*
1 fly-whisk*
1 letter from Tewodros

Edinburgh University Library
4 manuscripts (2/2*)
Horniman Museum, London
1 church manuscript*
1 sistrum*
Hughenden Manor, High Wycombe
Disraeli's necklace
John Rylands Library, Manchester
4 manuscripts (3/1*)
1 scroll
*The King's Own Regimental
Museum, Lancaster*
Cloth with Tewodros's blood
Borrett's ring
16 assorted items (some *)
Lancaster Priory
4 crosses [Staff question whether
these are plunder as they say
they were found in a pile of scrap
metal]
*National Archives of Scotland,
Edinburgh*
1 illustrated page*
National Army Museum, London
12 assorted items (some *)
*National Library of Scotland,
Edinburgh*
2 manuscripts, 1 scroll*
National Museums of Scotland
1 cross
1 goblet
1 scroll
1 manuscript page
2 manuscripts
3 bracelets/armlets

National War Museum of Scotland, Edinburgh
'Theodore's Cup'
Pitt Rivers Museum, Oxford
1 scroll
1 cross
2 swords/daggers*
3 gunpowder holders
1 shield with bullet hole*
1 cloth marked with symbols
Royal Armouries
'Theodore's sword'*
The Royal Collection
6 manuscripts
1 royal cap
1 sword
1 pistol, given to Tewodros by Queen Victoria [Possibly the one he used to shoot himself]
Slippers
Royal Engineers Museum, Gillingham
Bridle, saddle and stirrups*
Shield
Leopard-skin cape
Drum
1 scroll
University of Dundee Museum
1 scroll*

The Victoria & Albert Museum, London
'Abuna's gold crown'
2 of the queen's dresses
61 pieces of the queen's jewellery
1 of the queen's shawls
4 other items of adornment*
'Abuna's robes'
3 crosses (1/2*)
2 chalices
1 shield
1 gauntlet
1 service book
1 scroll*
1 set of drawings taken from a manuscript
The Wellcome Collection, London
6 scrolls (5/1*)
Westminster Abbey, London
1 Tabot
USA
Princeton University Library
2 manuscripts
1 scroll
The Smithsonian Institution, Washington DC
1 'Coptic Bible'
UCLA Library, Los Angeles
1 manuscript

The Maqdala Plunder, Still Missing

Identified in auction catalogues and accounts but location unknown:

- At least 100 other Ethiopian manuscripts in British collections. William Wright, the author of a catalogue of Ethiopian manuscripts in the British Museum, estimated at least 500 Maqdala volumes came to Britain in 1868. This book has identified about 400
- A cross presented to the Indian 1st Belooch Regiment after the battle. That regiment went on to become part of Pakistan's Baloch Regiment, which still exists and is based in Abbottabad
- Two manuscripts and a letter from Tewodros exhibited in Bombay in 1868
- 21 items displayed in the National Exhibition of Works of Art in Leeds in 1868
- An embroidered yellow silk robe, last seen in the South Kensington Museum in 1868
- A pair of Tirunesh's 'pyjamas' sent to the South Kensington Museum in 1869
- Two manuscripts mentioned in the periodical the *Bibliographer* in 1883
- A 'charm necklace' pictured in the *Illustrated London News* in 1892
- A 'bishop's crown' and two coffee pots listed in W. Webster's *Catalogue of Ethnological Specimens* in 1895
- One manuscript in the collection of US bibliophile Wilberforce Eames, put up for sale in 1905
- Two manuscripts in Lady Meux's collection, sold on after her death in 1910, despite her wishes that they be returned to Ethiopia

The Prince and the Plunder

- A silver-mounted Abyssinian *kaskara* and a machete sold by Christie's in London in 2003
- A horn cup sold via Christie's in London in 2014
- A drinking horn sold via Bonhams in London in 2017

The Maqdala Plunder, Returned

Full details at www.theprinceandtheplunder.com

- A copy of the *Kebra Nagast*
 Sent back in 1872 at the request of Emperor Yohannes IV
 Last seen: Kiddus Raguel Church, Entoto
- Crown
 Returned by the British government in 1925, a year after the visit to Britain by Ras Tafari Makonnen, the future Emperor Haile Selassie, who was then regent and heir to the throne
 Current location: Unknown. Possibly looted again by invading Italian troops in the 1930s. Possibly still in Rome. Investigations ongoing
- Crown and Tewodros's great seal
 Returned in 1965 during Queen Elizabeth II's state visit to Ethiopia
 Current location: Addis Ababa
- The 'Edinburgh Tabot'
 Returned by St John's Episcopal church, Edinburgh, in 2002
 Current location: The Ethiopian Orthodox Church
- The 'MacLennan Tabot'
 Returned by Dr Ian MacLennan in 2003
 Current location: The Ethiopian Orthodox Church
- Shield
 Returned by Prof. Fiona Wilson of Glasgow in 2004
 Current location: The Institute of Ethiopian Studies, Addis Ababa University

- Book of Psalms
 Bought from Maggs Bros and returned by the author and Amber
 Henshaw in 2004
 Current location: The Institute of Ethiopian Studies, Addis Ababa
 University
- A processional cross, an illuminated page from a manuscript, a sword
 and a sixteenth-century Portuguese soldier's helmet
 Returned by private donors in 2005
 Current location: The Institute of Ethiopian Studies, Addis Ababa
 University
- Locks of Tewodros's hair
 Returned by London's National Army Museum in 2019
 Current location: Addis Ababa, awaiting burial
- Three drinking horns, taken from Maqdala by Captain William
 Arbuthnot of the 14th Hussars, later embossed in Victorian silver
 Bought through an auctioneer in the Dorset seaside town of
 Bridport by the Scheherazade Foundation and returned with other
 artefacts to the Ethiopian Embassy in London in September 2021
 Current location: Flown back to Addis Ababa in November 2021
 and placed in the National Museum of Ethiopia

Notes

The chapter epigraphs come from the 2009 Oxford University Press edition of Samuel Johnson's philosophical fable *The History of Rasselas Prince of Abissinia*, with the original spellings. They are not meant to suggest that Alamayu is the nineteenth-century embodiment of the fictional prince dreamed up by an English writer 100 years earlier. The quotes are taken out of order and forced to follow Alamayu's narrative. It was just striking how often a phrase or a scene illustrated and echoed a moment in his tale.

Chapter One: Home

The details of Bell's early Ethiopian adventures come straight from his journal, extracts of which were published soon after they were written in 1842 in *Miscellanea Ægyptiaca*, the periodical of the Association littéraire d'Égypte. If the full journals have survived anywhere, it would be wonderful to read them as there are many holes left in John Bell's story. He is variously described in contemporary accounts as English, Scottish and Irish, a sailor and also a former British soldier. I tended to rely on the research of modern-day historian David Arrigo, who has written extensively about the 'Maltese interpreter' in the *Times of Malta*. Plowden referred to Bell's horrific injury in one of his reports back to London in March 1853, still kept in the files of confidential Foreign Office correspondence in Britain's National Archives (FO 401/1 No. 291, 23 March 1853). Plowden wrote that as Bell grew in political stature,

The story of his early entanglement with the bandits spread among Ethiopians, who saw it as 'rather a good joke'.

The story of Plowden's mind-altering meeting with Bell appears in the family chronicle *Records of the Chicheley Plowdens* and in the introduction to *Travels in Abyssinia and the Galla Country* – a collection of Plowden's writings including his descriptions of rivulets and other riches and his brief, final journal entry. That book describes how the consul's manuscripts reached his family after his death in a 'most mutilated state – loose sheets, some of them unfinished, others illegible, and a volume in pencil writing so minute as to be deciphered only with the greatest labour and patience'. Plowden's early interest in Kasa, his reports of Ras Ali's defeat and his full-blown adulation of the new King of Kings Tewodros appear in some of those same pages and throughout the Foreign Office correspondence, with his glowing assessment of the monarch and offer to 'share his dangers' in FO 401/1 No. 447, 25 June 1855. Tewodros's life is covered in much greater detail in Philip Marsden's wonderful book *The Barefoot Emperor*. He starts his story with Plowden, delves deep into the chronicles, follows every step of the monarch's march with his guns to Maqdala and includes a meditation on Tewodros's reinvention as a modern Ethiopian hero – as shown in all the graffiti and an oversized representation of one of his guns on a traffic island in Addis Ababa. It's a great read. The emperor's rise also appears in Zaneb's *The Chronicle of King Theodore of Abyssinia*, Sven Rubenson's *King of Kings* and Bahru Zewde's *A History of Modern Ethiopia*.

You can see an image of the letter bearing Kasa's early challenge – 'No one can face me' – on its original thick, coarse paper in *Acta Æthiopica: Volume 1* (No. 93) and the letters to the French consul and Queen Victoria in *Acta Æthiopica: Volume 2* (Nos. 4 and 24). Tewodros's words to Plowden – 'befriend my son' – come from *Travels in Abyssinia*. Europeans who heard Tewodros referring to white monkeys include Kerans, in a letter reproduced in *Kerans Family History*, and Stern, according to an article on his meeting with Bouta Workey in the 18 November 1869 edition of the *Dundee Courier*.

Notes

The missionaries' story can be tracked through church archives and through memoirs, including *The Autobiography of Theophilus Waldmeier*, *Notes from the Journal of F.M. Flad* and Stern's *Wanderings among the Falashas in Abyssinia*. Accounts of Bell and his family in Ethiopia can be found in the same memoirs and in Henry Dufton's *Narrative of a Journey Through Abyssinia in 1862–3*. Details of what happened to them after Bell's death and after Maqdala, not covered in this book, can be found on the website https://tandscandal.wordpress.com/. 'Theodore's Englishman' comes from the 8 September 1868 edition of *The Times*. Accounts of the deaths of Plowden and Bell and the awkward diplomatic approaches that followed come primarily from the Foreign Office correspondence. The early information on Tirunesh comes from Blanc's *A Narrative of Captivity in Abyssinia* and Dufton's *Narrative*. Blanc also shared the rumours about Tewodros's sleeping arrangements and his fear of poison. The observant Clements Markham described Alamayu's first home in his *A History of the Abyssinian Expedition*.

Chapter Two: Breakdown

Most of the events in this chapter, including Cameron's appointment, the agonised debates over what went wrong, and the letters from the captives, are covered in the Foreign Office correspondence. You can read Cameron's own account of his disastrous first meeting with Tewodros at FO 401/1 No. 802, 31 October 1862. Tewodros's letter to Victoria – the one that kicked off the whole crisis – is included in the files with the consul's report. A reproduction of the Amharic text, with the imperial seal and original English translation, appears in *Acta Æthiopica: Volume 2* (No. 117).

More details on the breakdown in relations with Stern, Cameron and his retinue and then their imprisonment can be found in Stern's *The Captive Missionary*, Waldmeier's *Autobiography* and Philip Marsden's *The Barefoot Emperor*. The descriptions of Rassam's mission come from his own two-volume *Narrative of the British Mission to Theodore, King of Abyssinia*, Blanc's *Narrative* and an account from Prideaux included in

Markham's *History of the Abyssinian Expedition*. Tewodros himself sets out the history of his grievances against the Europeans in a letter to Rassam on 5 January 1867, published in *Acta Æthiopica: Volume 2* (No. 207). Stern had insulted him, Cameron had withheld the reply to his letter and Rassam had sent off the prisoners prematurely. 'Subsequently I heard it said that the English and the Turks had become allies and were hostile to me.'

Punch published its murderous poem on 5 October 1867. Prideaux's letter about Alamayu's first political act, dated 11 December 1867, appeared in the 7 February 1868 edition of the *Pall Mall Gazette*. The parliamentary debates are from Hansard.

Chapter Three: War

Soldiers, captives and missionaries produced scores of memoirs, letters and official accounts setting out the story of Britain's Abyssinian Expedition. The mother of them all is the *Record of the Expedition to Abyssinia* compiled by order of the Secretary of State for War by Major Trevenen J. Holland of the Bombay Staff Corps and Captain Henry Hozier of the 3rd Dragoon Guards. It includes the reports from Holmes, Jesse, Markham and the excavators of Adulis. The most dramatic and colourful scenes of the campaign appear in Stanley's *Coomassie and Magdala*. But they should be treated with some caution. The *Daily Telegraph*'s man on the scene, Lord Windham Dunraven – far from a reliable witness himself – later described in his memoirs *Past Times and Pastimes* how the *New York Herald*'s reporter 'used to ask the assistance of my imagination when episodes were few and far between'.

Details of the British Museum's deliberations about sending in its own expert are in the museum's own archives, Wilson's *The British Museum: A History* and the correspondence preserved in 'Parliamentary Papers Connected with the Abyssinian Expedition', No. 743, 15 October 1867. The watercolour of Holmes by Dante Gabriel Rossetti is in the British Museum.

Notes

The accounts from Maqdala of the build-up to the battle and the fighting itself come from Rassam, Blanc and Waldmeier. The accounts from the British side come from Holland and Hozier, Stanley and soldiers' books and letters. The gruesome sight of the bodies lying in a row comes from the *Journal of Captain Frank James* kept in the National Army Museum. Herbert Borrett's letters back home, printed under the title *My Dear Annie* by the King's Own Royal Regiment Museum in Lancaster, give one of the best day-by-day descriptions of the campaign. The museum still has the ring he found.

Chapter Four: Plunder

The vultures dressed like Englishmen come from *The Life and Opinions of Major-General Sir Charles Metcalfe MacGregor*, a collection of his writings published by his wife in 1888. The treatment of Tewodros's body was confirmed by, among others, Clements Markham and Stanley, while details of the looting came from journalists and soldiers at the scene, including Captain James. Holmes's quick arrival on the summit and his early purchases are described in the British Museum's archives – *Original Papers*, XCIV no. 5, 184 – and in the Hansard records from 7 July 1868. 'Tédros ... mafeesh' comes from the unnamed *Times* correspondent, whose report was published a month later on 25 May 1868. Bizarrely he describes the slap on the back as an effort to console the queen, but acknowledges that the words and overall effect can't have been reassuring. 'No booty at Magdala' comes from Napier's telegram quoted in the 30 May 1868 edition of the *Illustrated London News*. The story of the jewels stuffed into the cricket ball appears in *The Iron Duke*, the journal of the Duke of Wellington's Regiment, in 1929. The story of the cross and the rhino shield appears in *Notes on the Life of W.A. Wynter*, published in 1902 by his son. Arrangements for the auction are described in detail in Holland and Hozier and in grumpy Milward's own journal, now in the library of the Institute of Ethiopian Studies in Addis Ababa.

The Prince and the Plunder

Several institutions, including the Royal Engineers Museum in Gillingham, still have the portraits of Alamayu and Speedy with the other photos from the campaign. Accounts of the return march appear in Holland and Hozier, Rassam's *Narrative*, contemporary journalistic accounts and the diary of the artist William Simpson, edited by Richard Pankhurst and published by Tsehai in 2003. Many of the details on the passages from Speedy come from Jean Southon's *The Rise and Fall of Basha Felika*, and from 'Captain Speedy's "Entertainment"', a paper written by Richard Pankhurst based on notebooks lent to him by Southon that Speedy used for his later lectures on Ethiopia.

Chapter Five: Exile

The last dash to the coast on the train comes from Simpson's autobiography and the details of their journey on the Feroze, including Alamayu's night terror, come from Simpson's edited diary. Zanab's letter to Krapf is reproduced in *Acta Æthiopica: Volume 2* (No. 250). The passages in Malta take details from David Arrigo's articles and another – 'The tragic prince of Abyssinia in Malta' by Giovanni Bonello. You can read the amazing story of the Ethiopian boy taken to India after Maqdala in Peter Garretson's *A Victorian Gentleman and Ethiopian Nationalist: The Life and Times of Hakim Wärqenäh, Dr Charles Martin*.

Much of the detail on Alamayu's first days in Britain came from correspondence and conversations with Graham Walker of the Friends of the Railway Studies Collection and Dr Harry Bennett from the University of Plymouth. The details of the many newspaper articles appear in the main text. The description of the girl 'presented' to Napier, and the account from the couple on the ship appeared in several papers including *The Glasgow Herald* on 18 July 1868. There is a great photo of the *Elfin* in Tony Dalton's *British Royal Yachts: A Complete Illustrated History* (2002).

Notes

Chapter Six: Arrival

The quotes from Victoria's journals have been published before by Amulree, Bates, Langton and Southon. Her letter to Lady Watermark is quoted in Julia Baird's *Victoria the Queen*, her ailments and the political turmoil described in A.N. Wilson's *Victoria: A Life*. The discussions about Alamayu's guardianship were handily compiled by the British authorities in 1872 in *Extracts from Correspondence respecting Arrangements for the Education of Prince Alamayou*, now in The National Archives and other repositories. The receipts for sausages and window repair, and for the velveteen suit, are owned by collector Ian Shapiro. The references to newspaper articles and to *Anecdotes of Alamayu* are noted in the main text. Dorothy Tennant's journal is held with the Stanley Archives in the AfricaMuseum in Tervuren, Belgium. The quoted entries were made in September 1876. Many thanks to the author Elizabeth Laird for tracking them down. We know about Amalayu's attachment to his mother's Psalter thanks to a letter from an unnamed Quaker who visited the Cottons and described his encounter with the prince in an article syndicated across Britain's newspapers, including *The Western Mail*, in October 1869. 'Alamayu can read the Testament well in his native tongue, and he fetched and showed with pleasure not only his departed mother's New Testament, printed by the Bible Society, but also an ancient copy of the Book of Psalms in Ethiopic, written on parchment, with wooden covers, which belonged to his mother.' Alamayu's first meeting with Tennyson – 'papa, papa, papa' – and the group watching the *Ripon* sail by are described in *The Letters of Emily Lady Tennyson*. The poet's account of his conversation with the prince comes from *Glimpses of Tennyson*. All of Allingham's contributions come from his diary.

Chapter Seven: Interludes

The bulk of the references in this chapter come from newspaper cuttings. Disraeli's speech on 2 July 1868 appears in Hansard and was

259

printed across the press. The fountains and fireworks at Crystal Palace were described on 9 July in *The Times*, which also printed the full guest list at the reunion dinner in Willis's on 29 July. *The Fall of Magdala* musical extravaganza was advertised in the *Standard* in October, as was *The Abyssinian Duet* in November – frustratingly without any details of the performance or the lyrics. Notices about the exhibitions in the Crystal Palace, the South Kensington Museum and Wales were crammed in with the rest of the classified ads on the front page of *The Times*. The smaller pieces of plunder are listed at the back of the official catalogue of the National Exhibition of Works of Art, at Leeds, published in 1869. Arnold's sneering review was published in the August 1868 edition of *The Gentleman's Magazine*, and the 'rude in extreme' description comes from John Hungerford Pollen's *Ancient and modern gold and silver smiths' work in the South Kensington Museum*, published in 1878. The newspaper and census sources for Bouta Workey are cited in the text. Good places to learn about the Wombwell and other menageries include the website www.georgewombwell.com/, Thomas Frost's 1874 book *The Old Showmen, and the Old London Fairs* and, if you fancy a bit of a detour, Michael Howell's *The True History of the Elephant Man* (1983). Joseph Merrick, whose mother, according to myth, had a life-changing encounter with a Wombwell elephant, and who was exhibited in the same sort of shows, was a contemporary of Bouta Workey.

You can follow Alamayu and Speedy's travels through the shipping reports and passenger lists in the papers, including the world-spanning *Homeward Mail from India, China and the East* and its corresponding *Home News for India, China and the Colonies*. The letters back and forth about the prince's future are covered in the aforementioned *Correspondence respecting Arrangements for the Education of Prince Alamayou*, the British Library, the Royal Archives and in Amulree, Bates, Langton and Southon. Alamayu's encounter with Prince Alfred appears in the privately published and anonymous *His Royal Highness the Duke of Edinburgh in the Oudh and Nepal forests. A letter from India* (1870).

Lord Russell's memo on Abyssinian policy, in a dispatch to Britain's consul-general in Egypt, Colonel Stanton, was printed in the *London*

Gazette on 31 October 1865. Lowe's defining quote, 'When I take up a principle I like to carry it out to its utmost extent', is in James Winter's 1976 biography of the Chancellor, *Robert Lowe*.

Chapter Eight: Retreat

Woizero Laqaya's heartbreaking letters are reproduced in *Letters From Ethiopian Rulers early and mid-nineteenth century*, published for the British Academy by Oxford University Press in 1985. Much of the story of Speedy's return to Britain and the custody tussle that followed is set out in a letter he wrote in the Langham Hotel in London to his brother Alfred in Penang in February 1872. I am very grateful to Speedy's great-great-nephew Tim Jerram for sending me a transcription from New Zealand. Much of the rest of the correspondence is again from the British Library, the Royal Archives and in Amulree, Bates, Langton and Southon. Every word of the embarrassing parliamentary debate is in Hansard and large chunks of it were reproduced across the national press. There is a vivid depiction of Sophia Jex-Blake's confrontation in Edinburgh in Helen Lewis's great *Difficult Women: A History of Feminism in 11 Fights* (2021).

Chapter Nine: Lessons

Alamayu stuck out at school in Britain, so when some of his classmates came to write their memoirs, they invariably included a passage about him, even if it was based on only the slightest acquaintance. His letter to Lady Biddulph is kept in the Royal Archives and quoted in full by Amulree. Thanks to Jill Barlow of the Cheltenham College Archives for the tour and the access to the School Class Lists, which give an insight into Alamayu's academic progress. The quotes from Hughes's *Tom Brown's School Days* come from the 2008 Oxford World's Classics edition and the references to *The Meteor* from the editions that Rugby has posted

online. *Wolfe's Wild Animals*, inscribed by Queen Victoria, is in the collection of Ian Shapiro. The reference to the burnt coke is from Dorothy Tennant's journal. The publicity interview about 'fagging' is from the 9 October 1911 issue of the *Indianapolis Star*. The bulk of the material from Cyril Ransome comes from *The Last Englishman* and his unpublished autobiography, together with other material in the Brotherton Library in Leeds. Alamayu's time in Sandhurst is stitched together from its Cadet Register, the letters in the newspapers, and studies on the college itself including Michael Yardley's *Sandhurst: A Documentary* (1987). You can read Lieutenant-Colonel G.F.R. Henderson's evidence in the minutes of the Parliamentary Committee on Military Education published in 1902. The best book on Charles Carmichael Monro is Patrick Crowley's *Loyal to Empire*, published by The History Press in 2016.

Chapter Ten: The Funeral Psalm

The debate about what to do with Alamayu after Sandhurst is preserved in letters in the Royal Archives. You can follow his last days in Headingley in the bundles of letters and telegrams in storage boxes in the Ransome Collection in the Brotherton Library at the University of Leeds. Details of the funeral service, the reading and the music can be found in the records at St George's Chapel and Windsor Castle and in the comprehensive press coverage. Ras Tafari's correction of Alamayu's memorial plaque was mentioned in a short story in *The Times* on 16 January 1932.

Chapter Eleven: Return

Gordon's travels, and the inquiry about the possibility of returning Alamayu to Ethiopia, are covered in FO 407/14 – a collection of Foreign Office 'confidential print' about relations between Egypt and Abyssinia. You can find it in The National Archives or online via archive.org.

Select Bibliography

Books

Allingham, W., *A Diary* (London: Macmillan & Co., 1907)

Ambatchew, Michael Daniel, *Alemayehu* (Addis Ababa: Neo Printers, 1999)

Bates, D., *The Abyssinian Difficulty* (Oxford: Oxford University Press, 1979)

Blanc, Henry, *A Narrative of Captivity in Abyssinia* (London: Smith, Elder & Co., 1868)

C.C. [Cornelia Cotton], *Anecdotes of Alamayu, the late King Theodore's son* (London: W. Hunt & Co., 1870)

Dufton, H., *Narrative of a Journey through Abyssinia in 1862–3* (London: Chapman, 1867)

Fraser, G.M.D., *Flashman on the March: From the Flashman Papers 1867–8* (London: HarperCollins, 2006)

Garretson, P.P., *A Victorian Gentleman and Ethiopian Nationalist: The Life and Times of Hakim Wärqenäh, Dr Charles Martin* (Cambridge: Cambridge University Press, 2013)

Getatchew, H., Rubenson, S. & Hunwick, J.O., *Acta Æthiopica: Volume 1.* (Evanston, IL: Northwestern University Press, 1987)

Holland, T.J., Hozier, H.M. & James, H., *Record of the Expedition to Abyssinia* (London: British Library, 1870)

Johnson, S., Tillotson, G. & Jenkins, B., *The History of Rasselas, Prince of Abissinia* (Oxford: Oxford University Press, 1977)

Laird, E., *The Prince Who Walked with Lions* (London: Macmillan Children's Books, 2012)

Markham, C.R. & Prideaux, W.F., *A History of the Abyssinian Expedition: With a chapter containing an account of the mission and captivity of Mr. Rassam and his companions* (London: Macmillan, 1869)

Marsden, P., *The Barefoot Emperor: An Ethiopian Tragedy* (London: Harper Perennial, 2008)

Matthies, V. & Rendall, S., *The Siege of Magdala: The British Empire against the Emperor of Ethiopia* (Princeton, NJ: Markus Wiener Publishers, 2012)

Pankhurst, Richard, *Economic History of Ethiopia, 1800–1935* (Addis Ababa: Haile Sellassie I University Press, 1968)

Plowden, W.C. & Plowden, T.C., *Travels in Abyssinia and the Galla Country, with an account of a mission to Ras Ali in 1848. From the MSS. of the late W.C. Plowden ... Edited by ... T.C. Plowden.* (London: British Library, 1868)

Rassam, H., *Narrative of the British Mission to Theodore, King of Abyssinia* (London: John Murray, 1869)

Rubenson, S., *King of Kings, Tewodros of Ethiopia* (Addis Ababa: Haile Selassie I University in association with Oxford University Press, 1966)

Rubenson, S., Rubenson, S., Aklilu, A. & Aregay, M.W., *Tewodros and His Contemporaries 1855–1868. Acta Æthiopica: Vol. 2.* (Lund: Lund University Press, 1994)

Simpson, W. & Pankhurst, R., *Diary of a Journey to Abyssinia, 1868: The diary and observations of William Simpson of the Illustrated London News* (Hollywood, CA: Tsehai, 2003)

Southon, Jean & Harper, Robert, *The Rise and Fall of Basha Felika: Captain Speedy, his Life and Times* (Penzance: Jean Southon, 2003)

Stanley, H.M., *Coomassie and Magdala: The story of two British campaigns in Africa* (London: Naval and Military Press, 1874)

Stern, H.A., *The Captive Missionary, Being an Account of the Country and People of Abyssinia* (London: Cassell, 1868)

Stern, H.A., *Wanderings among the Falashas in Abyssinia: Together with a description of the country and its various inhabitants* (London: Routledge, 1862)

Tennyson, E.T. & Hoge, J.O., *The letters of Emily Lady Tennyson* (University Park, PA: Pennsylvania State University Press, 1974)

Treanor, D., *Kerans Family History* (London: Treanor Books, 2013)

Waldmeier, T., *The Autobiography of Theophilus Waldmeier, missionary* (London: Leominster, 1886)

Weld, A.G., Tennyson, B. & Tennyson, A.T., *Glimpses of Tennyson and of some of his relations and friends* (London: Williams & Norgate, 1903)

Zewde, Bahru, *A History of Modern Ethiopia: 1855–1974* (London: James Currey, 1991)

Articles

Amulree, Basil William Sholto Mackenzie, Lord, 'Prince Alamayou of Ethiopia', *Ethiopia Observer*, vol. 13, no. 1, pp. 8–15, 1970

Arrigo, David, 'From Sliema to Abyssinia: the story of a Maltese interpreter', *The Times of Malta*, 2021

Bates, D., 'The Abyssinian Boy', *History Today*, vol. 29, p. 816, 1 Dec 1979

Bell, J.G., 'Extract from a journal of travels in Abyssinia, in the years 1840–41–42', *Miscellanea Ægyptiaca*, 1842

Great Britain, Foreign Office, FO 401/1–6 Foreign Office: Confidential Print Abyssinia, National Archives

Select Bibliography

Great Britain, Foreign Office, Papers connected with the Abyssinian Expedition. Presented to both Houses of Parliament by Command of Her Majesty (Command Paper; 3955), London: Printed for H.M.S.O., 1867

Great Britain, Parliamentary Papers, 1867

Jeśman, Czeslaw, 'The Tragedy of Magdala', *Ethiopia Observer*, vol. 10, no. 2., 1966

Langton, Jane, 'Alamayou, Prince of Abyssinia', *Report of the Society of the Friends of St George's and the Descendants of the Knights of the Garter*, vol. VI, no. 9, 1988

Pankhurst, Alula & Hirit Belai, 'Dejjach Alemayehu portrayed: Photographs, sketches, engravings, paintings, postcards and sculptures', paper delivered at the Maqdala 150 conference in Gondar, 11 April 2018

Pankhurst, Richard, 'Captain Speedy's "Entertainment": The Reminiscences of a Nineteenth Century British Traveller to Ethiopia', *Africa*, vol. 38, no. 3, pp. 428–48, 1983

Pankhurst, Rita, 'The Library of Emperor Tewodros II at Maqdala', *Bulletin of the School of Oriental and African Studies*, vol. 36(1), pp. 15–42, 1973

Zaneb & Moreno, Martino Mario, 'La cronaca di re Teodoro attribuita al dabtara "Zaneb"', *Rassegna di Studi Etiopici*, vol. II: 1, pp. 160–1, 1942

Acknowledgements

Anyone writing about Ethiopia has to stand back and admire the work that went before. Most of the books and studies listed above are available online – a particularly welcome development as the bulk of this book was written during the COVID-19 lockdowns of 2020 and 2021. You can find most of the older volumes on archive.org.

It is a dangerous business mentioning individuals because you inevitably leave someone out. Nevertheless, I would like to pick out Alula Pankhurst, the son of the late Richard and Rita Pankhurst, for special thanks for his encouragement and many tips and suggestions. I would also like to thank, in no particular order: the Rev. John McLuckie for finding the Tabot and starting off this plunder hunt; my friend Genet Asefa; the Rev. Belete Assefa; Graham Walker of the Friends of the Railway Studies Collection for his help in plotting Alamayu's train journeys; Dr Harry Bennett from the University of Plymouth's history department for helping set the scene for Alamayu's first steps in Britain; David Arrigo for his work on Bell, Speedy and Alamayu on Malta; Simon Wright of The History Press for his editing and patience; my nephew Joseph Piekos for the access; Caroline Holt-Wilson for so generously sharing her late husband's Alamayu collection; the staff in The National Archives and in the British Library's Asian & African Studies Reading Room; all the staff, librarians and curators who very generously provided details on the Maqdala treasures in their collections; Captain Speedy's great-great-niece Jean Southon; the collector–scholar Ian Shapiro; Eyob Derillo, curator of Ethiopic manuscripts in the British Library; Frezer Getachew Haile; Tahir Shah and Jason Webster of the Scheherazade Foundation; Emma Wood, Roger Hutchinson and the Arvon Foundation for their guidance; the Alamayu experts Elizabeth Laird and Ian Campbell; Dorothy Fielding and John Blundell who keep Alamayu's portrait hanging in the hall in Hollin Lane; the readers of my early drafts, including Lemn Sissay, Ras Cos Tafari, Dessalegn Bizuneh, Colin Seditas, Rawdon Heavens, Lucy Eyre, Heather McKay, Paula Swanborough and Mark and Eleanor Campanile.

I would also like to go back to the dedication and thank my family. Thanks to Amber, and again to Rawdon. And a special message to my daughter Esther. Yes, you are right, I have been writing this for longer than you have been alive, much, much longer. But look, here it is. I have actually finished it.

Index

Note: italicised page references indicate illustrations and the suffix 'n' indicates a note.

Abyssinia 4, 7–8, 9, 11, 25, 29, 41, 53, 79, 87, 106
 Abyssinians in Britain 105–6, 133–6
 Britain's policy towards 9, 11–16, 25–34, 41–4, 42, 138–40, 145
 Zemene Mesafint (Age of Princes/Age of Judges) 9–10, 35, 40
 see also Ethiopia
Abyssinian Expedition 43–4, 45–67, 59, 65, 68–93, 105, 113, 179, 219, 234
 funding for 44, 207
 Record of the Expedition to Abyssinia (Holland and Hozier) 46–8, 54, 59, 65, 85, 97, 179, 222, 225
 victory celebrated 127–36
 see also Maqdala; plunder
Aden, modern-day Yemen 34, 145, 147, 204
Adulis, modern-day Eritrea 53, 220–2, *220*, *221*, 246
AFROMET (Association for the Return of the Maqdala Ethiopian Treasures) 234, 239
Afton Manor, Isle of Wight 118–19, 133, 156
Alamayu
 appearance 79, 102–3, 110–11, 114, 169, 172
 birth and childhood in Abyssinia 17–22, 40, 57, 95
 character 57, 84, 111, 112, 125, 153, 154, 156, 158–9, 160, 163, 166, 167, 172, 177, 178, 183
 death, burial and remains of 185–9, *186*, 193, 242–4
 dyslexia, possibility of 138, 163, 178

Ethiopia, wish to return to 172, 181, 191, 192, 193, 243
 father, relationship with 22, 56, 159
 financial maintenance of 116, 125, 140–1, 142–3, 181, 182
 Maqdala ransacking, during the 72, 78–80, *79*, 96, 159
 mental health 78, 96, 98–9, 102–3, 120, 178, 179, 182–3, 186
 necklace 102, *103*, 123, *123*, 201–2, *201*, 246
 parents, mementoes of 121, 154–5, 188, 202–3, 204
 portraits of 78–9, *79*, 83, *84*, 102–3, *103*, *110*, 123–4, *123*
 and Queen Victoria 112, 113–15, 137–8, 146, 150, 155, 158, 159, 170, 182, 184, 185, 186, 187, 189
Alexandria, Egypt 102, 113, 126
Alfred, Prince 137–8
Ali, Ras 5, 6, 9–10, 13
Allingham, William 122, 123
Amharic 27, 74, 100
 Alamayu's knowledge of 92, 98–9, 135, 146–7
 Speedy's knowledge of 88–9, 90, 91, 98
animals
 on the Abyssinian Expedition 46, 47, 63, 96, 97
 collected as specimens 51, 223–6
Anson, Archibald Edward Harbord 142
Antalo, Ethiopia 55, 84, 109
Arbuthnot, William 238, 240, 252
archaeological excavations 220–2, *220*, *221*, 246

267

The Prince and the Plunder

Argyll, Duke of 142
Ark of the Covenant 7–8, 227, 237
Arnold, Edwin 130–3
Aroge plain, Ethiopia 56, 59, 60–3, 64, 80
Assefa, Rev. Belete 203
Axum, Kingdom of 53, 55, 220–1, 222
Ayshal, Battle of (1853) 9–10

Bailey, Henry 212–13
Bailey, Martin 228, 229
Bardel, Mr 29, 135
Bell, John (later, Yohannes) 3–6, 7–8, 9–10,
 12, 14, 15, 25, 26, 27, 31–2, 87
Best, George 108–9
Beta Israel (Falashas) 13, 29
Biddulph, Lady 160, 161, 181, 182, 187, 189
Biddulph, Thomas 155, 156, 160–1, 173
Birch, Arthur W. 142
Blanc, Henry Jules 16–17, 34, 35–6, 37,
 39–40, 56, 58, 129, 139, 199
Blanford, William Thomas 52, 223–6
Bogos, modern-day Eritrea 28, 52, 89
Bonello, Giovanni 102
Borrett, Herbert 63, 80, 84
Boulton, Edith 173
Bourgand, Mr 135–6
Bouta Workey, Prince (Wolde Selassie)
 133–6
British Empire 14, 25–6, 43, 107, 114, 140,
 142, 165, 173, 174, 175, 176, 179, 244
 Scramble for Africa 192
 see also India
British Library 216, 232, 233, 234, 246
British Museum 49, 53–4, 73, 200, 201–3,
 214, 215, 216, 218, 221–2, 224, 227, 233,
 239–40, 245, 246–7, 249
 see also Holmes, Richard Rivington
British Museum Act 239
Burlington Magazine for Connoisseurs 228

Calaqot, Tigray 86, 87
Cameron, Charles Duncan 25–9, 30, 32–3,
 34, 36, 37, 39, 40, 57, 58, 89, 139
Cameron, Julia Margaret 123–4, 123
Carter, T.T. 52
Chambers, Roland 172
Cheltenham College 144, 147, 151–6, 157–64,
 177

Clarendon, Lord 38
Clayton Cowell, Sir John 138, 148
Clery, Cornelius Francis 179
Cockrane, Horace 179
Cook, Dr 52
Cotton, Benjamin 118, 125–6, 156
Cotton, Cornelia ('Tiny') see Speedy,
 Cornelia (née Cotton)
Cowell, Sir John Clayton 187

Dalanta plateau, Ethiopia 55, 57, 60, 76, 80,
 109, 199
Darwin, Charles 124
Debre Tabor, Ethiopia 41, 87–8, 112
Dendy, Terri 211
Dickens, Charles 178, 185
Disraeli, Benjamin 114, 127, 207
Draper, Henry Montagu 166
Dufton, Henry 17

Eames, Wilberforce 249
Egypt 3–8, 10, 30, 70, 102, 126, 145, 176, 191–2
Elfin (yacht) 112, 113
Elizabeth II, Queen 242, 251
Eritrea 28, 47, 221, 223
 see also Adulis, modern-day Eritrea
Ethiopia 106, 124, 127, 189, 199, 200, 202,
 205, 210–11, 243–4, 249
 see also Abyssinia
Ethiopian Embassy 210, 229, 237, 242, 252
Ethiopian Orthodox Church 10–11, 13, 31,
 53, 70, 118, 203, 213, 217, 227, 236–41,
 236, 251

Fahla hill, Ethiopia 58, 59, 60, 65
Fairgrieve, Alex 133, 134, 135
First World War 176, 177
Flad, Martin 38
Flashman on the March (Fraser) 48, 164n
Franks, Augustus 221
Fraser, Charles Craufurd 77
Fraser, George MacDonald 48, 164n

Gabriote (Bell's servant) 4–5, 6
Gabriye, Fitawrawi 60, 63
Gafat, Ethiopia 13, 39, 41, 47, 63
The Gentleman's Magazine 130, 216
Gibbon, Edward 53

268

Index

Gibraltar 104, 126, 181, 183, 187
Giorgis, Samuel 147
Gladstone, William Ewart 114, 142, 149, 219
Gondar, Ethiopia 3, 15, 35, 55, 88, 139, 199, 219, 229, 238
Goodfellow, William West 53, 220–1
Gordon, Charles George (Gordon of Khartoum) 191, 193
Grant, John 187

Habtu, Hailu 213
Haile Selassie, Emperor (formerly, Ras Tafari Makonnen) 189, 232, 233–4, 248, 251
Hammel (Tewodros's horse) 129, *129*
Harrison, William 29
Hawtrey, William 171–2
Henderson, G.F.R. 176
Henshaw, Amber 252
Henty, G.A. 48
The History of Rasselas (Johnson) 3, 8, 19, 25, 45, 69, 95, 98, 113, 127, 145, 157, 181, 191, 193, 197
Holland, Trevenen J. 46, 128
 see also *Record of the Expedition to Abyssinia* (Holland and Hozier)
Holmes, Richard Rivington 48–9, 53, 54–5, 70–1, *71*, 73, 76, 77, 98, 128, 132, 187, 189, 199, 214, 216, 218, 228, 229, 240
Holt-Wilson, Sandy 166
Hozier, Henry 46, 128
 see also *Record of the Expedition to Abyssinia* (Holland and Hozier)
Hughenden Manor, Buckinghamshire 207, 247
Hughes, Jabez 117

Illustrated London News 83, 98, *208*, 249
India 7, 15, 26, 34, 43, 46–7, 82, 91, 97, 106–7, 118, 128, 173, 175, 200
 Alamayu in 79–80, 125–6, 136–41, 142–3, 151, 175
 India Office 28, 52, 118, 137, 140–1
 Indian troops 45, 47, 60, 61, 62, 63, 66, 76, 81, 97, 106, 128, 221, 249
 Secretary of State for 54, 115, 141, 142, 151, 215
 Speedy in 87, 125–6, 136–41, 160

Institute of Ethiopian Studies, Addis Ababa University 212, 213, 251, 252
Ireland 41, 114, 133
Isle of Wight 112, 113–26, *123*, 147, 148, 149, 156, 169, 173, 202

James, Cornelius 'Frank' 70, 72, 209, 210
Jenner, Sir William 149
Jeśman, Czeslaw 12–13
Jesse, William 49–51, 223–6
Jex-Blake, Evangeline 153, 178
Jex-Blake, Henrietta 153
Jex-Blake, Katharine 153
Jex-Blake, Mrs 185, 187
Jex-Blake, Sophia Louisa 153
Jex-Blake, Rev. Thomas William 144, 147, 149, 150–6, 157–8, 160, 161, 162–4, 166, 172–3, 174, 181, 187
Johnson, Samuel 8
 see also *The History of Rasselas* (Johnson)

Kasa (later, Tewodros II) 9–10, 64
 see also Tewodros II (formerly, Kasa)
Kasa Mercha of Tigray (later, Emperor Yohannes IV) 82, 96, 145, 192, 193, 227–8
Kasa (Speedy's Ethiopian servant) 103, 104, 108, 109, 122, 123, 124, 126
Kassaw, Dr Hirut 210
Kebra Nagast (*The Glory of Kings*) 7–8, 227, 251
Kerans, Laurence 32, 57, 89
Kiddus Raguel Church, Ethiopia 227, 251
King's Own Royal Regiment 61, 62, 73, 85, 86, 209, 211
Kodolitsch, Captain 98
Krapf, Johann Ludwig 99–100
Kwara, Ethiopia 10, 12, 21, 211
Kwer'ata Re'esu icon 227–30, *227*, 246

Laqaya, Woizero (Alamayu's grandmother) 146–7
The Last Englishman (Chambers) 172
Leeds 129, 173, 182–5, 206, 243, 249
Lockers Park School, Hertfordshire 166
Lowe, Robert 140, 143–4, 148, 149–50, 151, 155, 175, 187, 218–19

McCracken, Sir Frederick 176
MacGregor, Sir Charles Metcalfe 69, 74
Maciejewski, Justin 210
McLean, Seymour *231*, 232–4, 237
MacLennan, Dr Ian 239, 251
McLuckie, Rev. John 236–8, 240
Madras (Chennai), India 136, 221
Main-Ian, William 232–3
Malaysia 140
Malta 3, 102–4, *103*, 126
Maqdala (Magdala) 18–21, *18, 21,* 57, 106
 Alamayu and mother reside in 18, 19, 20, 21, 95
 British attack *65,* 66–7, *96,* 213
 British ransack 69–77, *81,* 106, 199, 233
 European prisoners on 33–6, 38–40, *39,* 56–7, 58–9
 see also plunder
Markham, Clements 20, 52, 72, 80
Martin, Charles (Hakim Wärqenäh) 106–7
Massawa (Red Sea port) 9, 11, 13–14, 25, 29, 30, 34, 41, 87, 89, 100, 112, 139, 223
Menelik I, Emperor 7
Menelik II, Emperor 35, 40–1, 172, 193
Mercier, Jacques 219
Meshesha 12, 21, 36, 57, 193, 211
meteorology 52
Meux, Lady 249
Milward, Thomas Walter 76, 77, 97, 130, 218, 219
missionaries 3, 11, 13, 23, 29, 30–1, 38, 39, 41, 48, 63, 88, 97, 99–100, 106, 228
Monro, Charles Carmichael 177–8
Museum of Archaeology and Anthropology, Cambridge 205, 247
Mussolini, Benito 55

Nainby, Sarah 184–5
Napier, Sir Robert 79–80, 84, 90, 91, 92, 98, 102, 103, 113, 114, 128, 181, 187
 leads the Abyssinian Expedition 45–7, 55, 64, 65, 66, 81–2, 128
 'little Abyssinian slave girl' of 105
 plunder of Maqdala 74, 75, 77, 87, 207, 218, 233
National Army Museum, London 210, 211, 243, 252

Northcote, Sir Stafford 115, 116, 151, 160–1, 175, 181, 182, 183, 187, 240, 243

Osborne House, Isle of Wight 113–15, 120, 121, 149, 173
Ottomans ('Turks') 9, 10, 26, 27, 28, 30, 32, 62, 191–2
Oudh 136, 140

Paget, Lord Clarence 103–4
Pankhurst, Dr Richard and Rita 198–9, 207, *212,* 228, 229, *245*
phrenology 111
Plowden, Walter 7–9, 10, 11–12, 13–15, 25, 26, 27, 87, 88, 132, 214
plunder 197–252
 'Abuna's Crown and Chalice' 73, 217–19, *217,* 248
 AFROMET 234, 239
 Alamayu allowed to keep 121, 154–5, 188, 202–3, 204
 Alamayu's necklace 201–2, *201,* 246
 animals 51, 223–6
 Britain, reception in 129–33, *129, 131, 132,* 198, 217, 218–19
 Ethiopia, returned to 210–11, 212–13, 218, 227, 238, 251–2
 Kebra Nagast (The Glory of Kings) 227, 251
 Kwer'ata Re'esu icon 227–30, *227,* 246
 manuscripts 76–7, *78,* 87, *129,* 130, 198–9, 210, 215–16, *215,* 233–5, 246, 247, 248, 249, 252
 missing pieces 56, 249–50
 Tabots 236–41, 246, 248, 251
 Tewodros's amulet 212–13, *212*
 Tewodros's clothes *129,* 130–3, *131,* 209–10, 211, 247
 Tewodros's horse (Hammel) *129, 129*
 Tewodros's remains 208–11, *208,* 243, 252
 Tewodros's sacred artefacts 215–16, *215*
 Tewodros's seal 32, 73, 97, 132, 215, 251
 Tewodros's weapons *129,* 214, 248, 251
 Tirunesh's Book of Psalms 121, 154, 188, 202–3, 246
 Tirunesh's clothes 204–6, *204,* 248, 249
 Tirunesh's jewellery 206–7, 248
 see also Maqdala

Index

Plymouth 104, 107, 108, 109, 209, 210
Ponsonby, Henry 150
Ponsonby, Lady 187, 189
Portugal 229, 230, 246
Prester John 7
Preziosi, Leandro 102, *103*
Prideaux, William Francis 35, 37, 40–1,
 128, 139
Punch 41–2, *42*, 44, 71, 133

Qorata, Ethiopia 5

racism 12–13, 41–2, *42*, 44, 71, 86, 110–11,
 170–1, 226, 234
Ransome, Arthur 172, 174–5
Ransome, Cyril 172–5, 181–2
Rassam, Hormuzd 34–8, 64, 72, 85, 87, 100,
 139, 199, 239, 245
 cares for royal family after fall of
 Maqdala 80–1, 82, 83, 85, 91–2, 100
 imprisoned on Maqdala 38, 39, 40, 56,
 58, 210
 and Tewodros II 34–5, 36–8, 56–7, 210,
 245
Rasselas, Prince *see The History of Rasselas*
 (Johnson)
Rawlinson, Henry 43
Record of the Expedition to Abyssinia
 (Holland and Hozier) 46–8, 54, *59*,
 65, 85, 97, 179, 222, 225
Rees, Sir John David 158
Reis Santos, Luiz 229
Reuters 104–5, 187
Rohlfs, Gerhard 105
Rosenthal, Mr 29, 31, 33, 36, 40, 57
Royal Collection, Windsor Castle 214, 235,
 248
Royal Engineers 78, 83, 199, 201, 212–13,
 220, 248
Royal Geographical Society 29, 52, 53
Rugby School 138, 163, 164–72, *167*, *168*, *170*,
 174, 177, 184
Ruskin, John 152
Russell, Lord 29–30, 139

Said, Dr Hassen 245
St George's Chapel, Windsor Castle 185,
 187, 242, 243

St John's Episcopal church, Edinburgh
 236–8, 251
Salama III, Abuna 31, 70
Sandhurst Royal Military College 174,
 / 175–9
Sanghera, Sathnam 49n, 116n
The Scheherazade Foundation 242–3, 252
School of Oriental and African Studies
 (SOAS) 231, 232
Seckendorff, Count 98
Selassie hill, Ethiopia 58, *59*, 60, *65*
Sheba, Queen of (Makeda) 7–8, 135, 227
Shoa, Ethiopia 35, 40, 139
silk 36, 63, 73, 131, 201, 202–3, 205, 206
Simien mountains, Ethiopia 16n, 80, 82,
 146
Simpson, William 83, 86, 98, 99, 101
Singapore 142
Sissay, Lemn 243
Sitapur, India 125, 137
Sladen, Douglas 157–8
slavery 12, 105, 111
Solomon, King 7–8, 9, 135, 227
Somsale, Woolda 105–6
Southon, Jean 161
Speedy, Cornelia (née Cotton) 118, 119, 120,
 125, 126, 142, 155–6
Speedy, Tristram Charles Sawyer 87–93,
 90, 152, 187, 192
 Alamayu, guardianship of 90–3,
 98–102, *103*, 109–10, 112, 114–26,
 117, 136–8, 140, 161
 Alamayu, loses guardianship of 140–4,
 147–50, 151, 152, 154
 Amharic, knowledge of 88–9, 90, 91, 98
 artefacts 'collected' at Maqdala 214, 245
 in India 87, 125–6, 136–41, 160
 meets Tewodros II 87–9, 208
 in Penang 140–3, 150
 and Queen Victoria 114, 115–16, 120
Spurzheim, Johann Gaspar 111
Stanley, Lord Edward Henry 44
Stanley, Henry Morton 48, 54, 60, 73–4,
 77, 120
Stern, Henry Aaron 29, 30, *30*, 31, 33, 36, 37,
 40, 57, 135
Stumm, Baron Ferdinand von 47
Stylianou, Nicola 205

271

The Prince and the Plunder

Sudan 10, 28, 29, 37, 176, 191–2
Suez 7, 50, 99, 101, 106, 126

Tabots 236–41, 246, 251
Tana, Lake 3, 4, 26, 36, 191–2
Tennant, Dorothy 120, 169
Tennyson, Alfred 121–2
Tennyson, Hallam 126
Tewodros II (formerly, Kasa) 42, 64, 199,
 208–16
 Abyssinian Expedition, during the 46,
 47, 55, 56–9, 62, 63–7
 Alamayu, relationship with 22, 56, 159
 amulet 212–13, 212
 appearance 56, 71, 208, 208, 215–16, 215
 British care of his sons, wishes for 12,
 36–7, 57, 80
 in British press 41–3, 42, 44, 69, 71
 character 10, 11–12, 22, 26–7, 29, 31, 58
 clothes 129, 130–3, 131, 209–10, 211, 247
 death and remains of 64, 67, 69–71, 71,
 76, 159, 160, 208–11, 208, 214, 243,
 252
 early life 9–11, 22
 Ethiopia, unifies 10, 11, 22, 199
 faith 12, 27
 horse (Hammel) 129, 129
 marriages 16–18
 pistols of 16, 22, 26, 38, 63–4, 88, 208,
 214, 248
 Plowden and Bell 10, 11–12, 13–15, 26,
 27, 31–2
 and Rassam 34–5, 36–8, 56–7, 210, 245
 sacred artefacts of 215–16, 215
 seal 32, 73, 97, 132, 215, 251
 slaughters Ethiopian prisoners on
 Maqdala 58, 120
 and 'the Turks' 10, 26, 27, 28, 30, 32, 62
 Victoria, communications with 10–11,
 26–8, 32, 33–4, 35, 36, 38, 131, 214
 see also plunder
Tigray 16, 35, 47, 80, 82, 86, 96
The Times 14, 62n, 98, 128, 139, 159, 178,
 179, 234
Tirunesh/Tiruwarq, Queen 16–20, 40,
 188, 205
 Alamayu, wishes for 79–80, 91–3,
 98–9, 115

Book of Psalms 17, 121, 154, 188, 202–3,
 246
clothes of 204–6, 204, 248, 249
death of 83–6, 91–3, 115
fall of Maqdala 72, 79–81
jewellery of 206–7, 248
at Maqdala 18, 20–1, 205
marriage to Tewodros II 16–18, 21, 56,
 205
piety 16–17, 81, 202
Tom Brown's School Days (Hughes) 138,
 163–4

V&A Museum (formerly South
 Kensington Museum) 130–3, 131, 132,
 204–7, 214, 216, 219, 245, 248, 249
Verney, Sir Harry 53
Victoria, Queen 97, 120, 121, 122, 146, 149,
 187, 189
 and Alamayu 112, 113–15, 137–8, 146, 150,
 155, 158, 159, 170, 182, 184, 185, 186, 187,
 189
 supports Speedy's guardianship of
 Alamayu 115, 147–8, 155
 and Tewodros II 10–11, 26, 27, 32, 33–4,
 35, 36, 38, 131, 214, 248
 Yohannes IV, writes to 227–8
Villemin, Jean-Antoine 85

Waldmeier, Theophilus 63, 64
Walker, C.H. 237
Westcott, Rev. A. 159
Westminster Abbey 197–8, 240–1, 242, 248
Wilson, David M. 54n
Wilson, Fiona 251
Woolf, Virginia 123n
Wright, William 249
Wynter, W.A. 75–6

Yatamanyu 22, 56, 72, 80, 82
Yohannes IV, Emperor (formerly, Kasa
 Mercha of Tigray) 82, 96, 145, 192,
 193, 227–8

Zanab, Alaqa 22, 92, 98–101
Zoological Society of London 49–50, 223
Zula, modern-day Eritrea 47, 55, 87, 93, 96,
 98, 220, 223